AMERICAN BEAUTY

" *May I never wake up from the American dream.* "

Carrie Latet

American Beauty is dedicated to America: to the great freedom
it allows and its extraordinary allure that calls to us all.
I also want to dedicate this book to my passionate and
patriotic parents, Elizabeth and Clarke Swanson,
and my great love, my husband, James Frank.

All photographs © Claiborne Swanson Frank.

© 2011 Assouline Publishing
601 West 26th Street, 18th floor
New York, NY 10001 USA
Tel.: 212-989-6769 Fax: 212-647-0005
www.assouline.com

ISBN: 978 1 61428 050 7
10 9 8 7 6 5 4 3 2

Printed in China.

CLAIBORNE SWANSON FRANK

WRITTEN AND CO-PRODUCED BY GENEVIEVE BAHRENBURG

AMERICAN BEAUTY

ASSOULINE

Foreword by Ivan Shaw 6
Preface by Lesley M. M. Blume 9
Introduction by Genevieve Bahrenburg 15

Jessi **Adele** 86 Genevieve **Bahrenburg** 204 Asia **Baker** 82 Veronica Swanson **Beard** 28 Lake **Bell** 178 Ashley **Bernon** 134 Maggie **Betts** 198 Diane **Birch** 148 Beth **Blake** 164 Georgina **Bloomberg** 184 Lesley M. M. **Blume** 30 Valerie **Boster** 116 Amanda **Brooks** 36 Kristen **Buckingham** 91 Sabrina **Buell** 54 Sophie **Buhai** 172 Carolyn **Burgess** 159 Meredith Melling **Burke** 68 Erin **Burnett** 80 Barbara Pierce **Bush** 112 Abigail **Chapin** 142 Lily **Chapin** 132 Alina **Cho** 170 Annie **Clark** 174 Misty **Copeland** 128 Danielle **Corona** 130 Casey Fremont **Crowe** 176 Cristina **Cuomo** 156 Chiara **de Rege** 91 Jessica **de Ruiter** 196 Lauren **duPont** 162 Sylvana Soto Ward **Durrett** 168 Maria **Echeverri** 78 Emilia **Fanjul** 43 Melanie **Fascitelli** 134 Erin **Fetherston** 58 Emily **Ford** 62 Amanda **Frank** 42 Betsy **Frank** 90 Claiborne Swanson **Frank** 12 Alexandra **Fritz** 190 Vanessa **Getty** 150 Emma J. P. **Goergen** 154 Isca **Greenfield-Sanders** 84 Mary Alice **Haney** 183 Amanda **Hearst** 126 Taylor Tomasi **Hill** 200 Joanna **Hillman** 114 Sarah **Hoover** 183 Lawren **Howell** 102 Cena **Jackson** 110 Field **Kallop** 180 Jenni **Kayne** 118 Celerie **Kemble** 52 Kick **Kennedy** 100

Solange Knowles 34 Lily Kwong 22 Aerin Lauder 56 Lauren Bush Lauren 194 Sasha Lazard 182 Rachel Lewis 76 Tamara Lowe 48 Jenna Lyons 202 Erin Martin 186 Marissa Mayer 98 Lisa Mayock 152 Kelsey McKinnon 135 Serena Merriman 106 Bonnie Morrison 74 Minnie Mortimer 144 Samira Nasr 92 Irene Neuwirth 140 Serena Nikkhah 24 Fernanda Niven 96 Summer Rayne Oakes 188 Michele Ouellet 70 Caroline Palmer 66 Monique Péan 160 Sophie Pera 20 Whitney Pozgay 94 Bettina Prentice 124 Lily Rabe 104 Devon Radziwill 66 Indre Rockefeller 108 Alexandra Lind Rose 64 Lela Rose 122 Jessica Sailer 50 Lisa Salzer 26 Lauren Santo Domingo 88 Gillian Schwartz 158 Bee Shaffer 72 Nicole Simone 166 Joan Smalls 120 Ruthie Sommers 158 Sara Gilbane Sullivan 43 Georgia Tapert 111 Ferebee Taube 60 Alexis Swanson Traina 18 Katie Traina 38 Hilary Walsh 32 Connie Wang 138 Marissa Webb 146 Ashley Wick 67 Elettra Wiedemann 44 Arden Wohl 46 Stephanie Winston Wolkoff 192 Elizabeth Woolworth 110 Nena Woolworth 136 Elizabeth Yarborough 40 Acknowledgments 206

This Time

Ivan Shaw, Photography Director, *Vogue*

A number of years ago, I had the unique experience of spending an afternoon with the legendary society portrait photographer Slim Aarons. Slim was as gifted a storyteller as he was a photographer, and his pictures and the stories behind them defined a generation of American society. After my first meeting with Claiborne about her exhibit *Indigo Light,* a series of twenty-nine portraits of the women in her world, I couldn't help but think of Slim and how Claiborne had opened the door to a world that seemed, after Slim's passing, to be forever closed. In many ways, it couldn't have been anyone but Claiborne who would re-open this door.

Claiborne and I originally crossed paths while she was working at *Vogue,* but it wasn't until after she had left the magazine that our friendship and collaboration truly began. During a chance meeting, Claiborne told me about a project she was working on and asked if I would mind taking a look. Of course I agreed. What struck me most upon seeing her early portraits was the feeling that finally someone was pursuing a theme—a woman taking pictures of her contemporaries—that I had always felt was waiting to be done. For years it had seemed that there was a new story to tell, and it just needed the right person to take the photographs. Claiborne was the right person.

Over the next year, we continued to discuss the venture and edit the images. Throughout that time, what I felt most strongly about conveying to Claiborne was the need to stay within her own world. I remembered the old Warhol quote, "Photograph your friends." I wanted Claiborne to dig deeper into what was closest to her and avoid the subjects that were furthest away. She agreed entirely, and I think we both shared a sense of excitement in knowing that she was recording something very personal and very special.

The result of this journey is a stunning portfolio of magical images that are at once deeply personal and visually arresting. Yes, the women are beautiful and the landscapes spectacular, but what brings me back to the photographs again and again is their poignancy. In each, Claiborne has captured a moment in time and a moment in that woman's life. Knowing these moments can't last and that the world and these women will change makes me think of F. Scott Fitzgerald, and if he were here, how he would tell these stories. But, really, the worlds of Slim Aarons and F. Scott Fitzgerald are not as far away as we might think. In fact, I think that if you look closely at these pictures you will see Slim, F. Scott, and all the others smiling admiringly in the background.

Preface

Lesley M. M. Blume, author and journalist

My grandmother's portrait hung in the library of her house. It was not painted by anyone of note, but it exuded feminine authority. As a child, I did not recognize the person in that painting: Its subject—a soft-mouthed, fertile young beauty—did not resemble the silver-haired, imperturbable doyenne my grandmother had become. And yet the portrait held a narcissistic fascination for me, for I had been told that I resembled her strongly, that I might have been a little branch cut from her tree, and that if fate chose to favor me, this is what I could expect to look like someday.

As the years passed, my limbs stretched, the planes of my face rearranged themselves, my cheeks hollowed, and the portrait appeared to watch with keen interest. Something extraordinary happened: The painting ceased to be a representation of a vaguely familiar stranger and became a mirror instead. Not an entirely accurate mirror, mind you—fate threw me some curveballs: a narrower nose, larger hands, and so on—but the overall resemblance was uncanny. It was disorienting and comforting at the same time.

All of this confirmed to me that nothing in this world truly belongs to us: Not even our faces and bodies can be considered proprietary. Our own physicality is, in reality, merely borrowed from our ancestors. Every feature is a reprise, a reinterpretation. In this respect, formal portraits of our forebears become more than literal depictions of people who lived and breathed and mattered long ago; they are guides that may illuminate who we are today.

My grandmother chose to be painted in a chastely collared white lace shirt, her dark, waist-long hair neatly braided and looped over her crown; my father—then a ringleted blond toddler—sits in a worshipful pose at her elbow. Her expression is one of deep contentedness. When I stand in front of this painting today, I ask myself: How am I like this woman, whose eyes and lips and cheekbones so closely resemble my own? Will I find pleasure in the things that evidently brought her pleasure? As I measure myself against her likeness, I assess the differences and similarities between us. How we have proven unalike: First and foremost, I am not a demure lady; instead I am theatrical and difficult. Where our interests have coincided: I am pathologically tidy, I am bookish, and my home is very much the center of my universe. My own portrait—shown in the pages of this very book— certainly tips off the viewer to these qualities, just as my grandmother's portrait tells you everything you need to know about her at a glance.

The bottom line: The family portrait serves as something of a prophet. No matter whose face adorns the canvas, its message to its heirs is as follows: You might innately be a great deal like this person, so make your choices accordingly. Embrace your ancestors' traits as they manifest themselves in your own appearance or opinions or aspirations—or fend them off like crazy. Then again, you ultimately may not have a choice in the matter. Heredity can be awfully dictatorial.

Clearly, staged portraits intrigue and instruct in a way that few other media can. It's a shame, then, that they have fallen out of fashion's favor. One might counter, What relevance does the traditional portrait have today? In bygone eras, a single painted or photographed image might be the only likeness created of a person throughout his or her entire lifetime. In fact, it might be the only proof that he or she had existed at all. But these days we are documented—and document ourselves—ad nauseam; our likeness is captured practically everywhere we go.

Hallways devoted to ancestral paintings have been swapped for white-noise social media photo galleries.

I would argue that today's scattershot portraiture largely consists of kaleidoscopic fragments that somehow never manage to reveal wholly the soul of their subject. In the past, formal portraits—whether beautifully articulated or not—aimed to do precisely that; symbolism intentionally saturated every detail, making the portrait a dense, layered declaration of identity and a display of life choices. Today's approach to documentation, on the other hand, almost entirely lacks this sort of staging or presentation. As a result, fewer clues are given to the subject's true persona; the distillation of self on canvas is missing. The painstaking assembly of details in the formal portrait is what makes it so telling.

If you were told that only one image could represent you for eternity, imagine the amount of thought you would put into it, the excruciating attention to detail. In today's parlance, you would be forced to curate yourself—which is not something that we're often forced to do anymore. It's a useful exercise, and can even be a harrowing one, for it makes you face the central question addressed by all the great works of Western literature: Who am I? No one—no matter how aggressively modern he or she may be—should miss out on this sort of opportunity for self-evaluation and self-immortalization. Nor should one's descendants be deprived of the portrait's complicated presence and influence in their lives. Some heirs, of course, won't give a damn about the picture, but for others it may become a key that unlocks door after door.

It's quite remarkable, when you think about it, that a single moment in a single life, frozen in time, will mean so many different things to so many people.

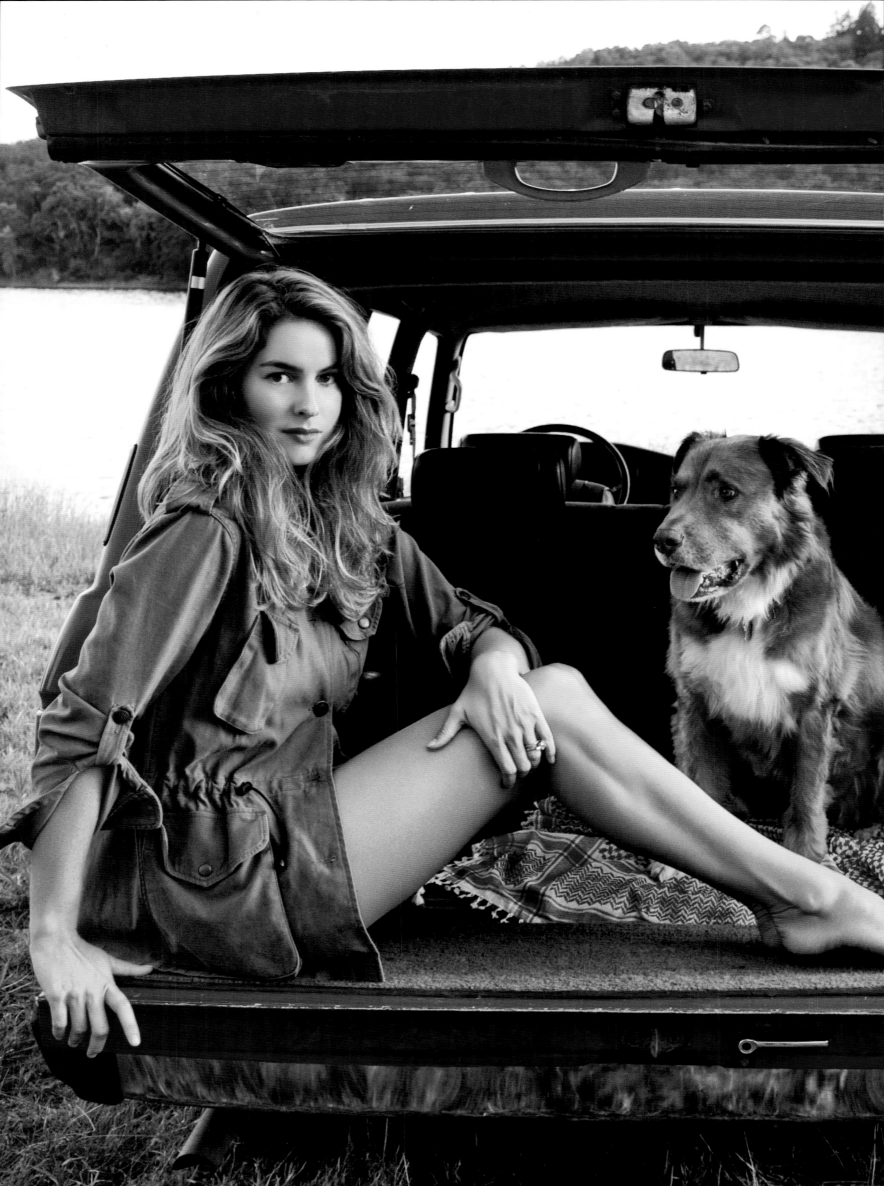

❝ *My goal is to find something
that takes your breath away.
I dream to shoot my vision of spirit
and soul. I set out to take
portraits that capture women
in their greatest beauty and truth,
whatever that may be.* **❞**

Claiborne Swanson Frank

Self-portrait on the banks of
Lake Hennessy in Napa Valley.
Claiborne is clad in her favorite
army jacket, sitting in the back
of her tomato-red Land Cruiser
with her dog, Gator.

" *It is capitalist America that produced the modern independent woman. Never in history have women had more freedom of choice in regard to dress, behavior, career, and sexual orientation.* "

Camille Paglia

Introduction

Genevieve Bahrenburg

Throughout America's history, courageous women have personified our nation's indomitable spirit. From Lady Liberty to Rosie the Riveter, Amelia Earhart to Hillary Clinton, bold, self-actualized women have embodied our national character. *American Beauty* is a tribute to our extraordinary country, whose freedoms have allowed women to soar to heights unimaginable in other times and places. Each woman in this book possesses an original blend of grit, grace, glamour, and gravitas that makes her a fitting exemplar of American beauty. These are portraits of women who revealed their true selves to another woman. Claiborne's vision is raw and honest, and her images are odes to the individuality of her subjects.

I first met Claiborne when we were both working at *Vogue.* I recall her first day at the office. Prior to her arrival, there was chatter among the assistants about the San Francisco import, as she and her two sisters, Alexis Traina and Veronica Beard, had just been photographed for a feature in the magazine's September issue on iconic American families, entitled "American Beauties." Long-legged and rosy-cheeked, Claiborne walked down *Vogue*'s Irving Penn–filled halls, passionate and brimming with vigor. She was wearing a white T-shirt, vintage navy blazer, and worn-in blue jeans; her signature mane was long and wild. We became friends later that first day

when we found ourselves together in the office kitchen. We hoisted ourselves up on the countertop and started talking about everything all at once—a conversation that continues to this day.

After spending nearly two instructive years under Anna Wintour, Claiborne left *Vogue,* married her husband, James Frank, and decided to pursue her deep, dormant dream of becoming a photographer. She enrolled at the International Center of Photography and began creating a photo essay of portraits celebrating the dimensions of the women nearest to her. After her instructor dismissed her vision of American women as too rarified to be relevant, the iron-willed Claiborne promptly withdrew. She rounded up her closest friends and family to sit for portraits. Her first shoot was of her dear friend Asia Baker, with whom Claiborne had worked in Wintour's office. Claiborne shot Asia on the beach in front of Baker's grandfather's house on Center Island, New York, on a bitingly cold, bright blue day, in Claiborne's vintage fur jacket, Asia's grandfather's felt hunting hat, and riding boots. Exhilarated by the success of the shoot, Claiborne decided to continue photographing more of the women in her world, a group of creatives with great personal style and charisma.

Claiborne was propelled by what she perceived to be the disappearance of the traditional portrait—at one time, one of a young woman's most meaningful rites of passage. Studying the photography books piled atop her coffee table, she searched in vain for traditional portraits of modern-day incarnations of American icons such as Lauren Hutton, Ali McGraw, Anjelica Huston, Slim Keith, and Talitha Getty. With this void in mind, Claiborne created *Indigo Light,* an exhibit of twenty-nine images paying homage to the lost art of portraiture. She worked with each of her subjects to find locations that resonated with them and styled them in clothes and jewelry from their own wardrobes, a formula she still follows.

Invigorated by the enthusiasm generated by her exhibit, and encouraged by her friend and mentor, *Vogue* director of photography Ivan Shaw, to expand her vision into a book, Claiborne decided to photograph American women embodying the same spirit as the subjects of *Indigo Light.* After further researching the history of American portraiture, Claiborne realized that she had the singular opportunity to create a body of work showcasing a unique group of women seen through the eyes of a contemporary who had also struggled with questions of identity, direction, and purpose before blossoming into her own. She drew on the legacy of great

female photographers like Sally Mann, Julia Margaret Cameron, Eve Arnold, Ellen Graham, Diane Arbus, Dorothea Lange, Lee Miller, and Imogen Cunningham. *American Beauty* was born.

The process of selecting women for a book on a subject as wide-ranging as American beauty was, admittedly, daunting, so we began by trying to distill who Claiborne's girl was. Over the course of several debates around the Franks' dining room table, we compiled lists of young American women who are making marks in their respective spheres of influence and who also radiate a dynamic synthesis of style, moxie, and soul. Claiborne made her final edits; rare were the occasions when she did not decide on a subject instinctually.

Claiborne spent most of her childhood in California. She grew up in San Francisco and spent her summers and weekends in Napa Valley, where her family owns Swanson Vineyards. It was in Napa, where she grew up riding her Appaloosa, Premonition, bareback through the vines, that she developed her love of the outdoors and the wide-open landscapes that are referenced in so many of her portraits. American beauty is a rich tapestry of traits, backgrounds, and experiences, and the women in these pages are as diverse and resistant to stereotyping as our nation itself. Through these images, one may see what American beauty and style look like through Claiborne's lens: from cover girl Lily Aldridge, draped in an American flag, to model Elettra Wiedemann, in her grandmother Ingrid Bergman's reconfigured evening gown, to actress Lake Bell holding court in her mother's vintage Rodolfo dress. From Google's Marissa Mayer to CNN's Alina Cho, Barneys' Amanda Brooks, ABT's Misty Copeland, and J.Crew's Jenna Lyons, this book is a celebration of graceful, gutsy women who show us that it is possible to realize even the loftiest of dreams.

This spirit is not new. American women such as Susan B. Anthony, Betty Friedan, and Gloria Steinem fought ferociously for the freedoms that American women are capitalizing on now. We are using the sturdy foundation built by our foremothers to charge confidently, unobstructed, ahead. Claiborne's careful selection of subjects, as well as her own personal story, demonstrate that if a woman is sufficiently ambitious, focused, and gifted there is nothing she cannot accomplish. The promise of the American dream is reflected in the eyes of each woman in these pages.

*"It is with the reading of books
the same as with looking at pictures;
one must, without doubt, without
hesitations, with assurance, admire
what is beautiful."*

Vincent van Gogh

Alexis Swanson Traina

b. New Orleans, Louisiana The eldest of the Swanson sisters, Alexis Swanson Traina has been Claiborne's long-standing muse. In many ways, she personifies the beguiling beauty and poetic grace that Claiborne seeks out in all of her subjects. Alexis is a wife, mother, daughter, and sister, above all else, and lives between San Francisco and Napa Valley, where she is Swanson Vineyards' creative director, known for her brazen innovations of fine wine rituals.

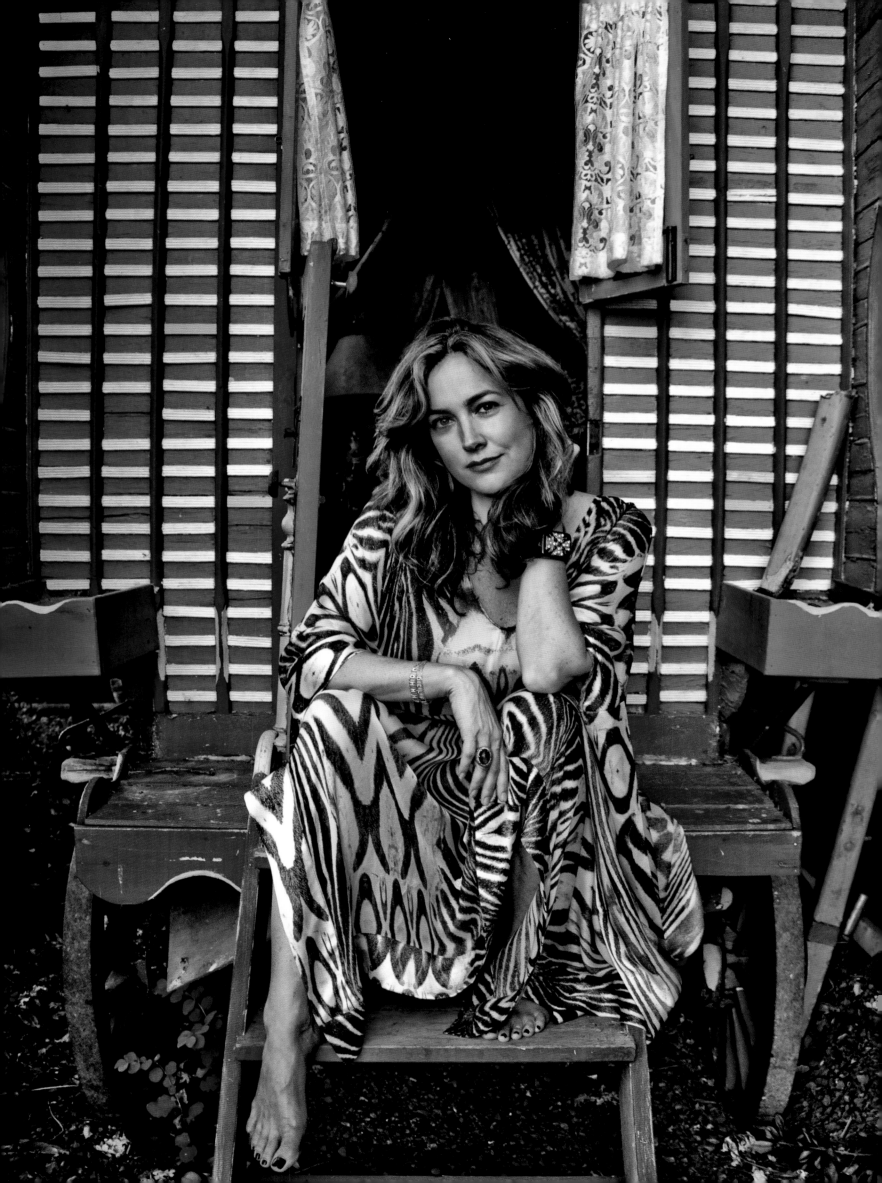

“Beauty and femininity are ageless and can't be contrived, and glamour, although the manufacturers won't like this, cannot be manufactured. Not real glamour; it's based on femininity.”

Marilyn Monroe

Sophie Pera

b. Milan, Italy "Even though I was deep into my tomboy phase, at age twelve I discovered fashion magazines, and would rip my mother's American *Vogue* apart searching for looks for the future me. From there, I began plotting how to dress the future for everybody," says Sophie Pera. Starting her fashion career under the influence of Anna Wintour, Phyllis Posnick, and Alexandra Kotur at *Vogue*, Pera, now the fashion market editor at *Town & Country*, enjoys cultivating an eclectic sense of style, mixing menswear pieces with feminine sequins and leather with feathers.

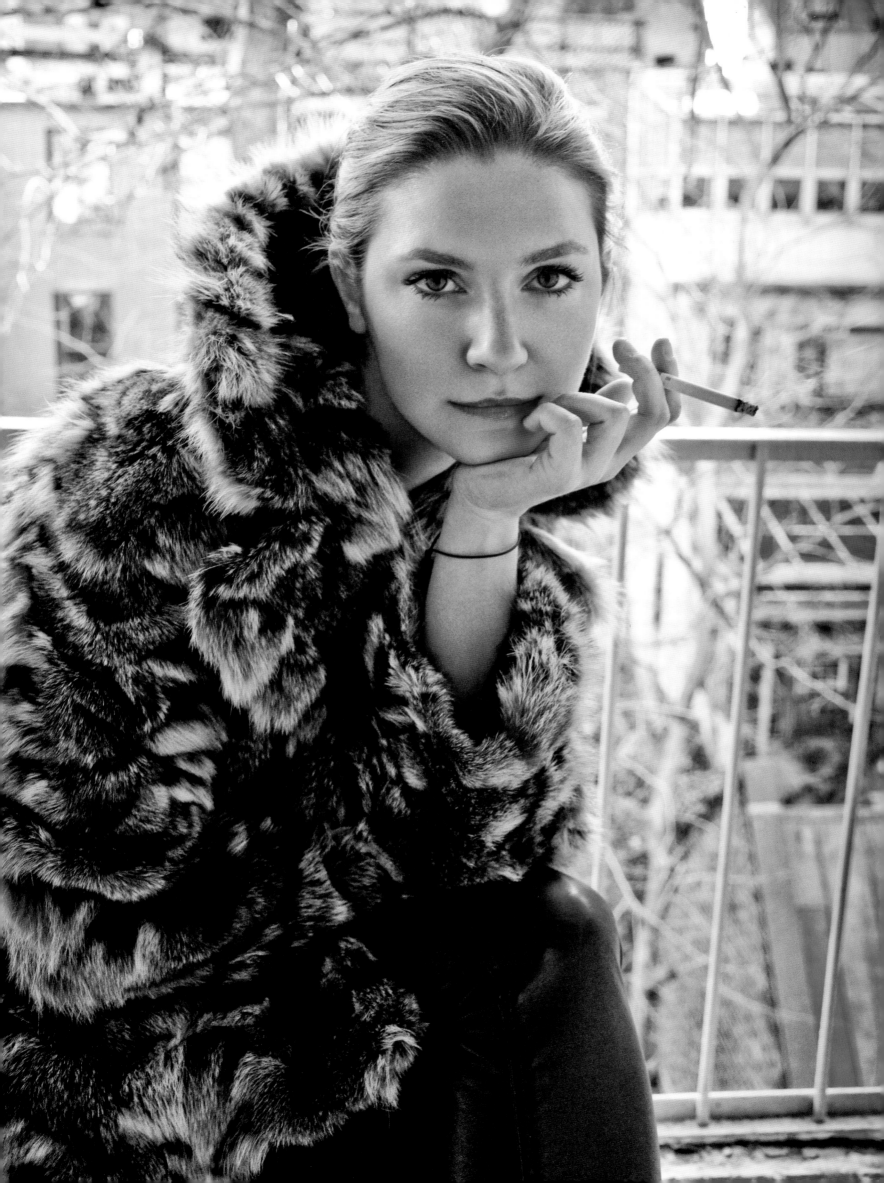

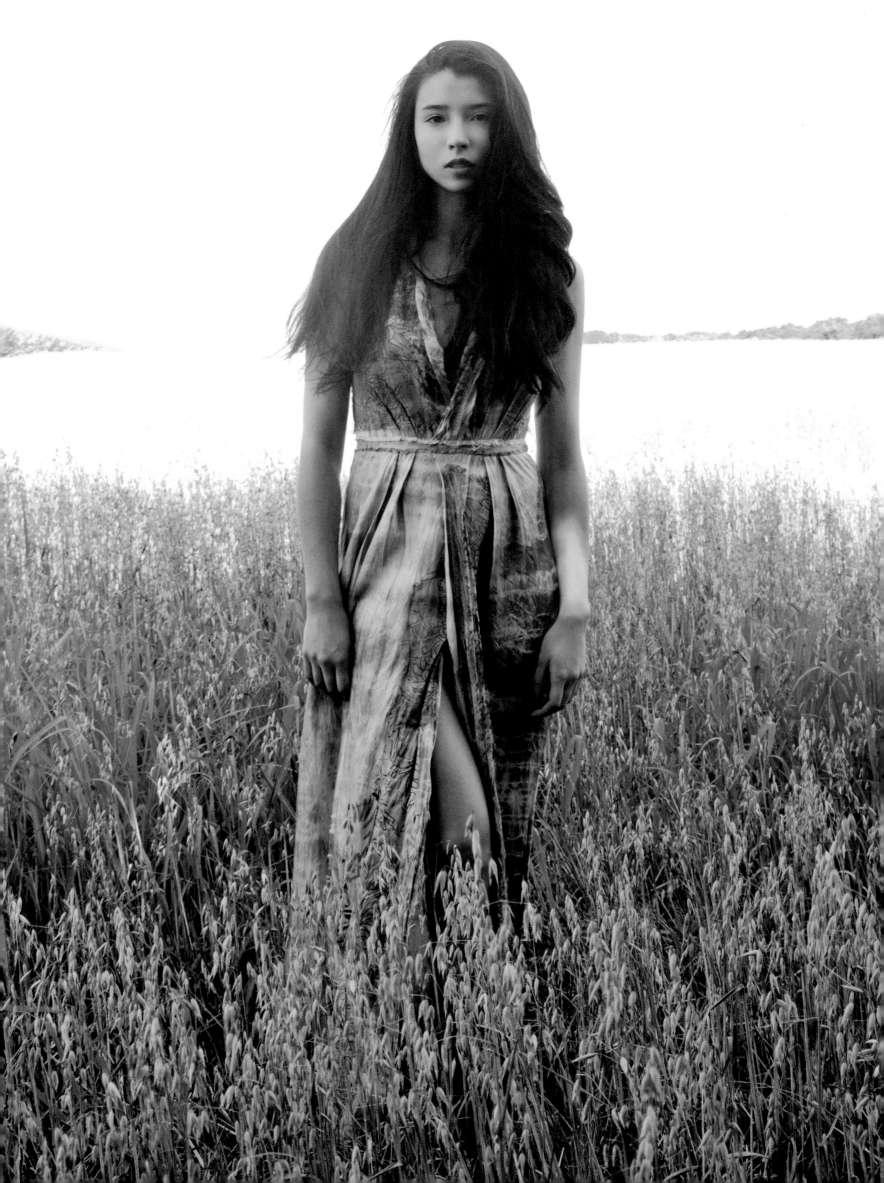

> *We delight in the beauty of the butterfly, but rarely admit the changes it has gone through to achieve that beauty.*
>
> *Maya Angelou*

Lily Kwong

b. San Francisco, California As a model, muse, writer, activist, and media architect, there's little Lily Kwong can't—and doesn't—do. Currently a sociology and urban studies major at Columbia University, where she is a Sudhir Venkatesh Film & Multimedia Fellow, Kwong has worked at *GQ* and has modeled in campaigns and runway shows for Dior and Proenza Schouler. She also works with her father on Nuvana, a social media and educational gaming company that encourages children to get away from their computer screens and head into the world on community-based "missions."

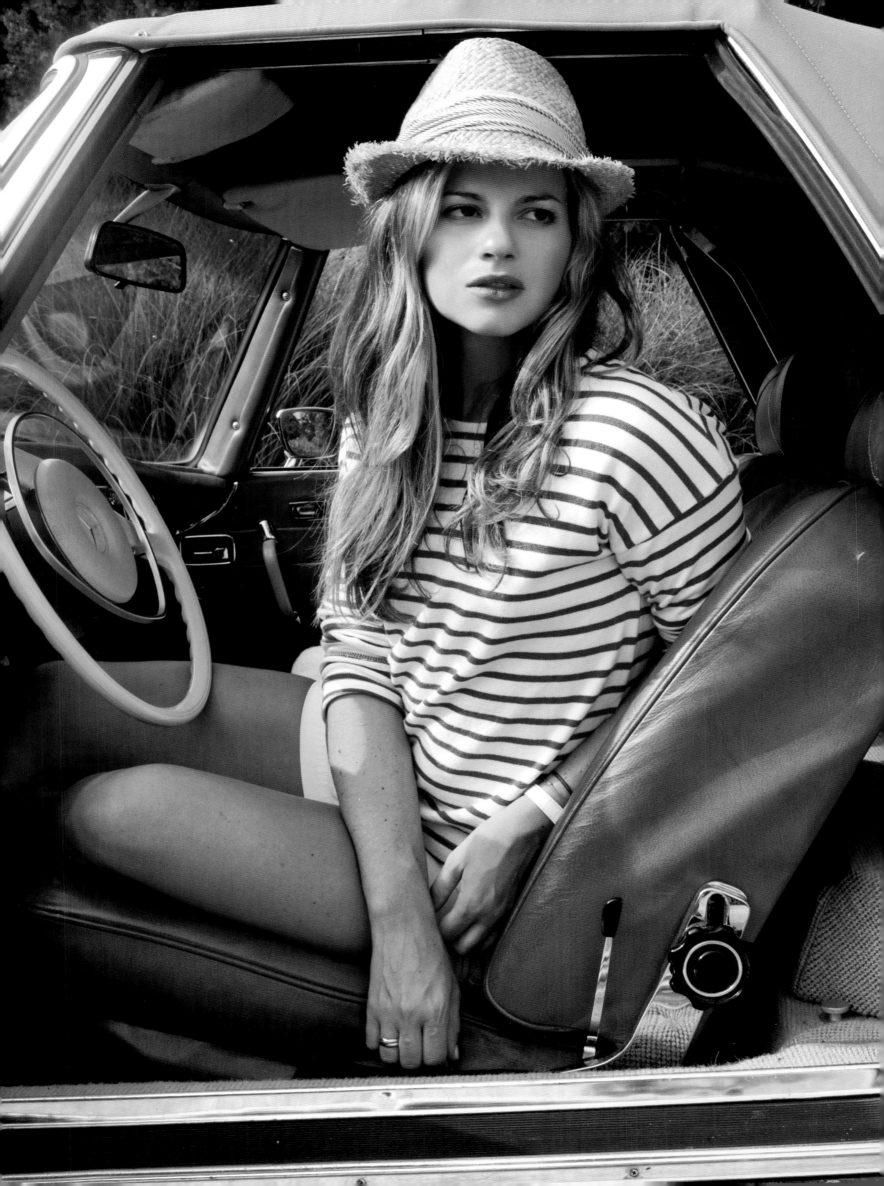

> **" All of my beauty icons are men. It's all about effortlessness. It's all about looking underdone. "**
>
> *Alexa Chung*

Serena Nikkhah

b. New York, New York "Being surrounded by the world's most talented editors revolutionized the way I think about fashion," says Serena Nikkhah, a former *Vogue* accessories editor, who credits her years in the magazine's halls as the most influential in her style education. Born to a Brazilian mother and an American father, she is currently based in London, where she works in fashion public relations.

> *I don't think about ages, I think about women.*
> *What it means to be modern, how women feel, how they live.*
> *Because beauty and sensuality come from within. Numbers*
> *mean nothing. You can have an old soul in a young body or a young*
> *soul in an older one. It's about the experience,*
> *the universality of women.*
> *Donna Karan*

Lisa Salzer

b. Syosset, New York Following in the tradition of her maternal grandmother, who sold estate jewelry that captured her imagination from a young age, Lisa Salzer maintains her fascination with gems through her celebrated jewelry line, Lulu Frost. Photographed in a J.Crew column dress and recycled remnants of estate jewelry, the relentlessly creative designer describes her style as "ladylike, eclectic, and elegant." But more than the glitz, she values hard work and the sense of accomplishment that comes with that, explaining, "It's sort of that gorgeous 'Go West' metaphor for always searching for the unexpected joys in life."

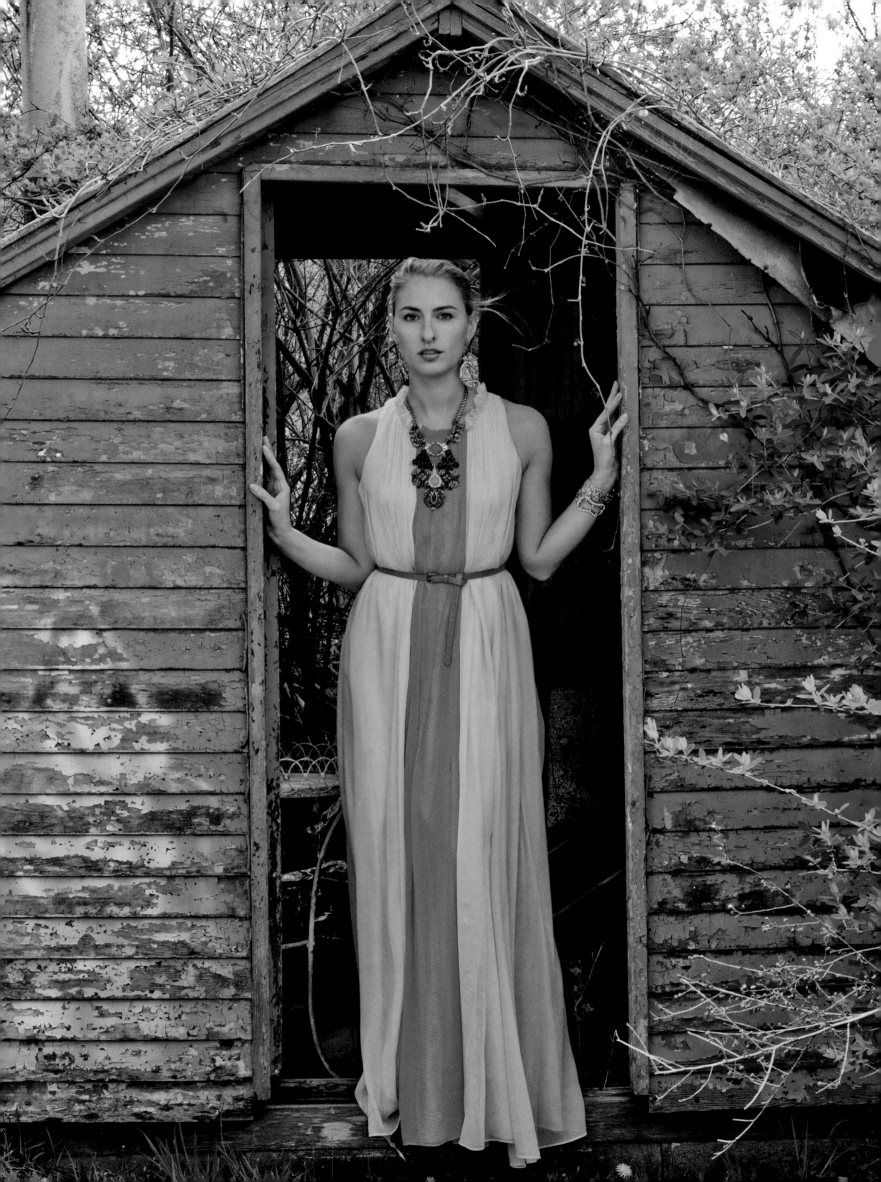

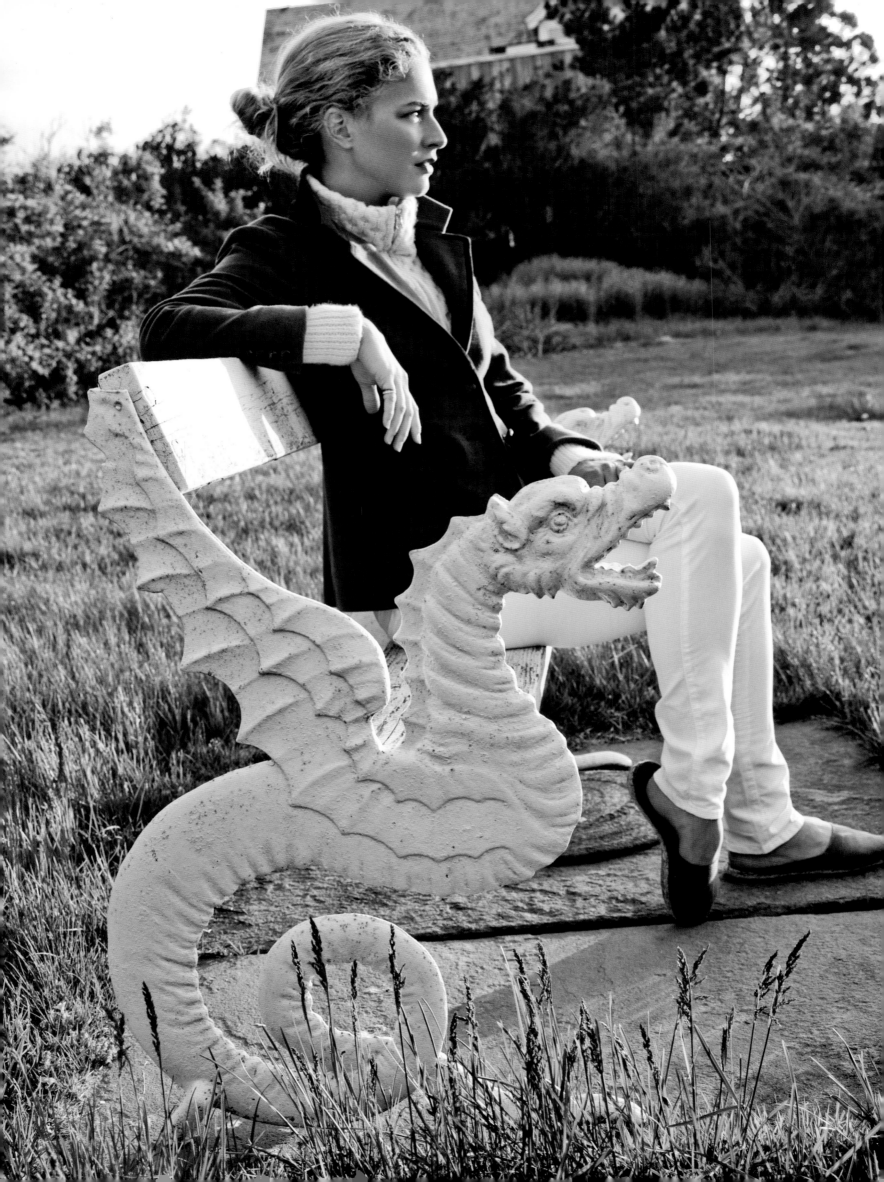

> **"*While you have to be natural, you also have to be different. If, that is, you want to make an impact.*"**
>
> *Slim Keith*

Veronica Swanson Beard

b. Naples, Florida From the time that she was a little girl, traipsing around the Swanson household in one of her many pairs of high heels—accessorized, always, with a matching purse and hair ribbon—Veronica Swanson Beard has served as an inspiration to sister Claiborne, exposing her to the marvels of fashion, art, and music. For Beard, "American beauty is about being comfortable in your own skin—whether you're in a Hanes T-shirt and cutoffs or an Oscar de la Renta gown." After the birth of her second child, Veronica pursued her long-standing dream of becoming a designer, and together with sister-in-law Veronica Miele Beard founded the eponymous line Veronica Beard, a women's ready-to-wear collection of iconic staples.

" Apart from the superficial, beauty is what a woman offers to the world through the grace of her gestures, the confidence of her walk, and the strength of her gaze. "

Mark Eisen

Lesley M. M. Blume

b. New York, New York "My mother was a concert pianist and my father was a newsman, and our life was populated with music, words, and fascinating characters. Every work of fiction I've written likely draws on this period in my life," says journalist and social commentator Lesley M. M. Blume, seen here in front of her personal library. In addition to penning *American Beauty*'s preface and regularly contributing to *Vanity Fair, Vogue, Huffington Post,* and *The Wall Street Journal,* Blume has written four books, the most well-known being *Let's Bring Back,* an ode to all things antiquarian.

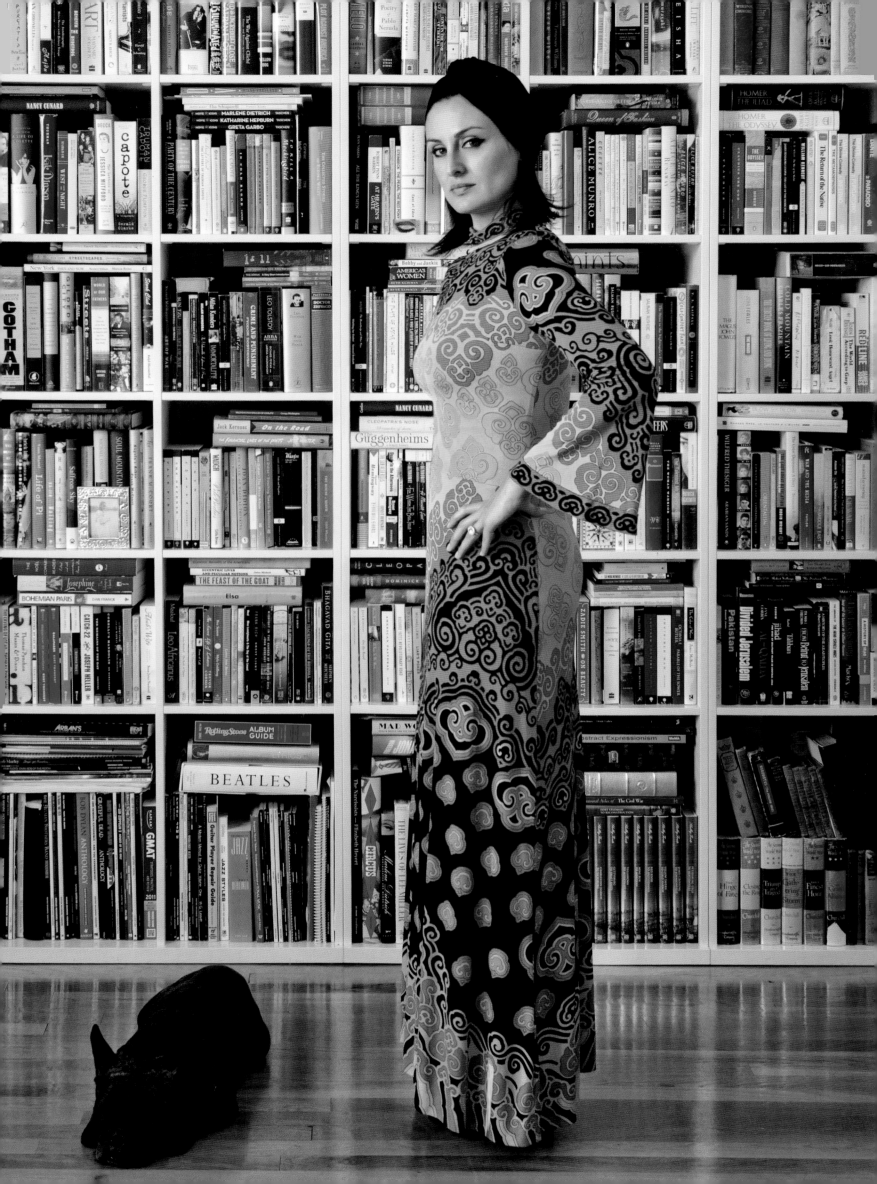

66 *Nothing makes a woman more beautiful than the belief that she is beautiful.* *99*

Sophia Loren

Hilary Walsh

b. San Francisco, California Known for her unaffected style and fresh, gritty take on fashion photography and celebrity portraiture—using subdued lighting to emphasize natural beauty—Hilary Walsh is captured in her denim-on-denim uniform in Laurel Canyon, California. Raised in Philadelphia, she currently lives in Los Angeles with her son, Henry, and her husband, Emmett. For Walsh, whose icons include Jane Birkin and Joni Mitchell, "American beauty can mean just about anything nowadays, since everyone in America is from someone else's lineage. I think 'all-American beauty' is represented by a liberated spirit and appearance."

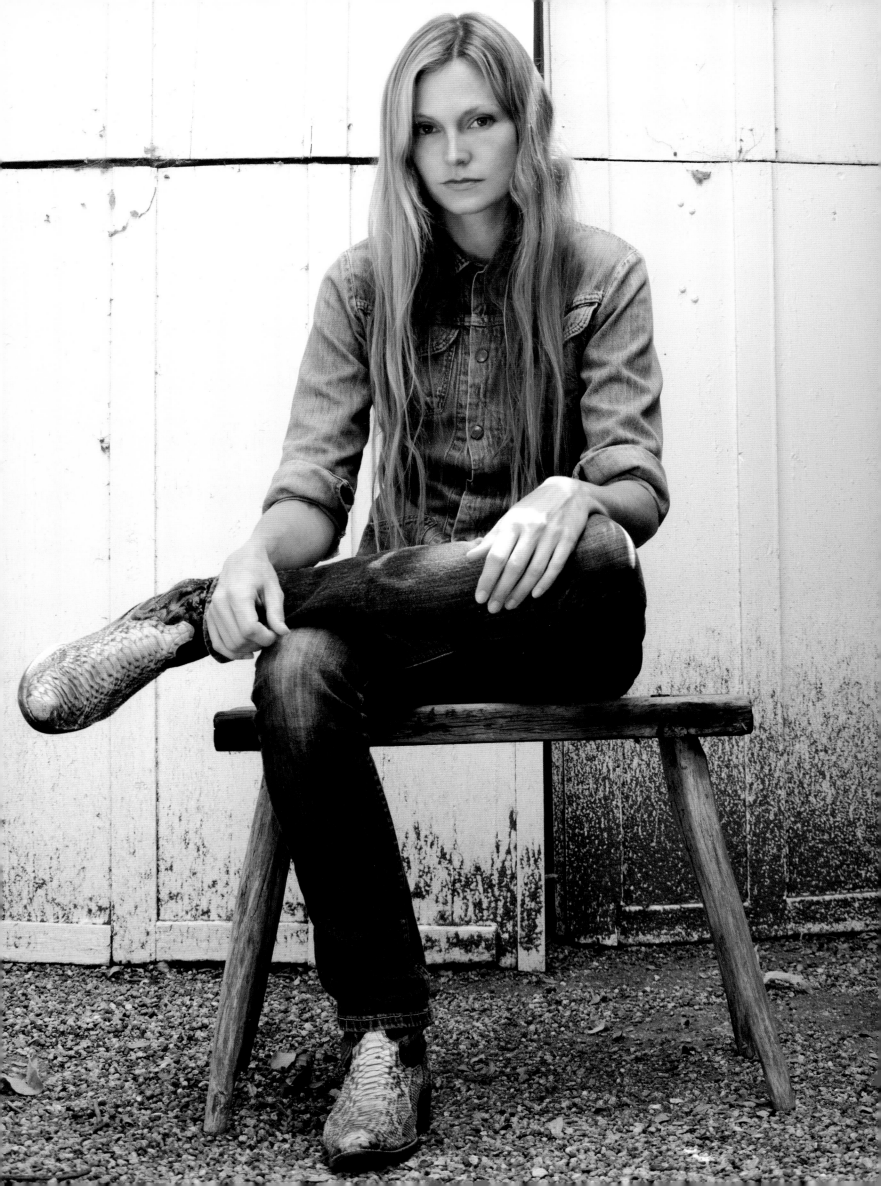

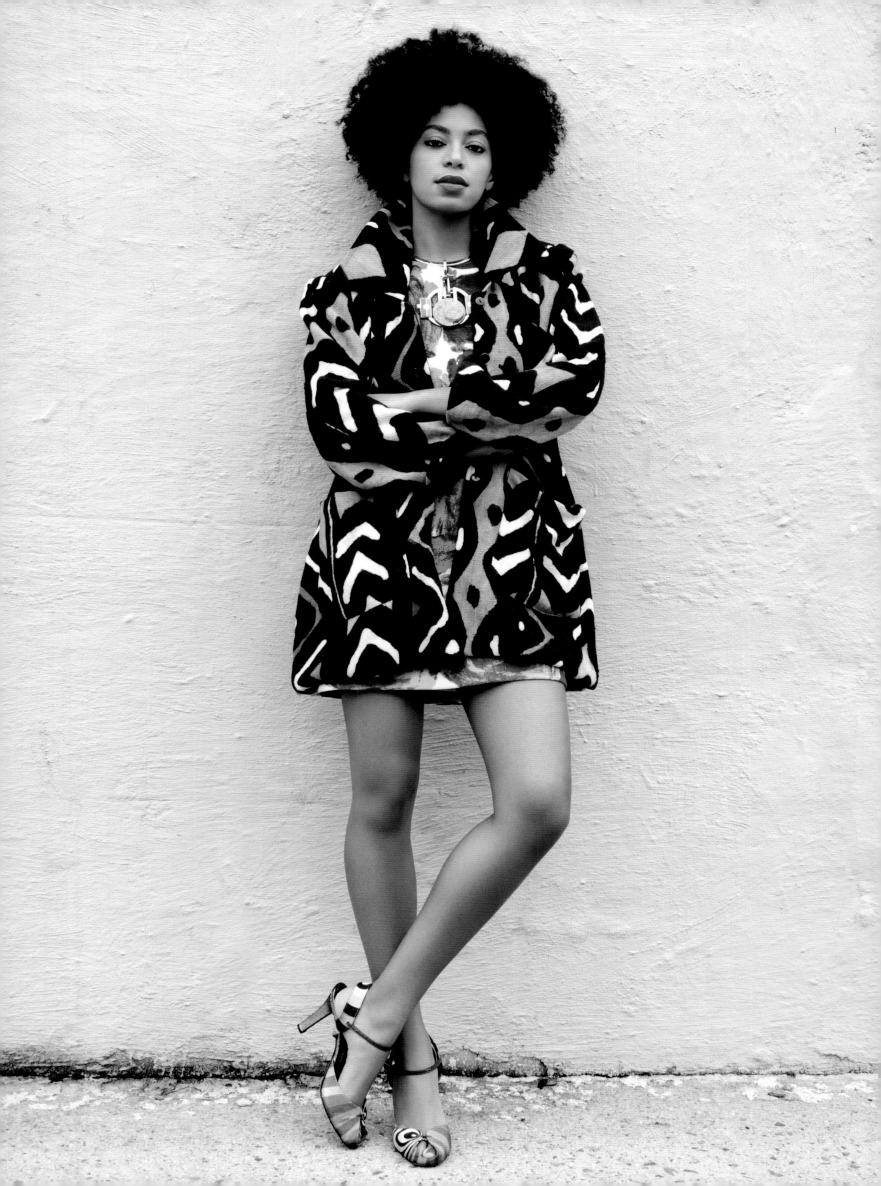

66 *I've just learnt that the more I photograph women,*
the less it is about transformation.
Women are beautiful.
All that really matters is enhancing that. 99
Mario Testino

Solange Knowles

b. Houston, Texas Solange Knowles, younger sister to Beyoncé, is a preternaturally gifted performer and creative powerhouse. A singer-songwriter, producer, DJ, and mother, she broke into the music scene at the age of 16 and has since released two albums: her debut, *Solo Star,* in 2003, and the critically acclaimed *Sol-Angel and the Hadley St. Dreams* in 2008. Knowles has an electric personal dynamism, which permeates every sphere of her life from her music to her friends to her business ventures. Her career as a performer began when a Destiny's Child backup dancer had to unexpectedly leave a world tour. An accomplished songwriter of rare dexterity, Knowles co-wrote most of the songs on her first two albums, and has written and co-written songs for her sister Beyoncé and Destiny's Child. "I was brought up in Texas going to rodeos and sifting through screw tapes," she says. "I spent family reunions in Alabama and Louisiana with my Creole cousins cooking some of the best crawfish étouffée you've ever had in your life. I raised my son the first year of his life in the country fields of Idaho, and took him to his first day of school in sunny California. As a new New Yorker, I'm excited to continue my journey as an American woman. This country is the fabric of my life's journey."

> *A photograph can be an instant of life captured for eternity that will never cease looking back at you.*
>
> Brigitte Bardot

Amanda Brooks

b. Palm Beach, Florida "American style represents simple, classic, practical clothes. It's Jackie O. in the seventies, with her T-shirts, pressed pants, sandals, and headscarf; and Lauren Hutton, who also always hits the nail on the head." Long celebrated for her singular style, Amanda Brooks, the women's fashion director of Barneys, credits her mother—who used to pick her up from dance class in leather Alaïa—for teaching her about style. An accomplished writer, Brooks has penned style-related articles for *Vogue* and *The New York Times,* in addition to authoring *I Love Your Style* (HarperCollins, 2009).

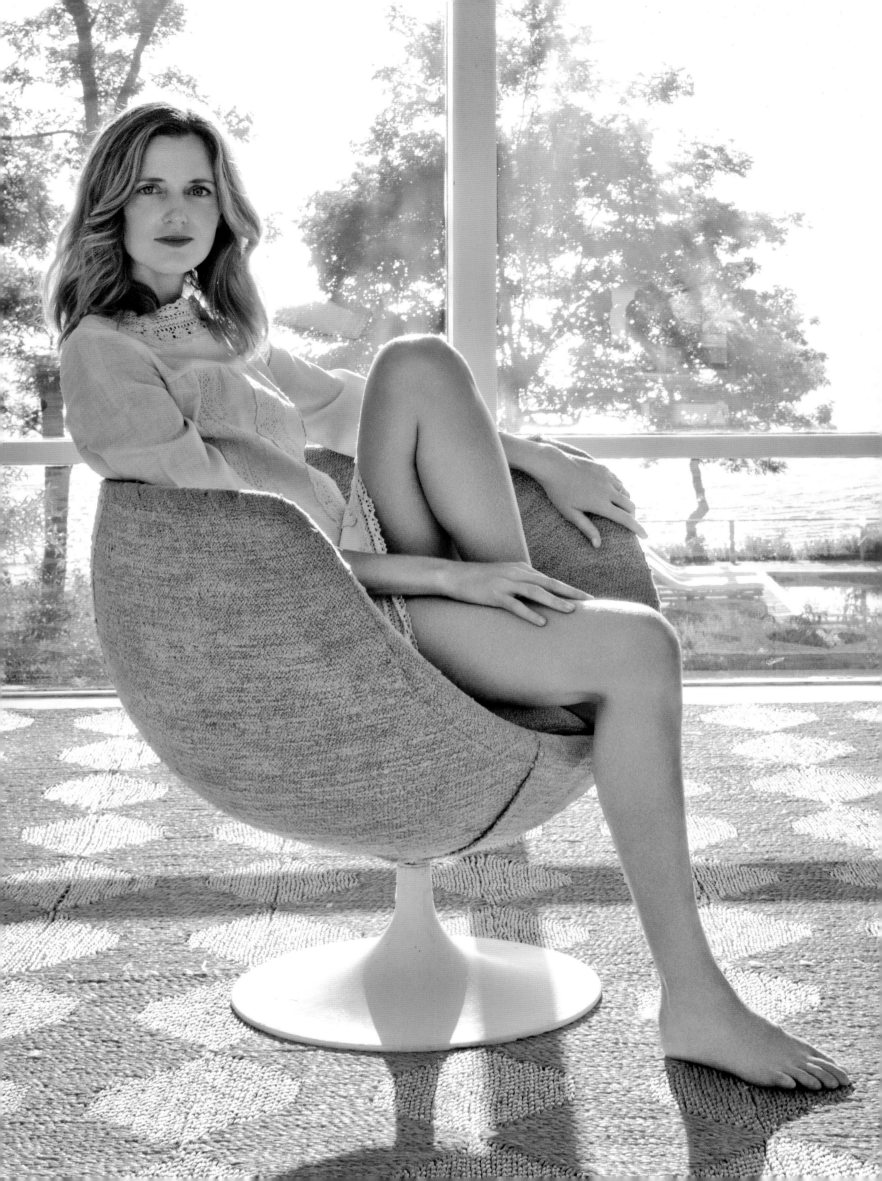

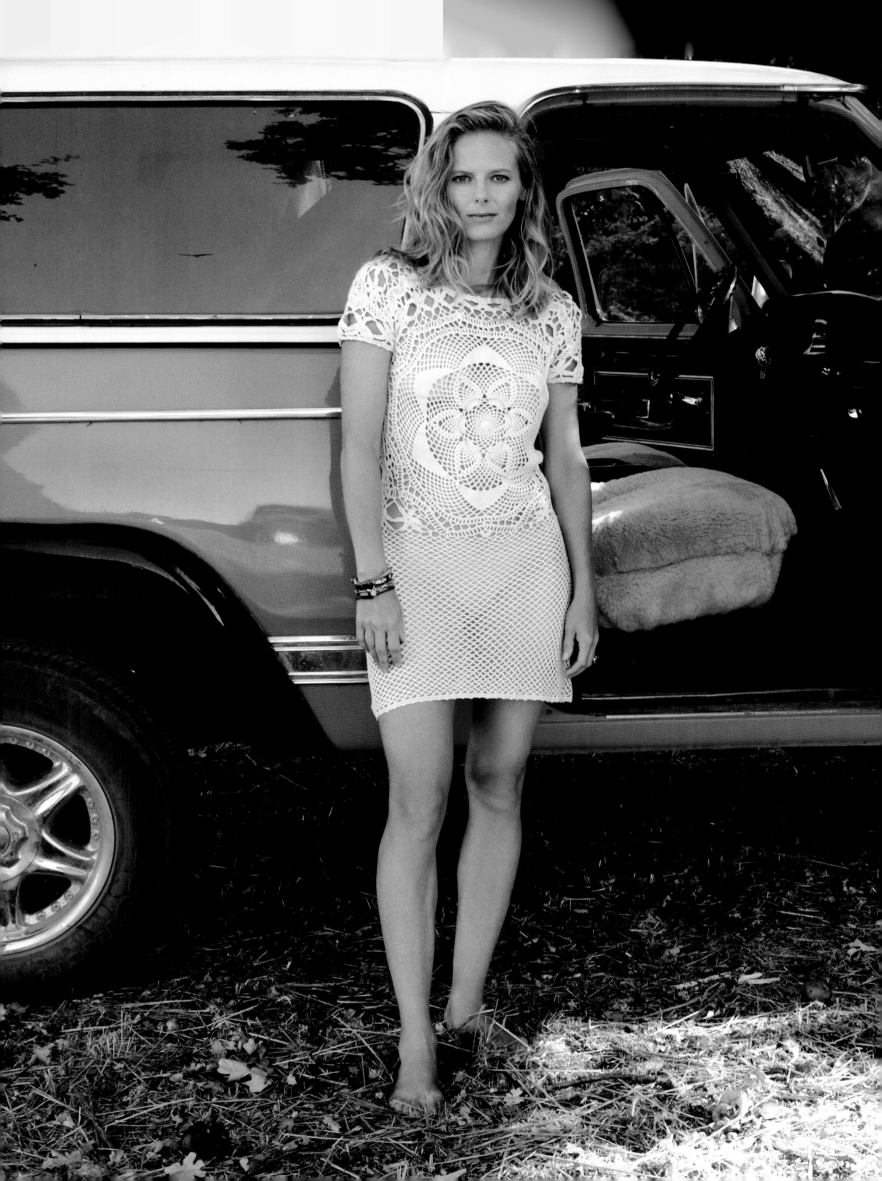

> *"Beauty is also submitted to the taste of time, so a beautiful woman from the Belle Epoch is not exactly the perfect beauty of today, so beauty is something that changes with time."*
> *Karl Lagerfeld*

Katie Traina

b. Sun Valley, Idaho Photographed on a dirt road in the vineyards of Napa Valley, Katie Traina is a consummate outdoorswoman who grew up skiing, hiking, playing tennis, and biking. She serves on the board of directors of Compass Family Services, the oldest organization in San Francisco dedicated to helping families break the cycle of poverty and homelessness. Traina lives in San Francisco with her husband and daughter, Daisy.

Elizabeth Yarborough

b. Louisburg, North Carolina "An old soul in new Ferragamos," is how Elizabeth Yarborough describes herself. Photographed atop a large oak stump, surrounded by overgrown daisies, she looks like she stepped out of a Singer Sargent painting. Yarborough's upbringing in a tiny historic town in North Carolina has endowed her with wide-eyed optimism and graceful humility that translates to everything she does—from designing bangles in wool, silk, and linen, to crafting handmade thank-you notes. The book editor-turned-designer of Yarborough Jewelry garners inspiration from her grandmother's sewing box and Elsa Schiaparelli's trompe l'oeil designs, and finds unexpected beauty in everyday objects like buttons, plates, spools, and upholstery tassels.

> *I feel there is something unexplored about women that only a woman can explore.*
>
> Georgia O'Keeffe

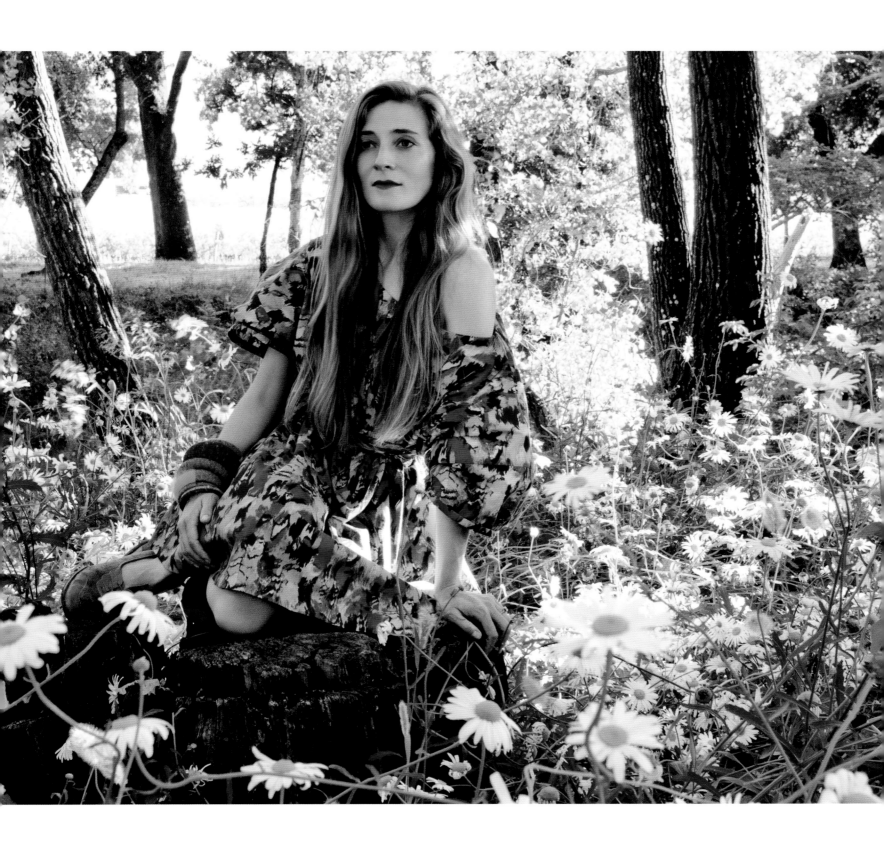

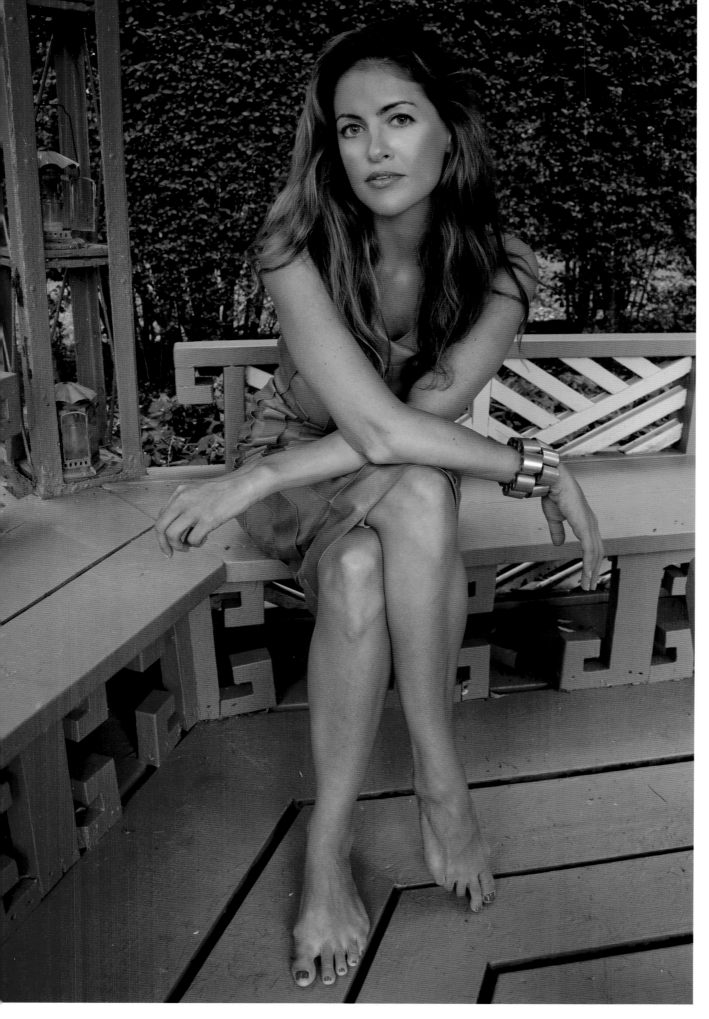

Amanda Frank

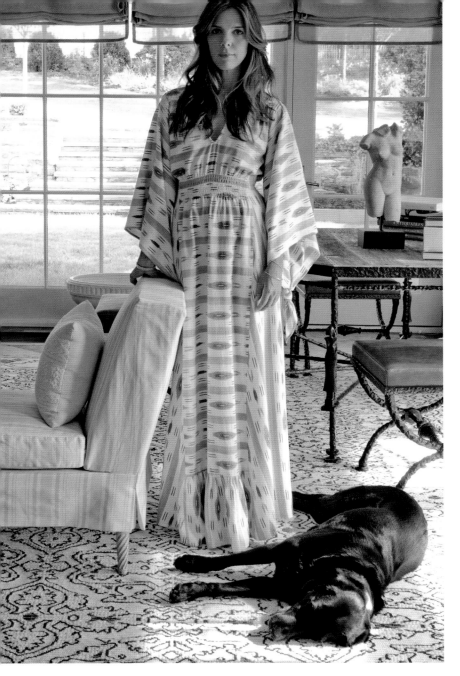

> **"***Elegance is innate. It has nothing to do with being well dressed.***"**
> *Diana Vreeland*

Emilia Fanjul

> **"** *Men's ideas about beauty come from their high school years.* **"**
> *Fran Lebowitz*

Sara Gilbane Sullivan

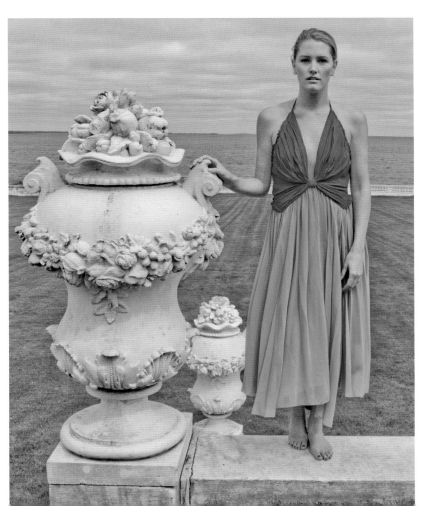

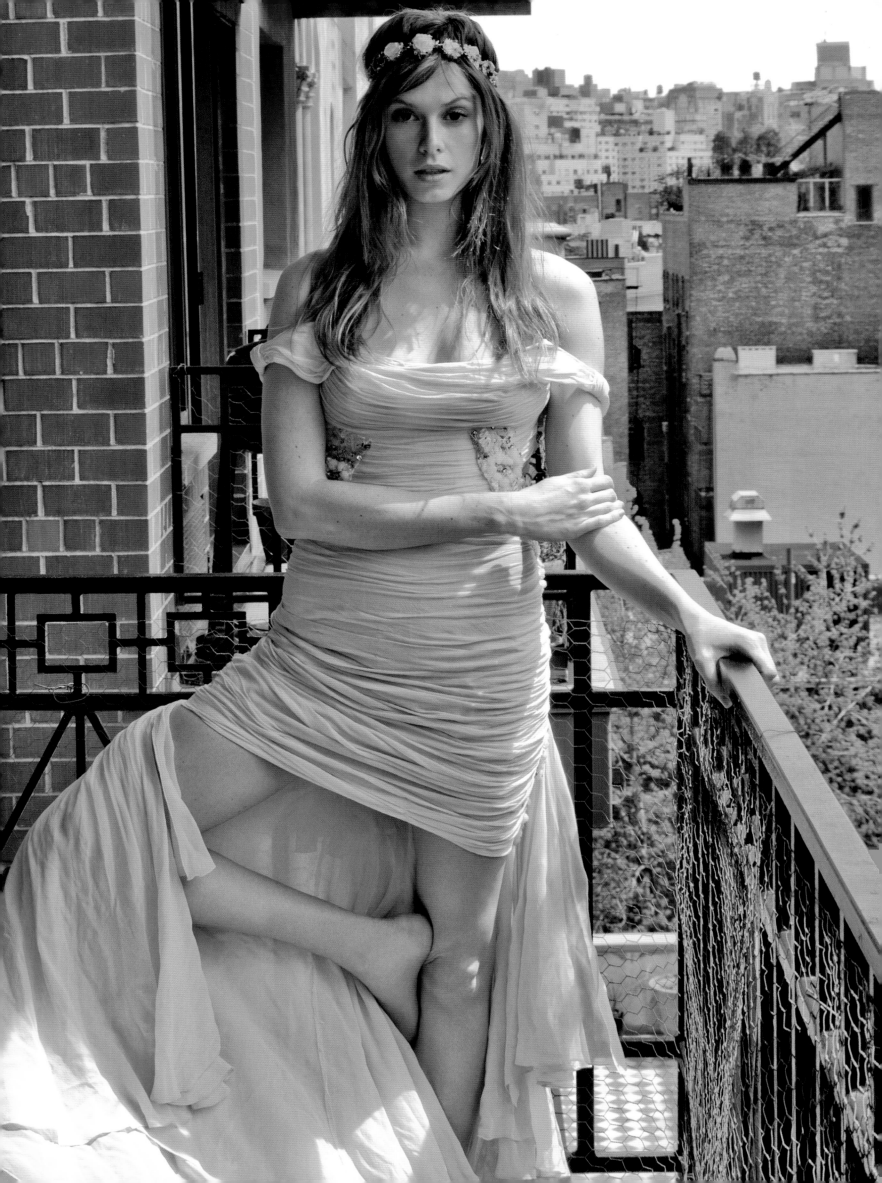

> ## " *The better you look, the more you see.* "
> *Bret Easton Ellis*

Elettra Wiedemann

b. New York, New York Model and activist Elettra Wiedemann, the daughter of Isabella Rossellini and the granddaughter of Ingrid Bergman, is a living embodiment of historically American beauty. Here she chose to wear her grandmother's chiffon sheath, reconfigured for her by designer Prabal Gurung, because it symbolized her modernity while nodding to her storied lineage. In addition to modeling in campaigns for Abercrombie & Fitch, Lancôme, and Ferragamo, Wiedemann recently completed a master's in biomedicine at the London School of Economics, and is actively involved in One Frickin Day, the nonprofit that she co-founded with fiancé James Marshall. The organization allows her to leverage her connections in order to raise funding for charity projects around the globe, including the building of solar-power installations in clinics in Rwanda and Haiti. "When it's all said and done," says Wiedemann, "I hope that I helped protect the beautiful places and brought the dark places more light."

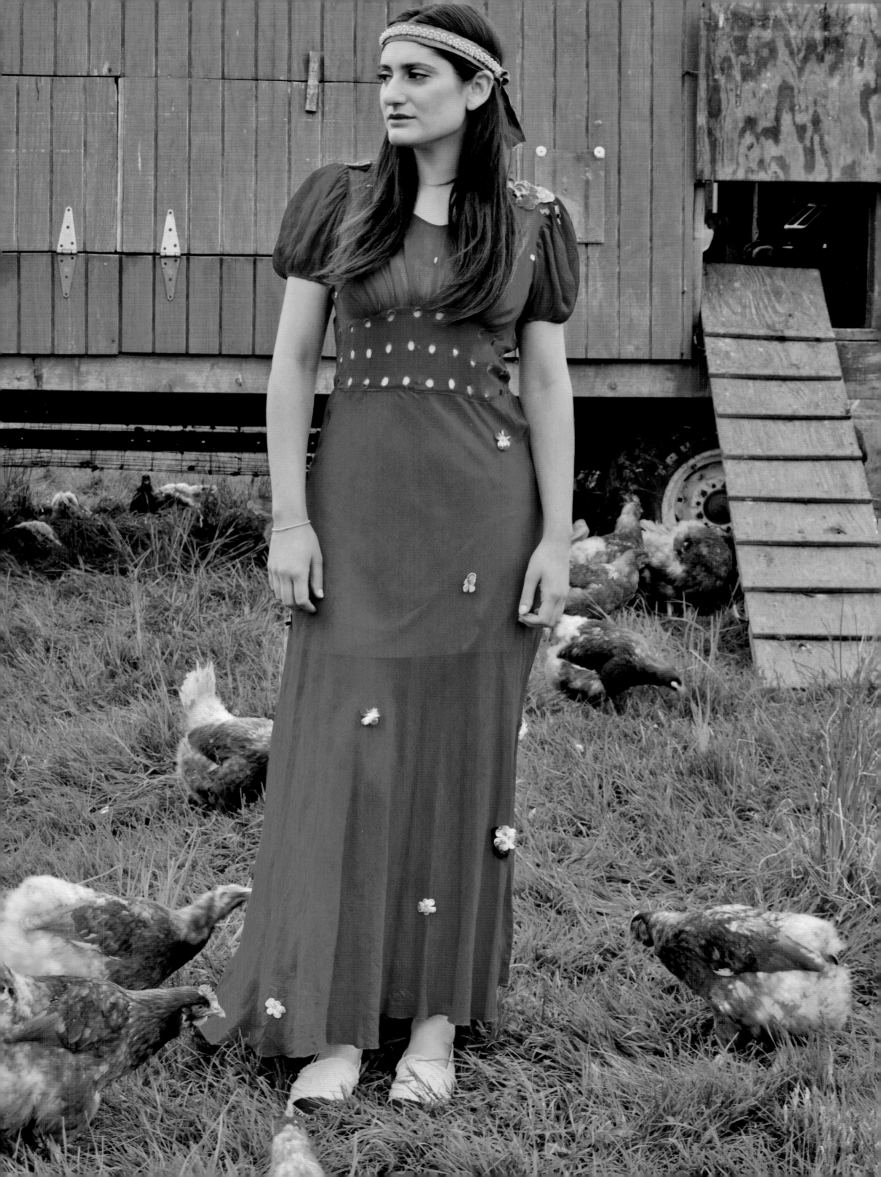

> *Be your own best friend and don't forget to wink at yourself every now and then.*
> Diane von Furstenberg

Arden Wohl

b. New York, New York Arden Wohl, seen here in front of a chicken coop in upstate New York in Chanel espadrilles and her favorite vintage red dress, is as eclectic as her professional interests. A pastry chef, headband devotee, and filmmaker, Wohl co-produced *Playground* (2009), a documentary about child prostitution in America, with George Clooney and Steven Soderbergh. Wohl's other film credits include *Coven,* an imaginative interpretation of *Hansel and Gretel,* and *The Goatsucker.*

> *Real beauty is so particular, so unknown,*
> *that one doesn't recognize it for being beautiful.*
>
> Marcel Proust

Tamara Lowe

b. Honolulu, Hawaii For Tamara Lowe, American style is about freedom—whether that means dressing like a 1920s Ralph Lauren starlet on safari or a Studio 54 vixen in Halston. The New York City–based writer, freelance creative consultant, and filmmaker has brought her innovative thinking to brands like Mercedes-Benz and Barneys, and most recently worked with Starbucks to direct a short film for singer Diego Garcia.

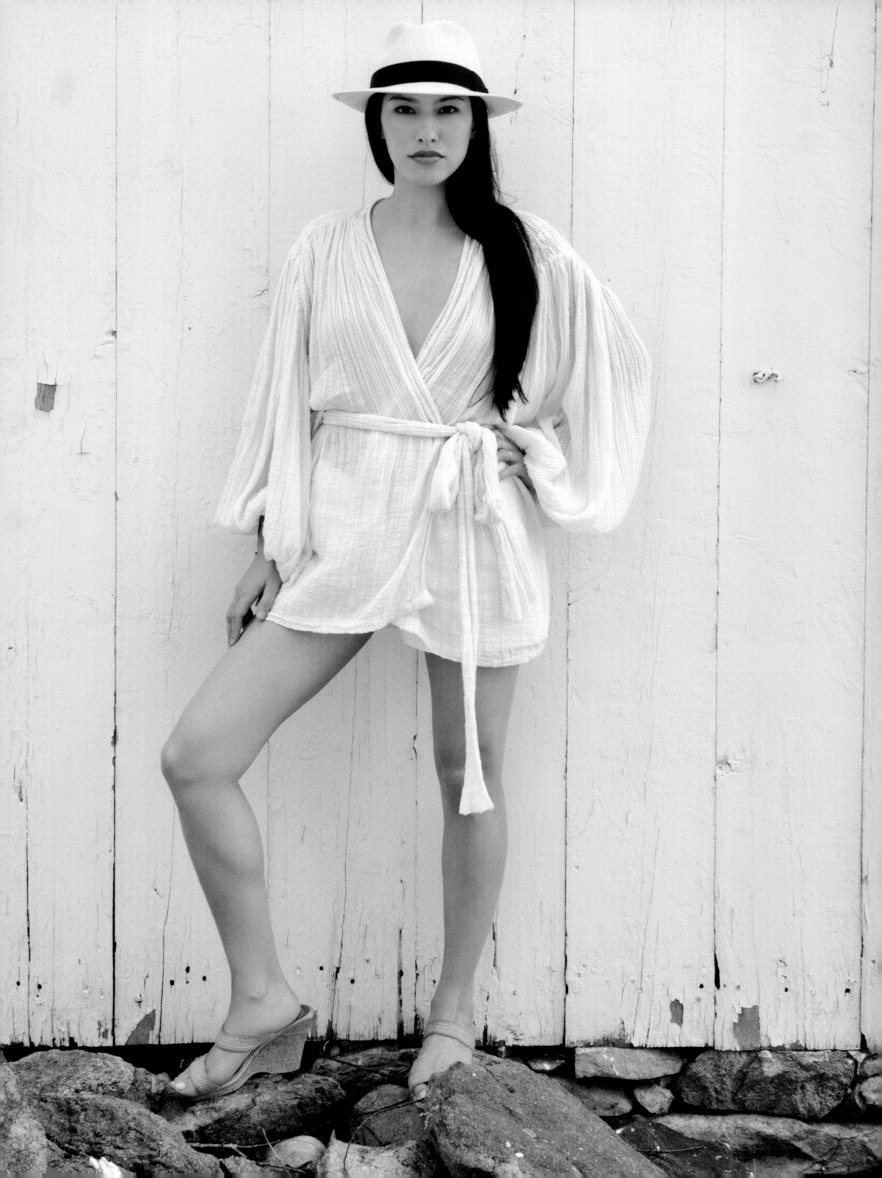

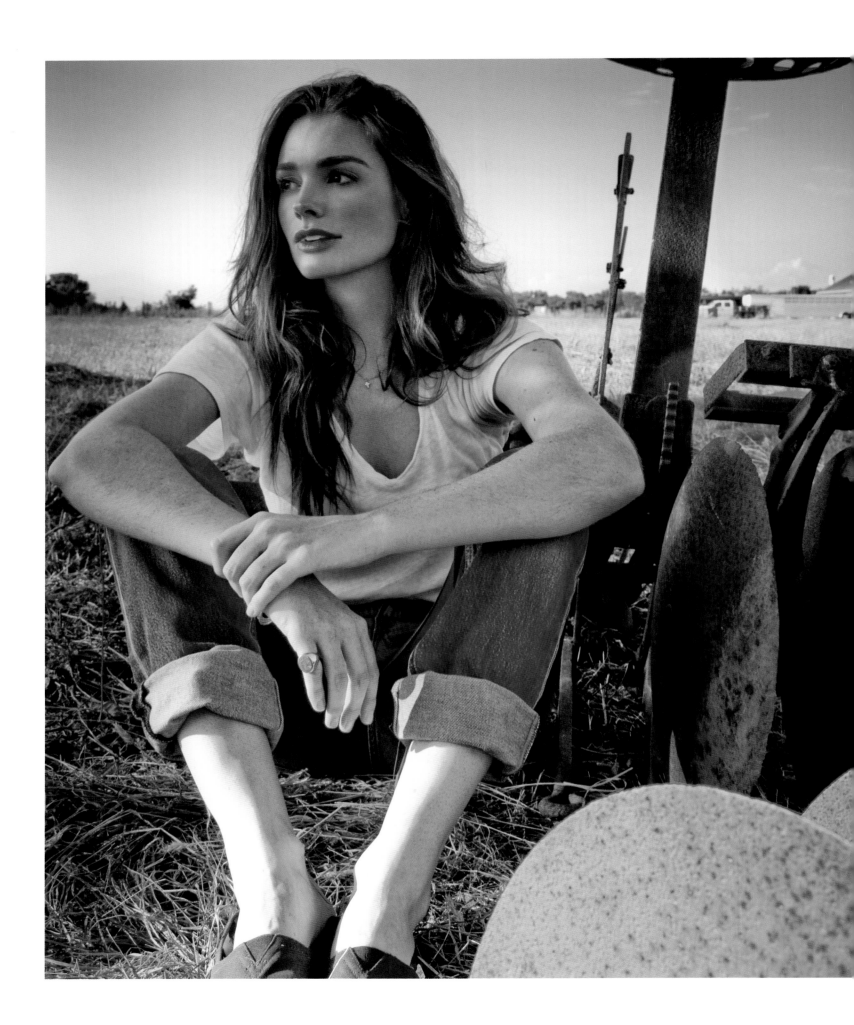

> ❝ *I esteem it a chief felicity of this country that it excels in women.* ❞
>
> *Ralph Waldo Emerson*

Jessica Sailer

b. El Paso, Texas "I am a true cowgirl at heart. I could hang out with my horses and dogs all day long," confesses *Vogue* market and sittings editor Jessica Sailer, who also edits the magazine's popular Index section. Raised in the mountains of Tucson, Arizona, Sailer, seen here on the horse farm where she spends weekends with her husband, Mark Van Lith, is also an accomplished polo player and rider. Of her style, she notes: "I have always been aesthetically driven—I studied art history and spend my free time scouring auctions for amazing furniture and art finds."

> *One says that beauty is the promise of happiness. Inversely, the possibility of pleasure can be the beginning of beauty.*
> Marcel Proust

Celerie Kemble

b. Palm Beach, Florida With a love of design forged early in life—Kemble used to spend afternoons as a kid exploring Palm Beach's antiques stores and properties—it is no wonder that Cecilia "Celerie" Kemble went on to join her mother's interiors business, Kemble Interiors, Inc. Utilizing textures like sea cloth, shagreen, Lucite, and lacquer, Kemble crafts singular, sought-after interiors, and has authored two books to prove it: *To Your Taste: Creating Modern Rooms with a Traditional Twist* (Clarkson Potter, 2008) and *Black & White (And a Bit in Between)* (Clarkson Potter, 2011).

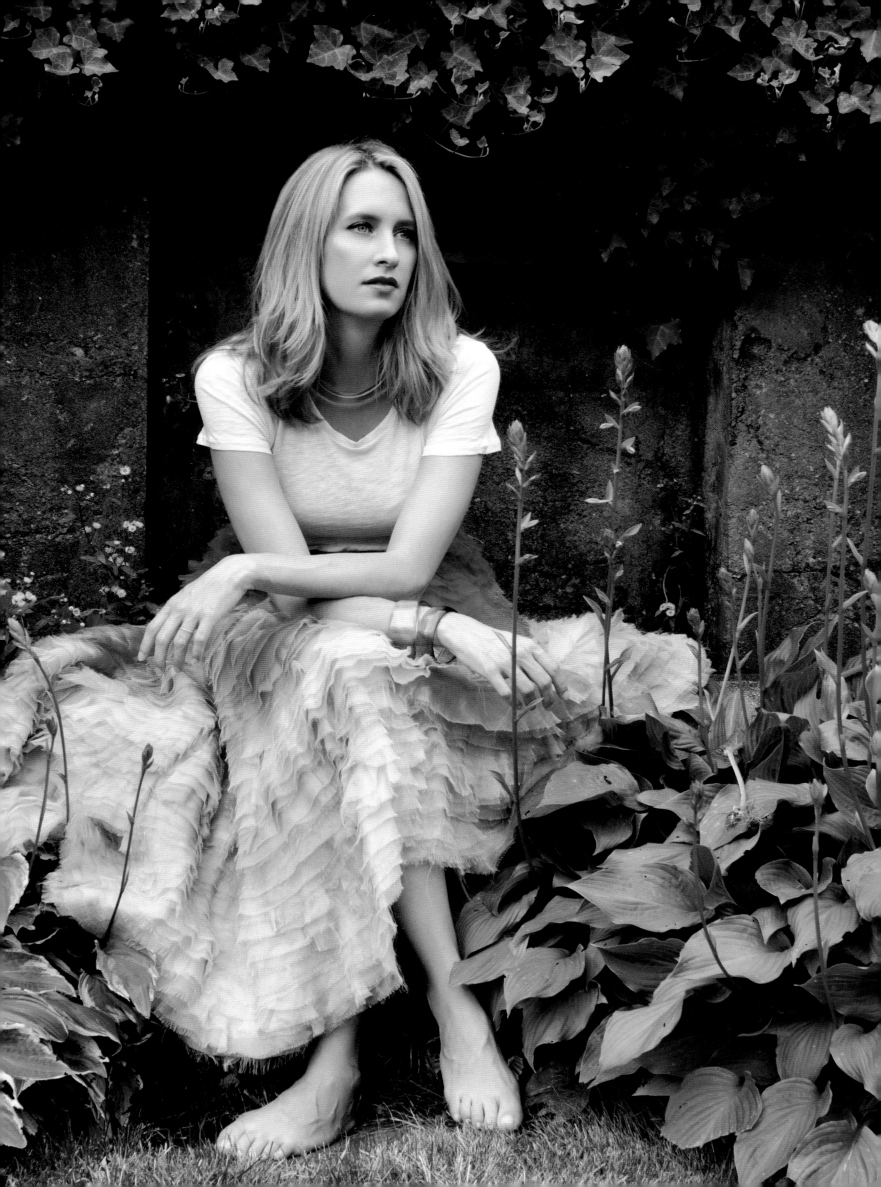

" *My beauty philosophy: better underdone than overdone.* "

Padma Lakshmi

Sabrina Buell

b. Sun Valley, Idaho "Laid-back, a little hippie, beautiful," says contemporary art advisor and collector Sabrina Buell, when describing what she deems quintessentially American surf style. She is here photographed in West Marin, California, where she originally learned how to surf. Buell, formerly the West Coast director for Matthew Marks Gallery, lives with her boyfriend, industrial designer Yves Behar, and their baby girl in San Francisco.

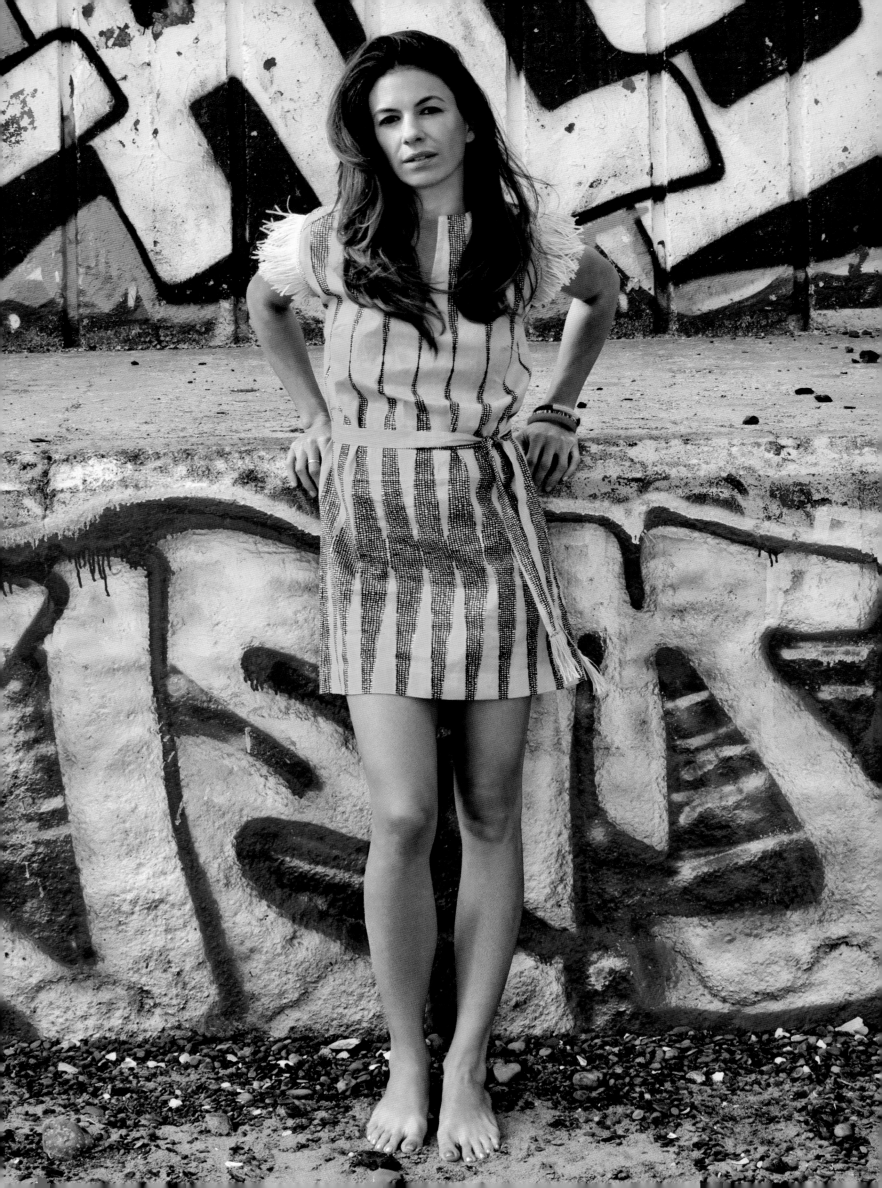

66 *Style is primarily a matter of instinct.* 99

Bill Blass

Aerin Lauder

b. New York, New York Photographed atop her father's vintage Thunderbird, Aerin Lauder exudes the particular brand of easy elegance with which she has become synonymous. After fifteen years at her grandmother Estée's company as style and image director, Lauder has ventured out on her own as the chairman and creative director of Aerin LLC, her own luxury lifestyle brand. "I was always surrounded by strong, passionate women— they taught me how to follow a dream and the importance of dedication."

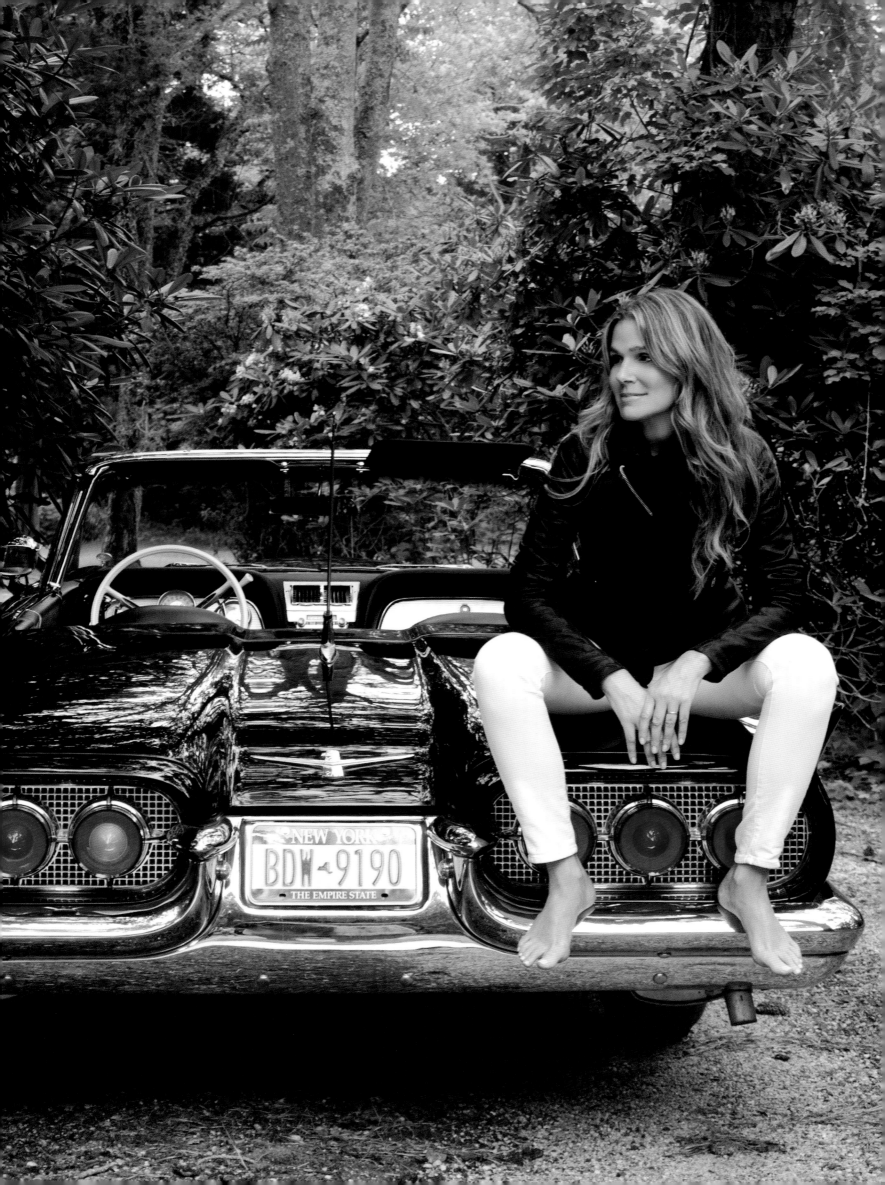

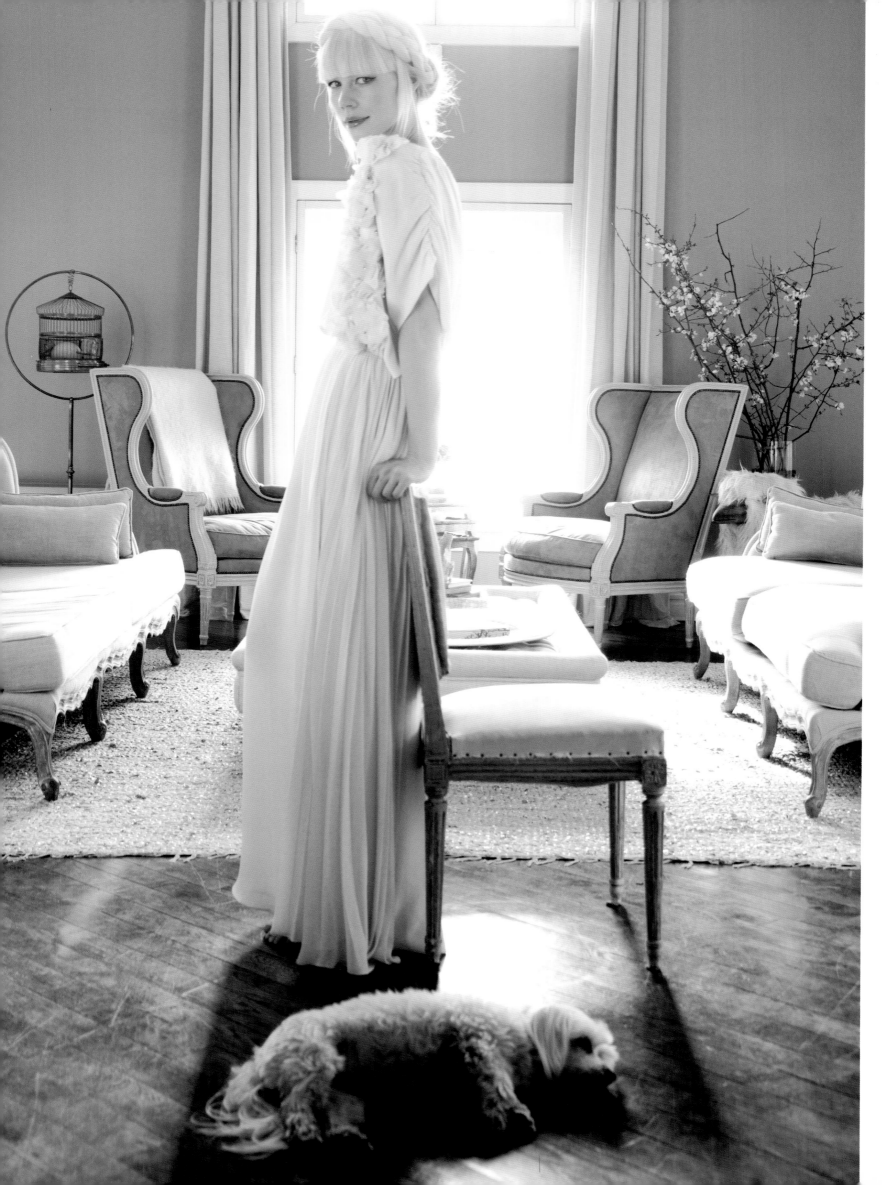

Erin Fetherston

b. Piedmont, California Photographed in her TriBeCa apartment with dog Tulepan at her feet, designer Erin Fetherston radiates ethereal romanticism. After debuting her eponymous label at the Paris haute couture shows in 2005—where she won a loyal brand following almost instantly—Fetherston's work has garnered many accolades, including the 2007 Ecco Domani Fashion Foundation award and a CFDA/*Vogue* Fashion Fund award nomination. Presently, she is focused on developing her new line, Erin by Erin Fetherston.

"No matter how plain a woman may be,
if truth and honesty are written across her face,
she will be beautiful. "

Eleanor Roosevelt

Ferebee Taube

b. Rocky Mount, North Carolina Ferebee Taube is photographed leaning against her barn in Milbrook, New York, on a 60-degree day in March. In addition to consulting for brands like Theory, Chloé, and Sigerson Morrison, Taube has worked in celebrity relations at both Harrison & Shriftman and Calvin Klein. She is currently working on a Web site called the TheFeyt, which will employ algorithmic and social networking technology to recommend designer fashion to users based on their personal tastes. Taube lives in Manhattan with her husband and their three sons.

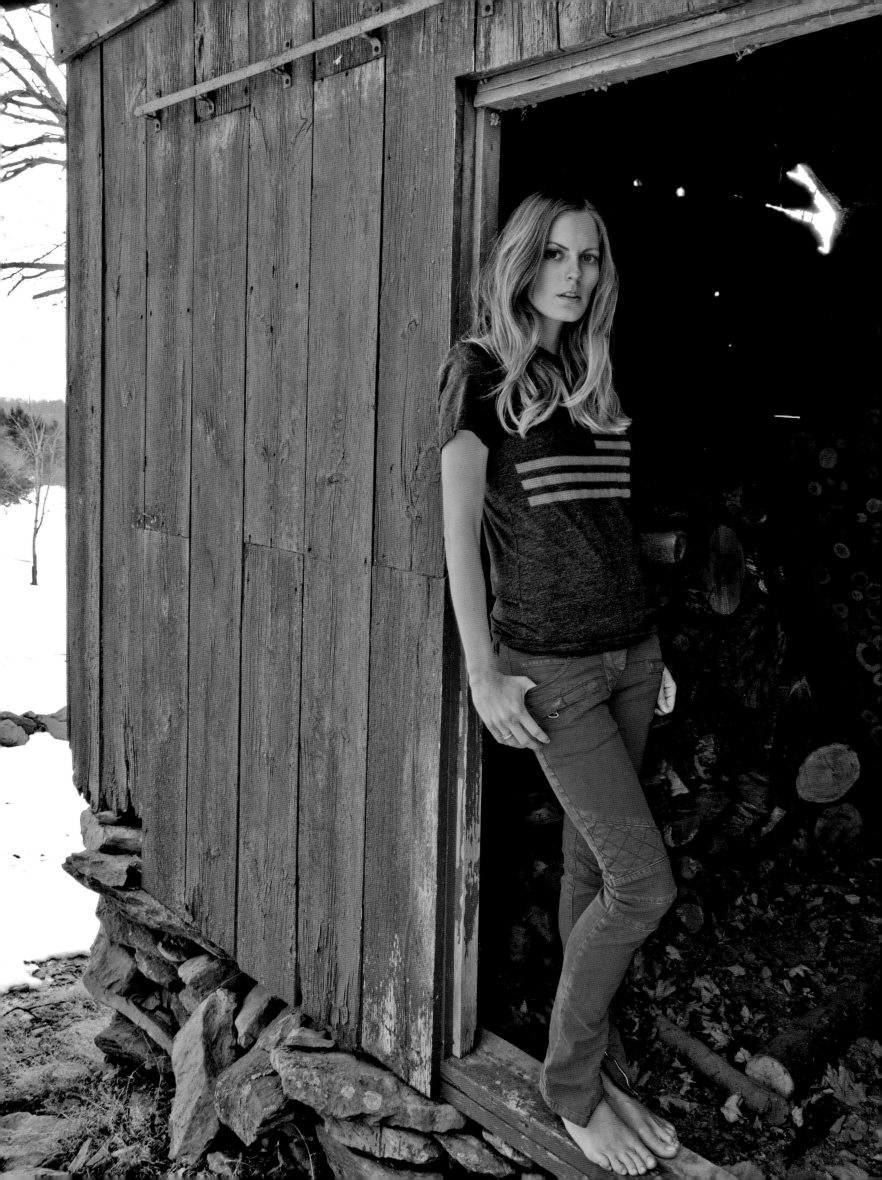

> *"The more people explore the world, the more they realize in every country there's a different aesthetic. Beauty really is in the eye of the beholder."*
> *Helena Christensen*

Emily Ford

b. Naples, Florida The epitome of West Coast casual–meets–East Coast polish, Emily Ford is the senior advisor at Global Philanthropy Group, where she advises celebrities like Demi Moore and Ashton Kutcher, Ben Stiller, Tory Burch, and John Legend on giving. Married to American politician and businessman Harold Ford, Jr., Ford moved to New York in 2003 to work as in-house celebrity stylist at Nina Ricci and Carolina Herrera ("working for her was like a finishing school with a sense of humor"), and is currently the COO of Basta Surf. She supports The Toby Project, a free spay and neuter program in New York, as well as The Actors Fund, a program that takes care of actors and dancers in times of medical or emotional need.

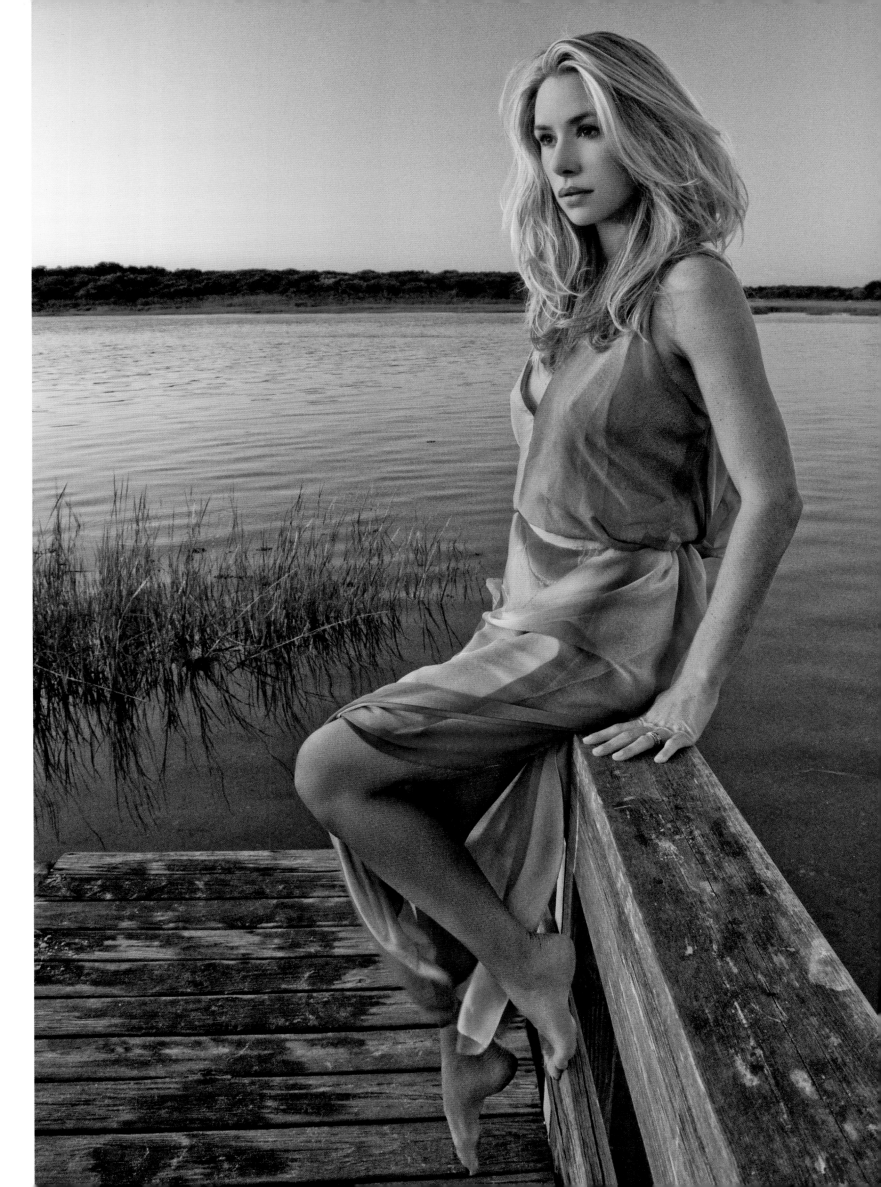

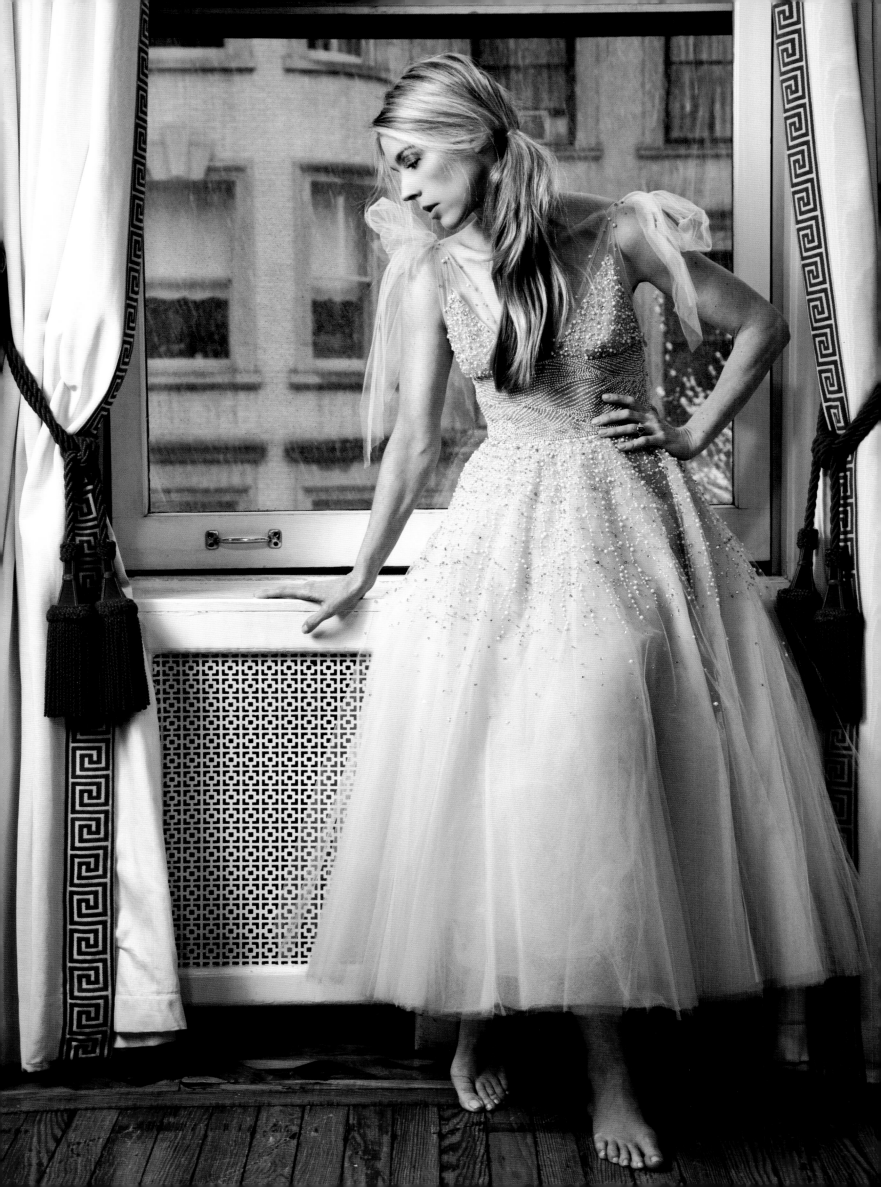

66 I think happiness is what makes you pretty. Period. Happy people are beautiful. They become like a mirror and they reflect that happiness. 99
Drew Barrymore

Alexandra Lind Rose

b. New York, New York It was during an episode of *The Love Boat*—when Halston arrived on deck, accompanied by several models dressed in his gowns—that Alexandra Lind Rose knew fashion design was her destiny. She was eight years old. Gifted with a highly evolved sense of grace and a refreshing naïveté, Rose, casual even in a corseted gown, believes American style is epitomized by "being strong, straightforward, and natural." Rose and her husband, Louis, live in New York with their daughter, Kingsley.

Caroline Palmer

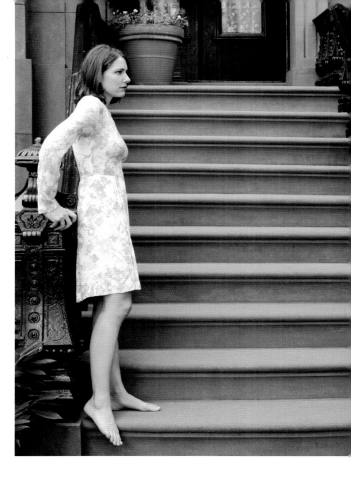

❝ *I think that something needs to be weird in order to have a real beauty. Beauty can be quite boring, especially if you're talking about beauty that doesn't last. And what lasts is exactly the thing that maybe wasn't pretty at first—it comes over time to be beautiful or interesting or exciting.* **❞**

Carine Roitfeld

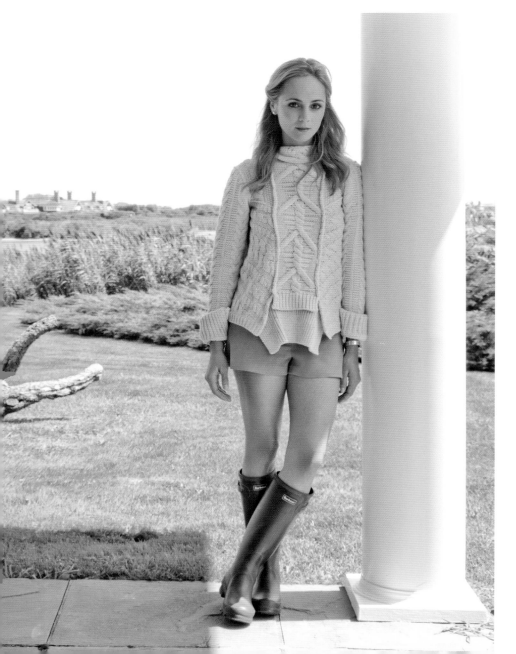

Devon Radziwill

❝ *Styles, like everything else, change. Style doesn't.* **❞**

Linda Ellerbee

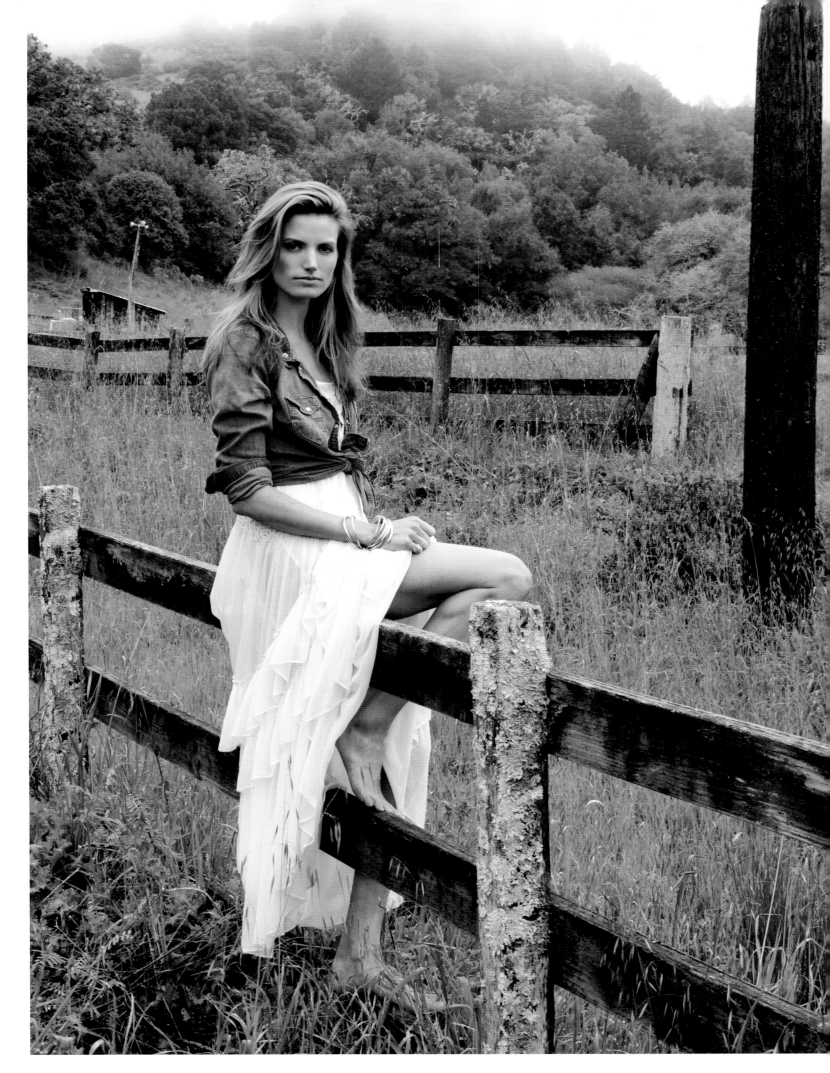

Ashley Wick

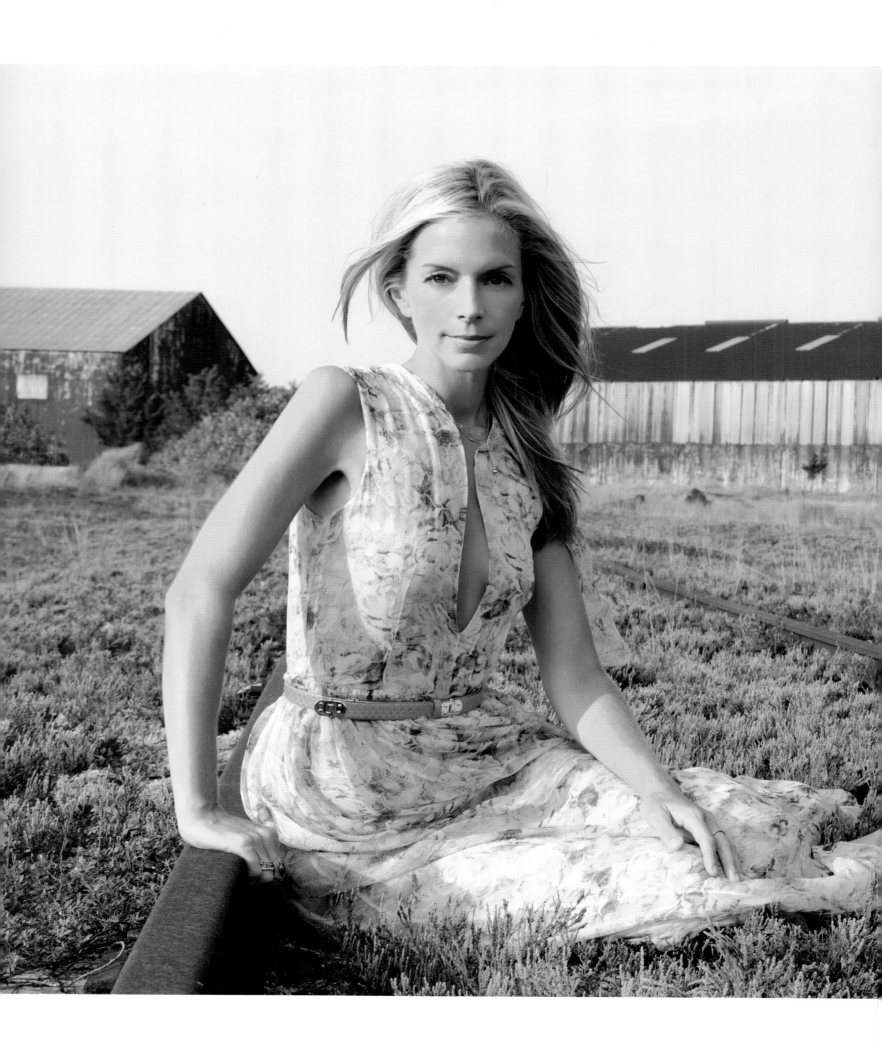

> ❝ *It's funny, our beauty standard has become harder and tougher because we live in a tough age.* ❞
>
> Tom Ford

Meredith Melling Burke

b. Boston, Massachusetts "American style for me begins with natural, undone beauty," says Meredith Melling Burke, photographed on an overgrown, abandoned railroad track. "A fresh, almost naked face, and soft, unmanipulated hair." As the senior market editor of *Vogue*, she is celebrated within the industry for championing emerging fashion talents like Jack McCollough and Lazaro Hernandez of Proenza Schouler, Alexander Wang, and Laura and Kate Mulleavy of Rodarte. "Through *Vogue* and the CFDA/*Vogue* Fashion Fund I have witnessed firsthand the daily struggles these designers must go through to realize their creative visions. The only thing better than anointing young designers as the New Establishment is being able to call many of them close personal friends."

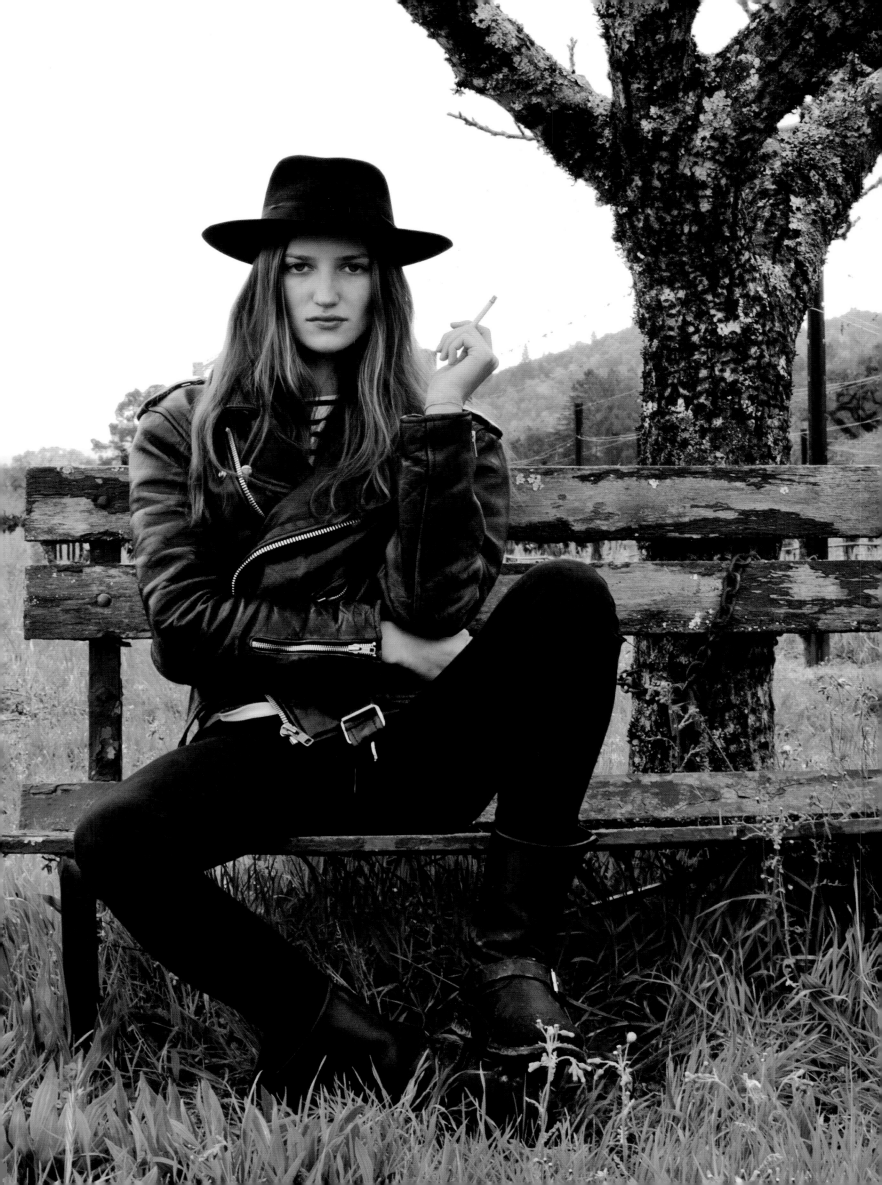

> *Most people can be made to look beautiful—someone can do your hair and put some makeup on—but being sexy is something inside and not everybody has it.*
> *Lara Stone*

Michele Ouellet

b. St. Helena, California "I feel very alive almost all of the time," admits model and winemaker Michele Ouellet. Raised in a winemaking family, Ouellet, photographed on a wooden bench in Napa Valley, where she grew up, became partners with her mother in 2008, when they started their own label, Lorenza Rose. When it comes to personal style, she prefers the unfettered kind. "I love fashion, but I'm not a big shopper. When I'm in Napa Valley, I am ready to get dirty in the vineyards, so I stick to denim, stripes, and my tomboy style."

" For beautiful eyes, look for the good in others; for beautiful lips, speak only words of kindness; and for poise, walk with the knowledge that you are never alone. "

Audrey Hepburn

Bee Shaffer

b. London, United Kingdom "She's pushy, honest, and confident being the only woman in a man's profession," says Katherine "Bee" Shaffer, of one of her biggest inspirations: the character of Hildy Johnson from *His Girl Friday*. "She shuns the traditional female roles of wife and mother—and I like to think of American women as rule breakers." The daughter of *Vogue* editor in chief Anna Wintour currently lives in Los Angeles and works at Ryan Murphy Productions as an associate producer. Photographed in a Dolce & Gabbana dress at the boathouse of her family's home in Mastic, Long Island, with her dog Scout by her side, Shaffer's unique combination of brains, beauty, and charisma make her a sparkling example of America's emerging new creative guard.

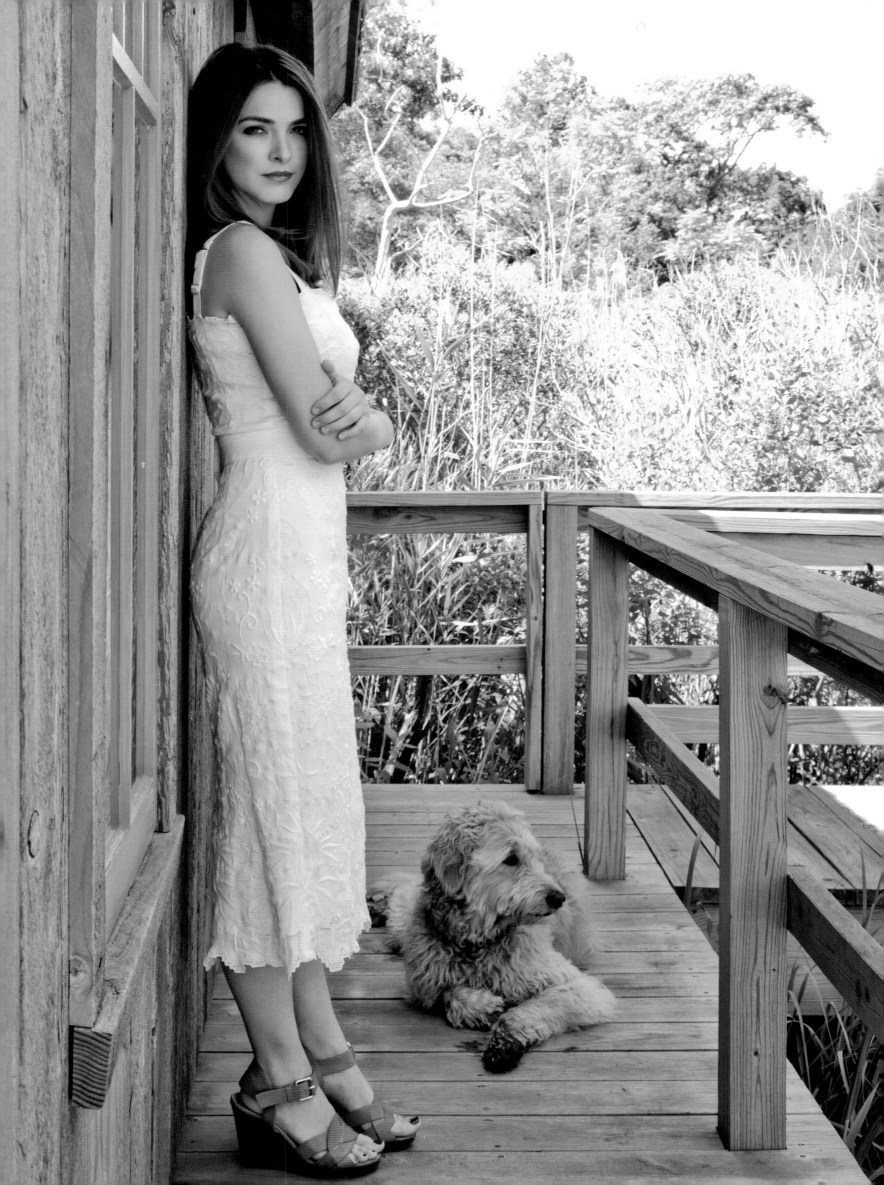

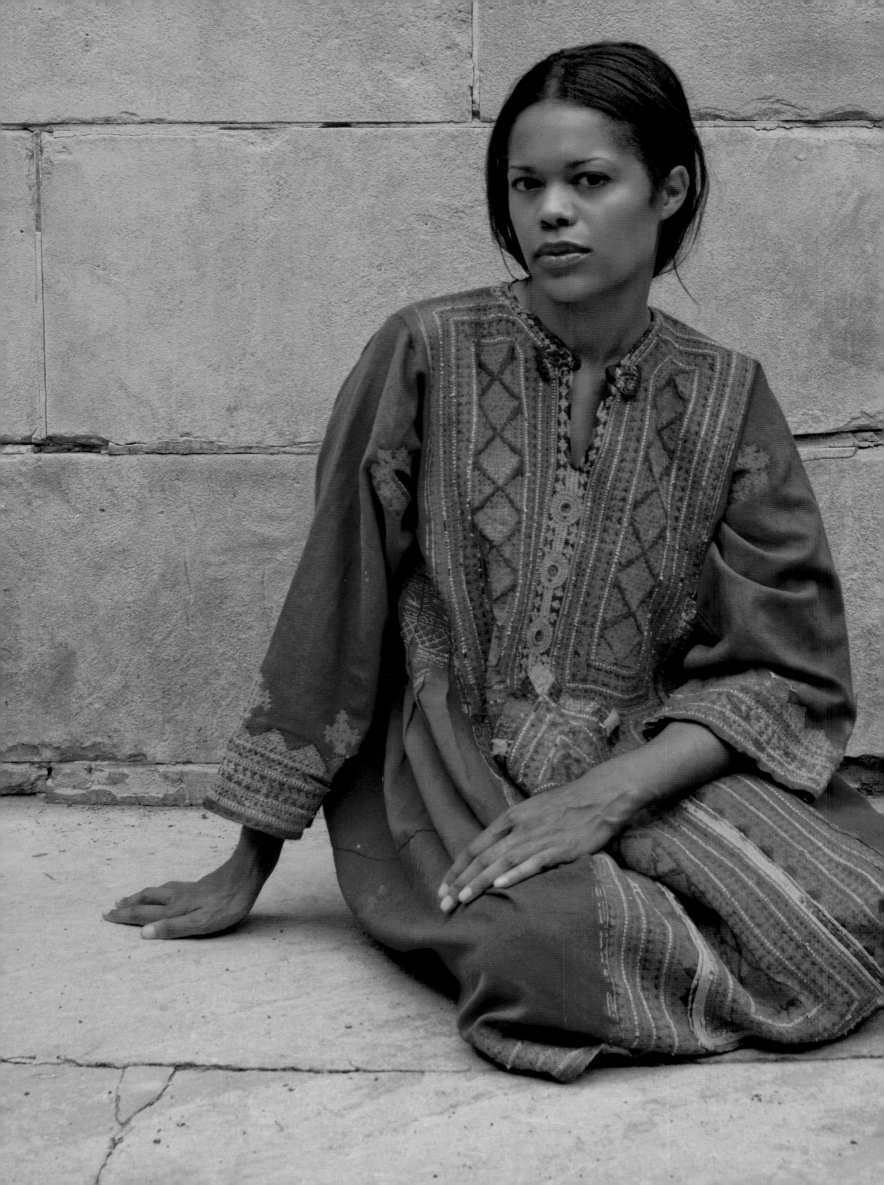

" *Real beauty is to be true to oneself.
That's what makes me feel good.* **"**

Laetitia Casta

Bonnie Morrison

b. San Francisco, California With a laid-back California style she describes as "polyamorous"— that is, equal parts avant-garde, vintage, romantic, and sporty—Morrison, a fashion brand consultant, can still recall the moment she found her calling. "I vividly remember the first *Vogue* I ever read—it was 1984. Nothing super-momentous happened, except that I never really considered any other industry after that."

> **66** *A witty woman is a treasure;*
> *a witty beauty is a power.* **99**
> *George Meredith*

Rachel Lewis

b. San Francisco, California "Whether I am cuddled up at home, diligently working in the office, or lounging on the beaches of Hawaii, I always have my laptop by my side. There are no heavy materials to haul around, no messes to clean up, and no mistakes that can't be unchanged," says Rachel Lewis, who works for the Adobe Flash Player team. With the encouragement of her bohemian parents, her love of painting and illustration emerged as a toddler. Since adolescence, she has continued to use fine art as an outlet while pursuing a budding interest in computer science.

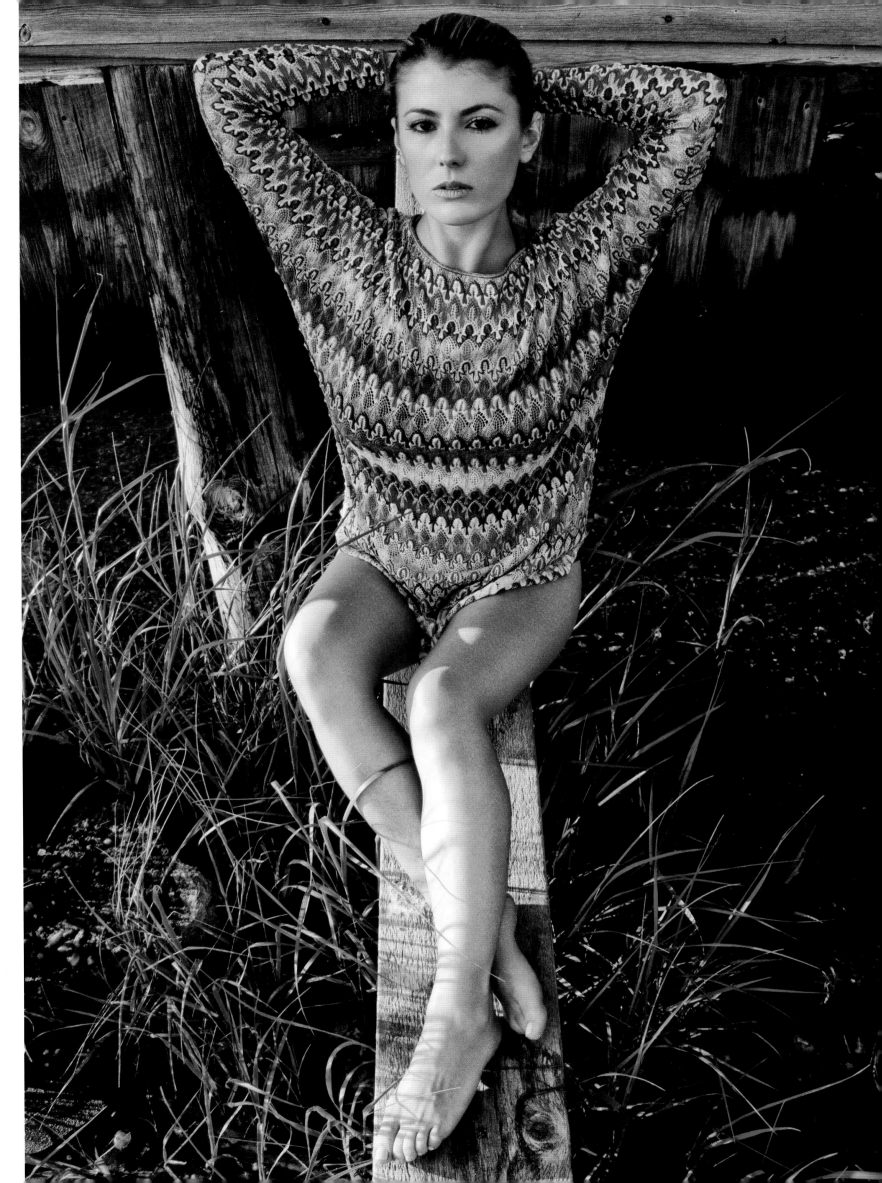

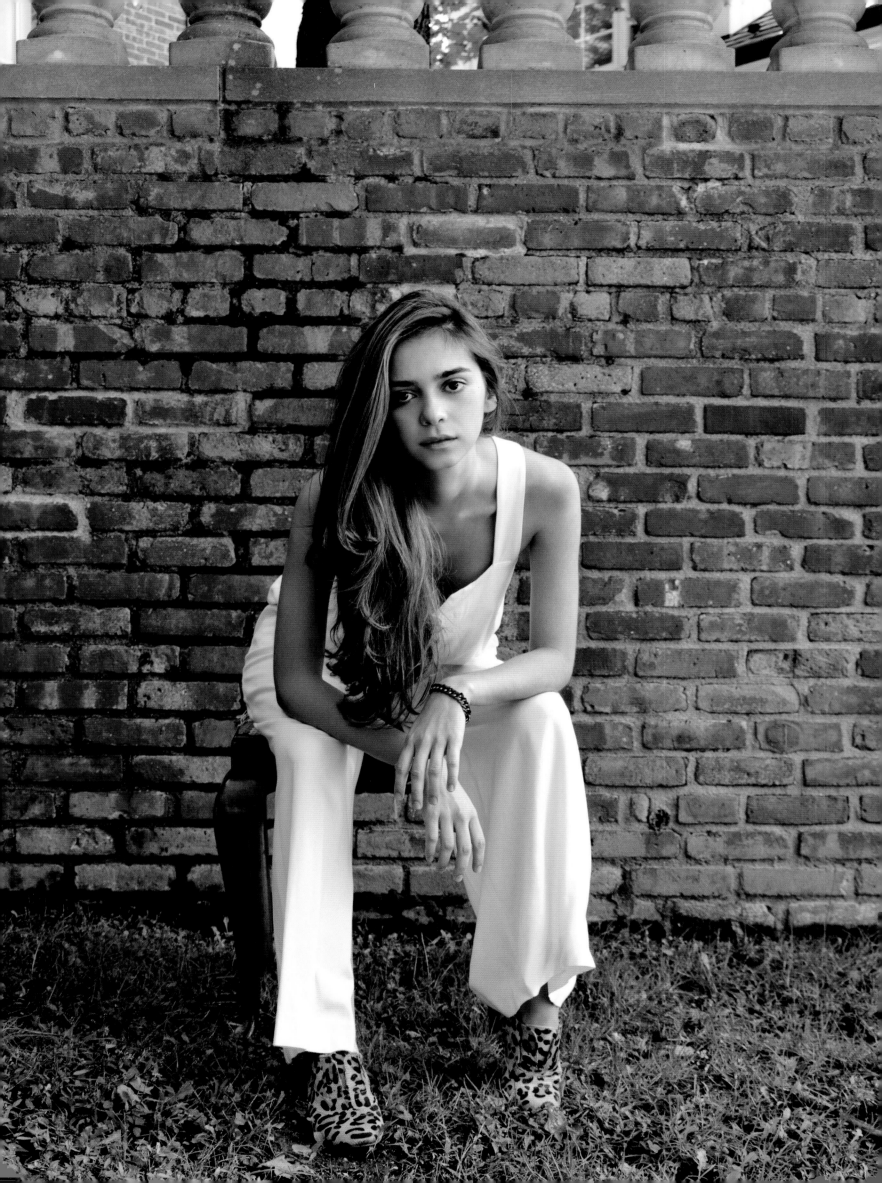

Maria Echeverri

b. Medellin, Colombia When Maria Echeverri was a young girl, she read in Natalie Wood's biography that whenever the actress was nervous, she would pretend to be Zelda Fitzgerald; this struck Echeverri as quintessentially American. She is currently working on her master's thesis—focusing on how fashion and clothing are interpreted through the senses—at New York University in Visual Culture: Costume Studies, a program that was started in conjunction with the Metropolitan Museum of Art's Costume Institute. "I really respond to the emotion of human imprint in material objects," she says of her interest in costume design. "There is a Pablo Neruda quote that sums it up beautifully: 'The mark of a hand or a foot, the constancy of the human presence that permeates every surface. This is the poetry we are seeking.'" Her parents were forced to leave Colombia at a trying time in the nation's history, but she still feels very connected to it, and credits her broad thinking to the fact that she was raised with two cultures in mind.

> *"I don't mind living in a man's world*
> *as long as I can be a woman in it."*
> *Marilyn Monroe*

Erin Burnett

b. Salisbury, Maryland Seen here in front of the USS *Intrepid* aircraft carrier, Erin Burnett is the host of *Erin Burnett OutFront* on CNN. She previously worked at NBC and CNBC, where she anchored *Street Signs* and co-anchored *Squawk on the Street.* She also regularly appeared on NBC's *Meet the Press, Today,* and *Nightly News,* as well as contributed daily to MSNBC's *Morning Joe.* A member of the Council on Foreign Relations, Burnett has hosted documentaries including *India Rising: The New Empire; The Russian Gamble; Dollars & Danger: Africa; On Assignment: Iraq; Big Money in the Middle East; City of Money & Mystery;* and *Iran: The Forbidden Zone.*

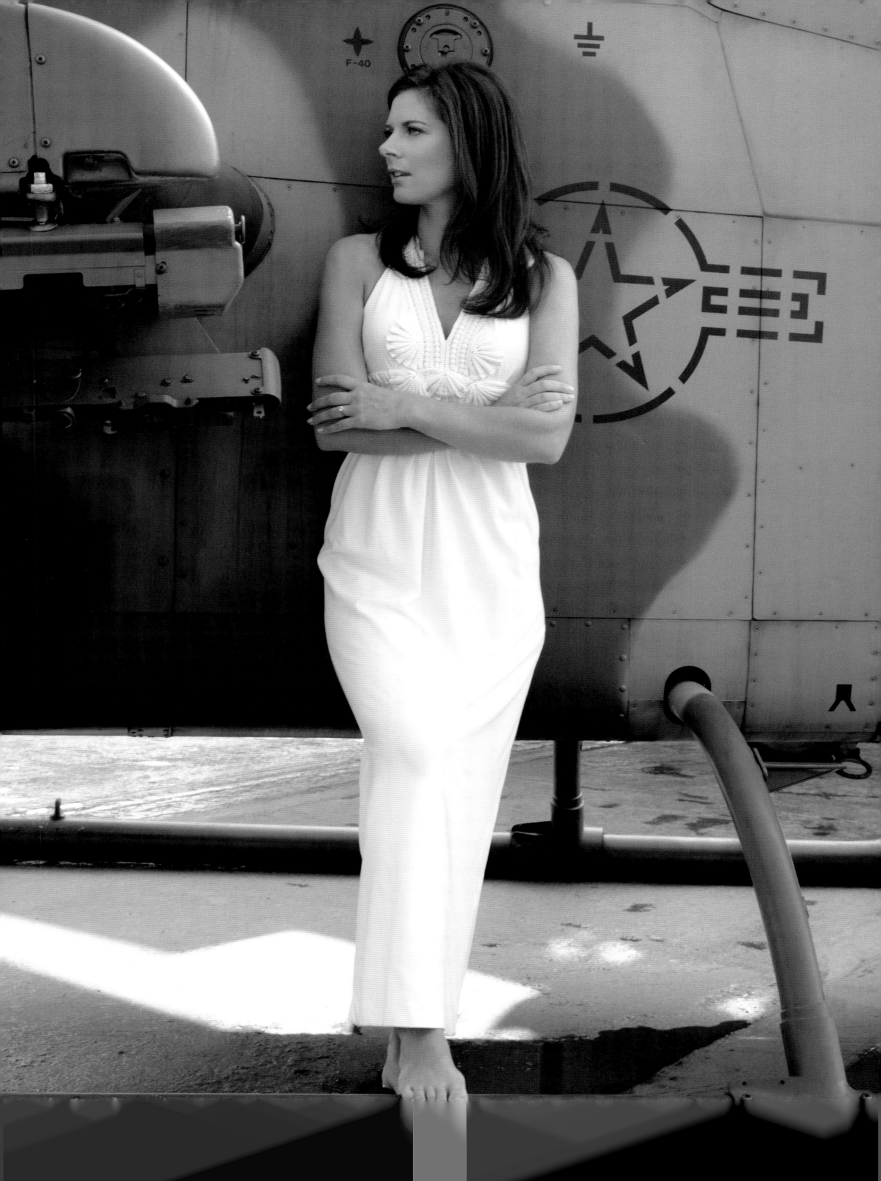

Beauty is something very personal that you feel, and that you respond to deep inside of yourself. It's difficult to define, but when you see it, it troubles and moves you. The type of beauty that I like comes from real people. A pure, natural beauty that isn't fabricated.

Calvin Klein

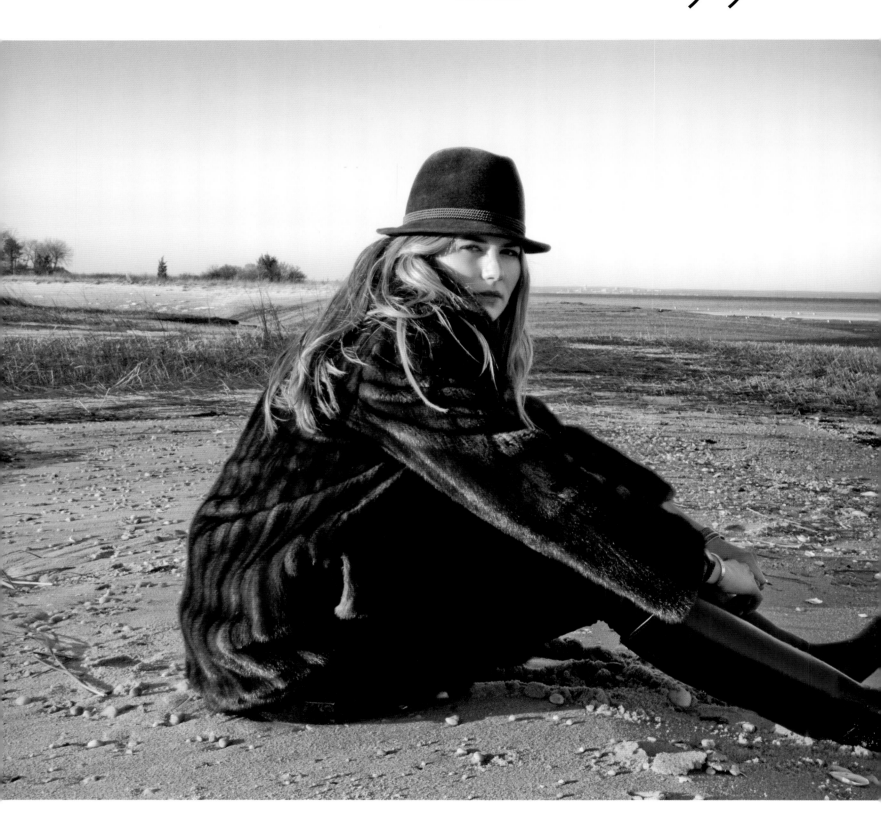

Asia Baker

b. New York, New York "To me, interior design is like a form of living art," says Dartmouth graduate Asia Baker, a vision of uncontrived, old-world American style in one of her grandfather's felt hunting hats. "I admire beauty, functionality, and design." The former *Vogue* staffer, who went on to join the Roman and Williams design team—conceiving celebrated New York interiors like The Royalton, Andrew Carmellini's restaurant The Dutch, and the eighteenth floor of the Standard Hotel—has since branched out on her own. With a sense of design and architecture inherited from her father and aunt—the former an architect, the latter an interior designer—Baker possesses an intuitive sense of color and proportion that makes her one of today's most promising talents.

*"*She behaves as if she was beautiful. Most American women do. It is the secret of their charm.*"*

Oscar Wilde

Isca Greenfield-Sanders

b. New York, New York Isca Greenfield-Sanders, a native of New York City's East Village and one of the most promising up-and-coming artists of her generation, comes from a long line of accomplished creatives. Her grandfather is painter Joop Sanders, a founding member of the American Abstract Expressionist group; her uncle is sculptor John Sanders; her father is photographer and filmmaker Timothy Greenfield-Sanders; and her sister is Liliana Greenfield-Sanders, a filmmaker and the director of *Ghosts of Grey Gardens.* Isca herself creates oil and watercolor paintings of people and landscapes out of recycled photo slides, and has had numerous solo exhibitions in New York, San Francisco, Munich, Stockholm, and Aspen, Colorado. Her work is in collections at the Solomon R. Guggenheim Museum in New York; the Museum of Fine Arts, Houston; and the Museum Morsbroich in Leverkusen, Germany.

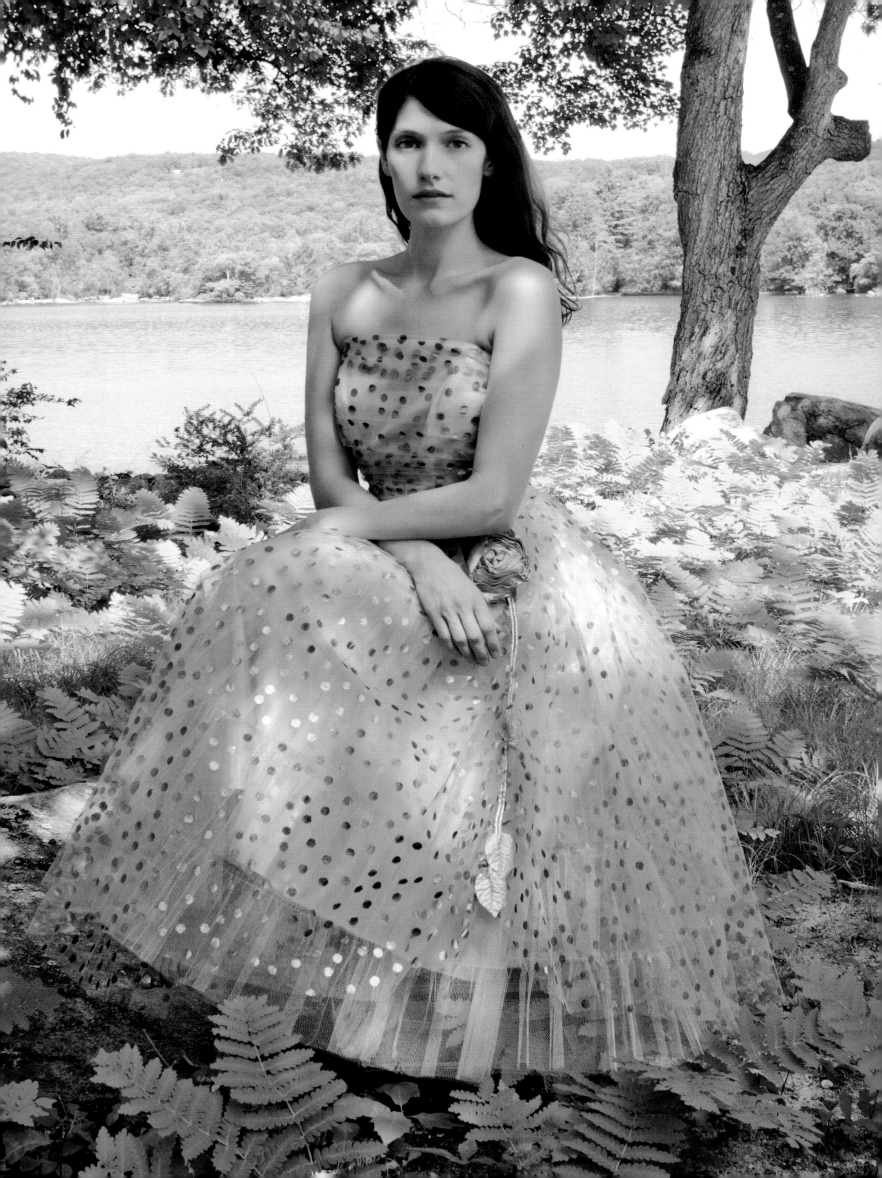

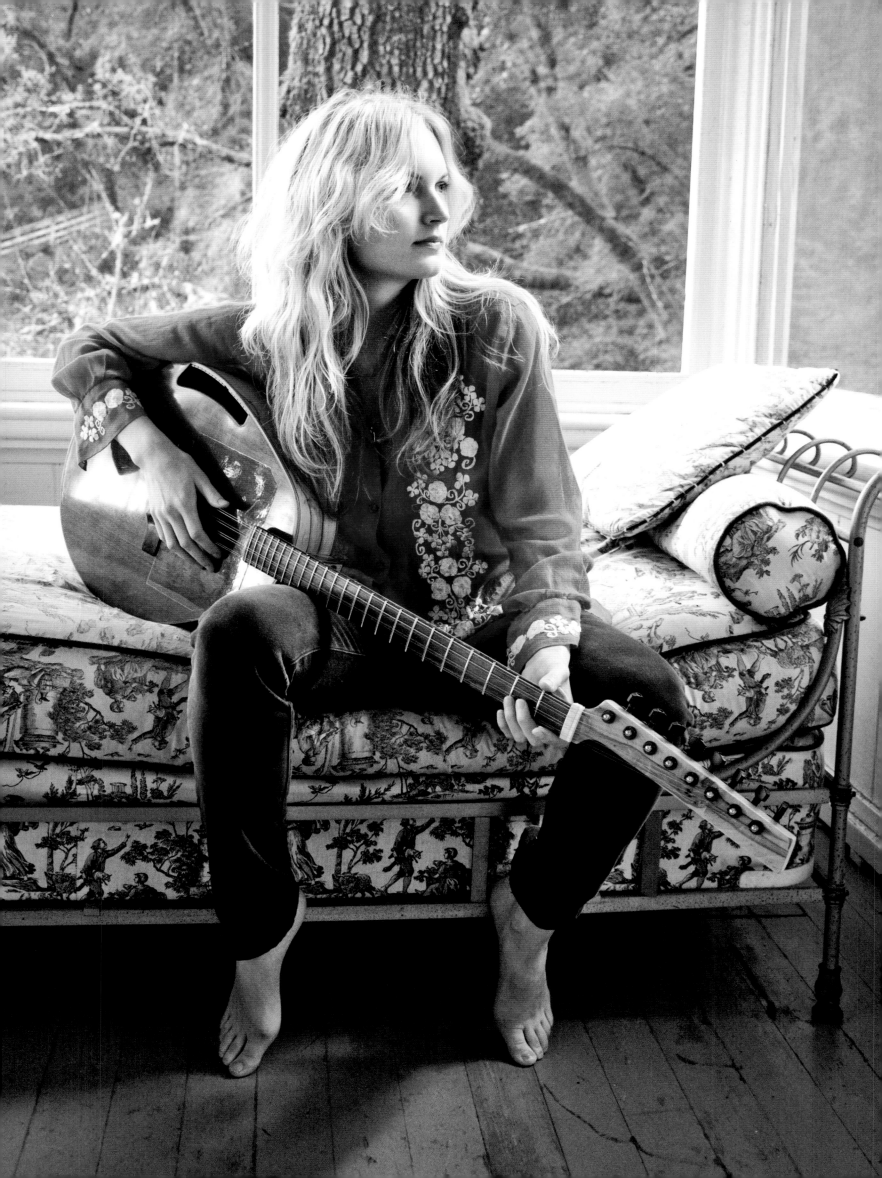

> *In art and dream may you proceed with abandon. In life may you proceed with balance and stealth.*
>
> *Patti Smith*

Jessi Adele

b. Angwin, California "I grew up in Northern California, and even though I have lived in many cities throughout my life, the country has truly created the woman I am today," explains singer-songwriter Jessi Adele, whose stage name is Lone Valkyrie. "It reminds me of the simple things in life: the quiet and the solitude, and also the mysteries hidden in those silent places." Adele just completed her self-titled debut album, *Lone Valkyrie.*

> *Fashion has two purposes: comfort and love.*
> *Beauty comes when fashion succeeds.*
>
> *Coco Chanel*

Lauren Santo Domingo

b. Greenwich, Connecticut As muse to designers like Gilles Mendel and Olivier Theyskens, Lauren Santo Domingo is one of New York society's most glamorous amazons. "Working at *Vogue* has dramatically changed my life. Fashion is an industry run by and for women, and it is exciting to be part of a magazine that has defined our generation," states the *Vogue* contributing editor. Santo Domingo recently launched her own members-only shopping site, Moda Operandi, which allows visitors to buy directly from designer collections as soon as they hit runways. She lives in New York with her husband, Andres, and their baby boy. She is photographed here just months after she gave birth to her son, on a beach road in a John Galliano dress.

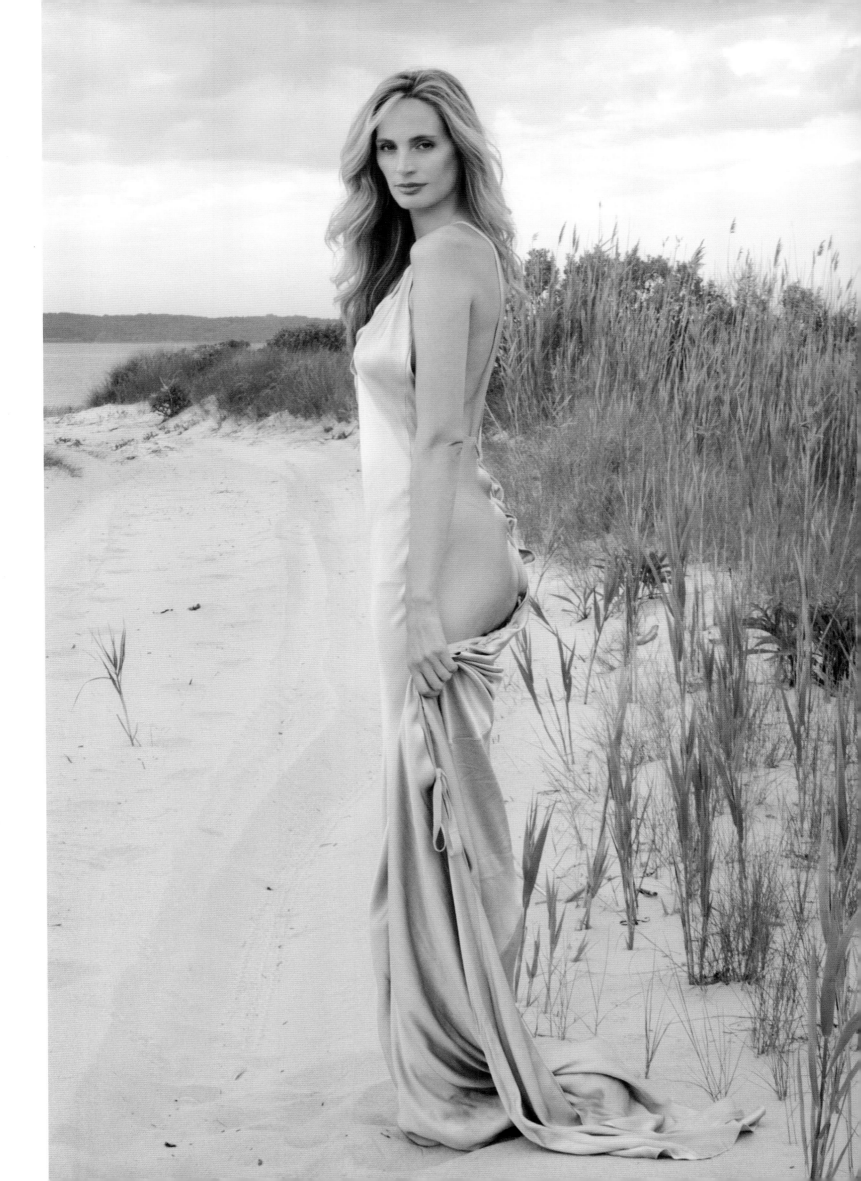

Betsy Frank

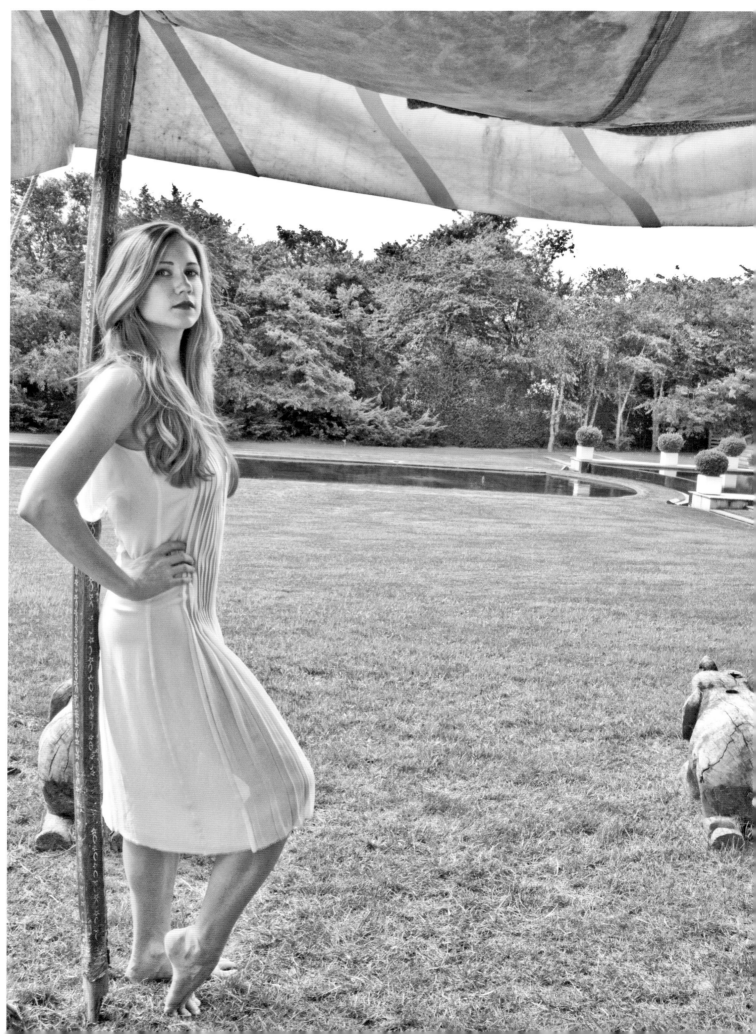

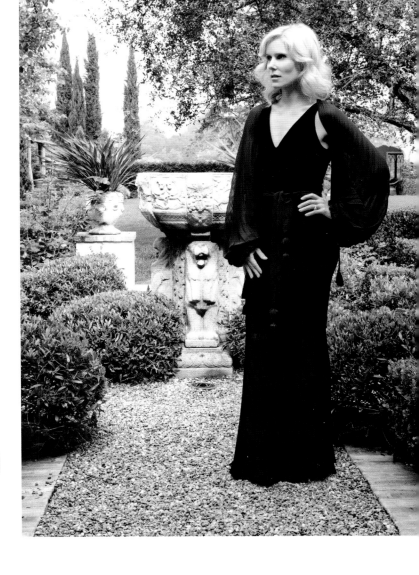

66 *To me beauty is as much about the inside as the outside—a woman who is confident, sophisticated, and funny is incredibly beautiful and charming.* 99

Tommy Hilfiger

Kristen Buckingham

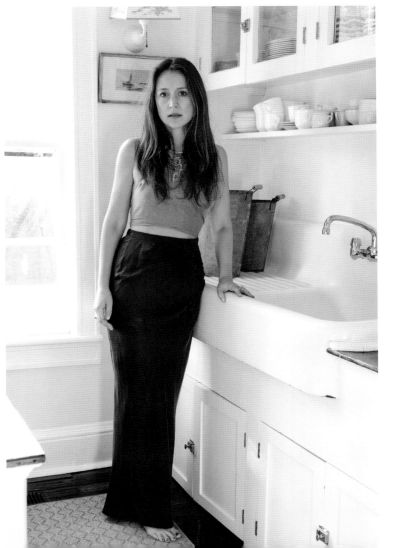

66 *I sincerely feel that beauty largely comes from within.* 99

Christy Turlington

Chiara de Rege

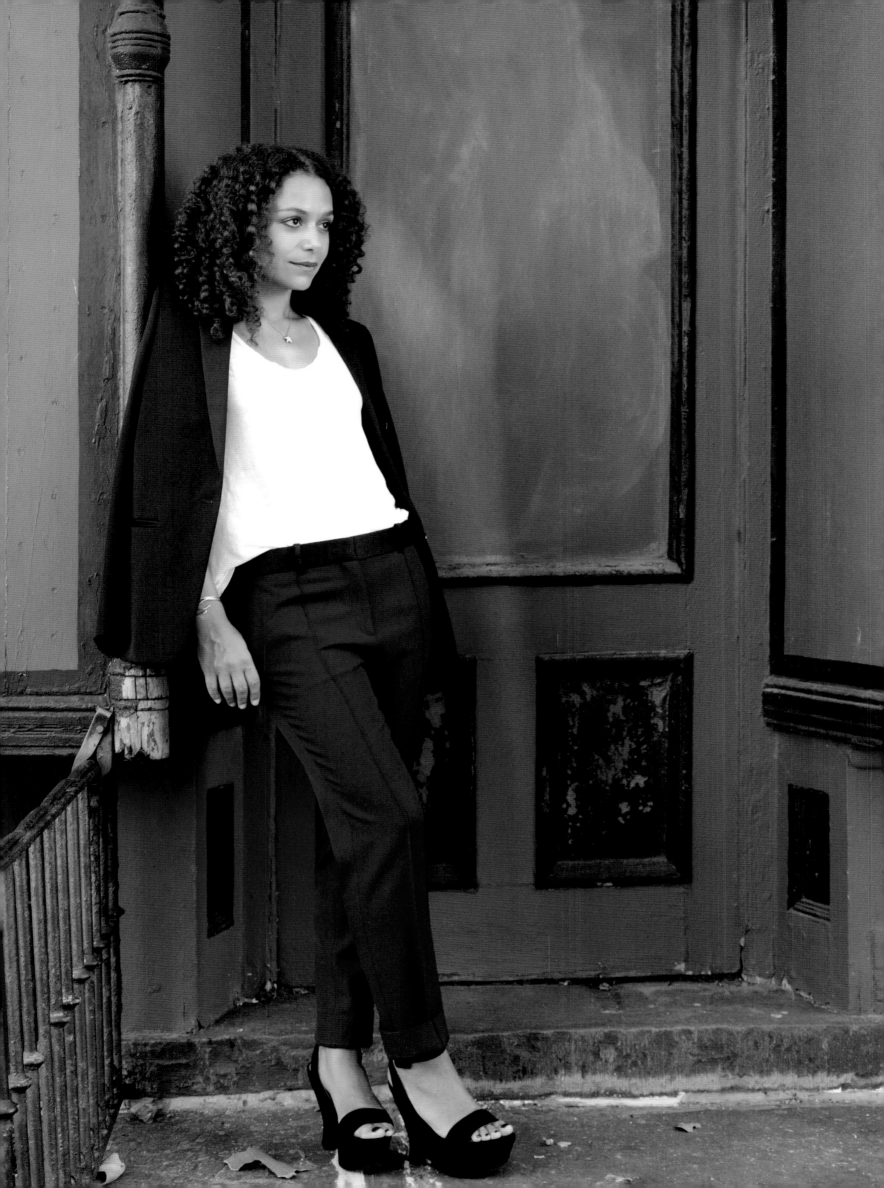

> *Beauty isn't something that satisfies someone's eyes,*
> *but that touches the soul in a certain way.*
>
> *Art Cooper*

Samira Nasr

b. Montreal, Canada Crediting men like Bob Marley, Jacques Cousteau, and Yves Saint Laurent for her androgynous style, which she describes as "practical and easy in a high heel," stylist Samira Nasr has worked in fashion for over a decade. After logging time as a staffer at *Vogue* and *Harper's Bazaar,* Nasr has gone on to style for *Vogue España, Elle,* and *W.* The New Yorker is photographed here in Brooklyn's Vinegar Hill, wearing Céline pants and a tuxedo jacket.

" *Beauty is a fragile gift.* "
Ovid

Whitney Pozgay

b. Phoenix, Arizona During her senior year at the University of Texas, Whitney Pozgay created costumes for one of the theater department's shows. On closing night, she was heartbroken to see all the costumes and headpieces that she had painstakingly designed sent to storage; she decided then that she would spend her life as a fashion designer. Hugely influential in her style education was her aunt, Kate Spade, who championed the importance of crafting a specific, singular aesthetic. Before going to work for Spade—and later, Steven Alan—Pozgay honed her skills at F.I.T. and Parsons. In fall 2010, Pozgay ventured out on her own with her clothing line WHIT, a mod take on preppy traditionalism that has turned the heads of many a New York fashion editor.

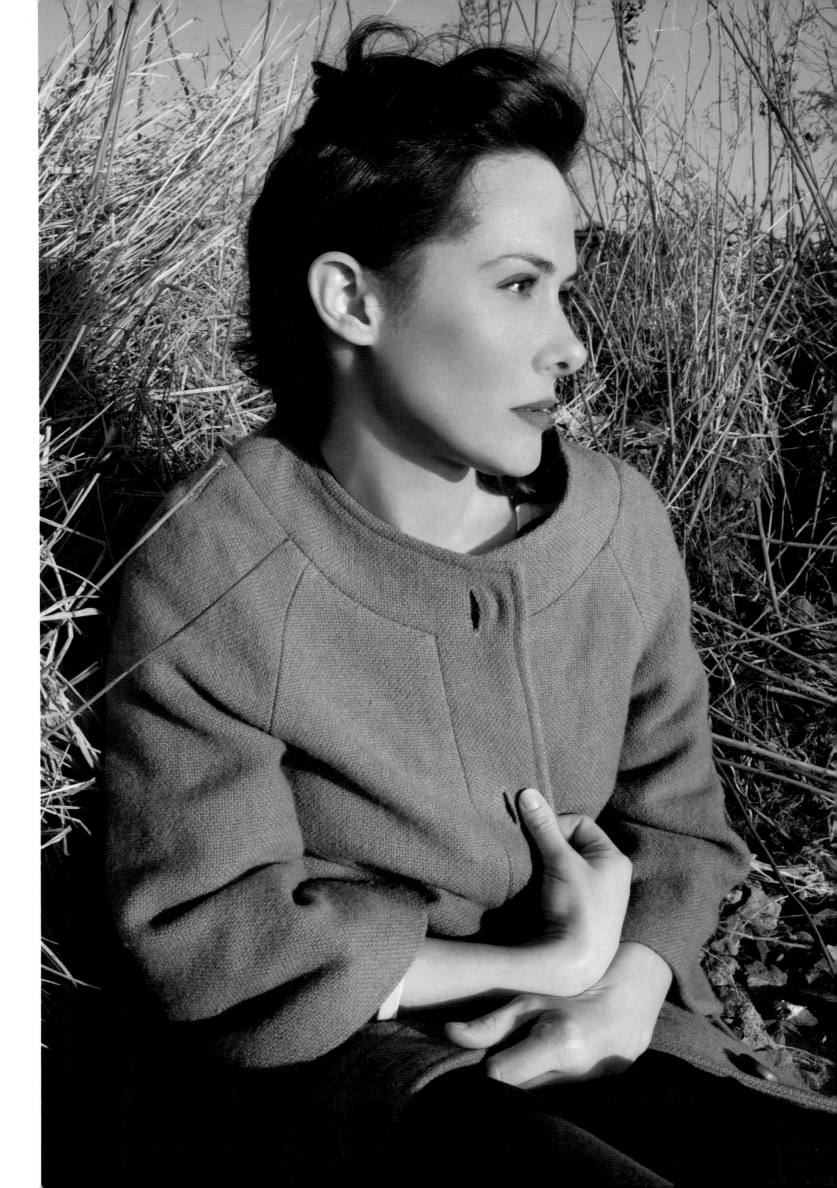

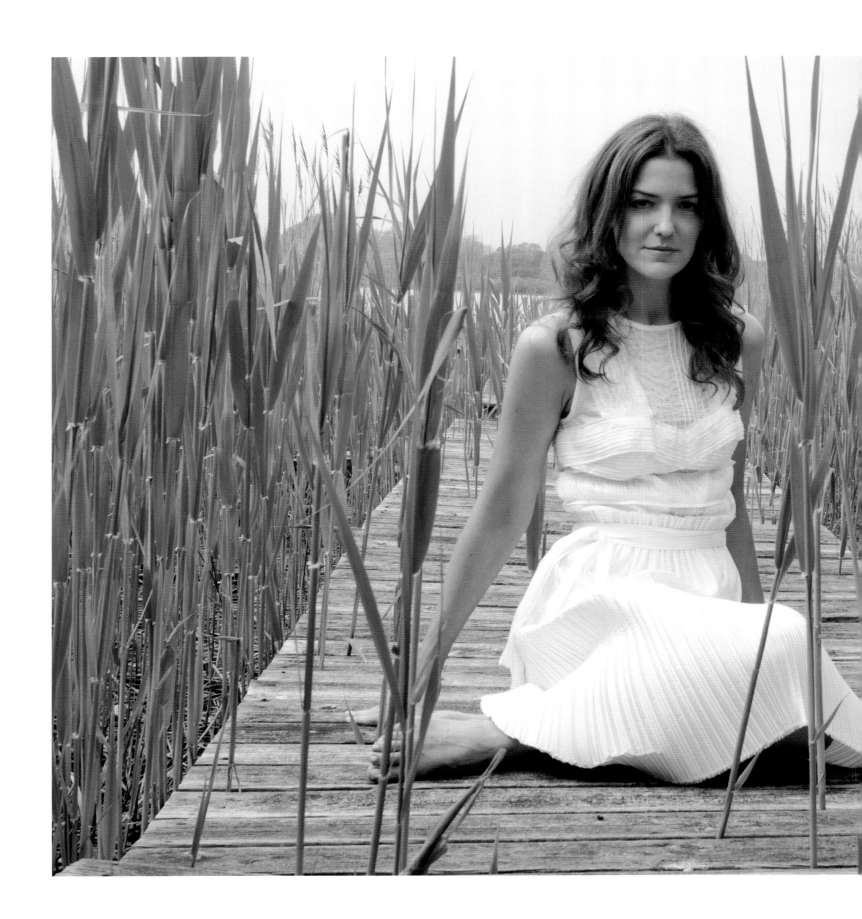

Fernanda Niven

b. New York, New York Photographed on an abandoned dock in Southampton, New York, Fernanda Niven, the granddaughter of Hollywood legend David Niven, radiates old-world elegance. A longtime proponent of sustainability, she was one of the founders of Organic Avenue, a pioneer in the freshly pressed juice industry. Niven is a contributing editor to *Town & Country,* and sits on the board of Edible Schoolyard, Alice Waters's program to promote good nutrition in schools and local environments. It is her dream to bring organic menus to cafeterias across America.

Because beauty isn't enough, there must be something more.

Eva Herzigova

Marissa Mayer

b. Wausau, Wisconsin "My most American qualities are a love of ideas, entrepreneurship, and building things—be it products, companies, or dreams," says Google's Marissa Mayer. Consistently ranked as one of the most powerful women on the planet, she is a vice president at Google, and was the company's first female engineer and one of its first twenty employees. Mayer is shown here at her alma mater, Stanford University, wearing the dress Naeem Khan designed for her—based on one Jacqueline Kennedy wore on a visit to India—as a "going away" dress for the last day of her wedding to Zachary Bogue.

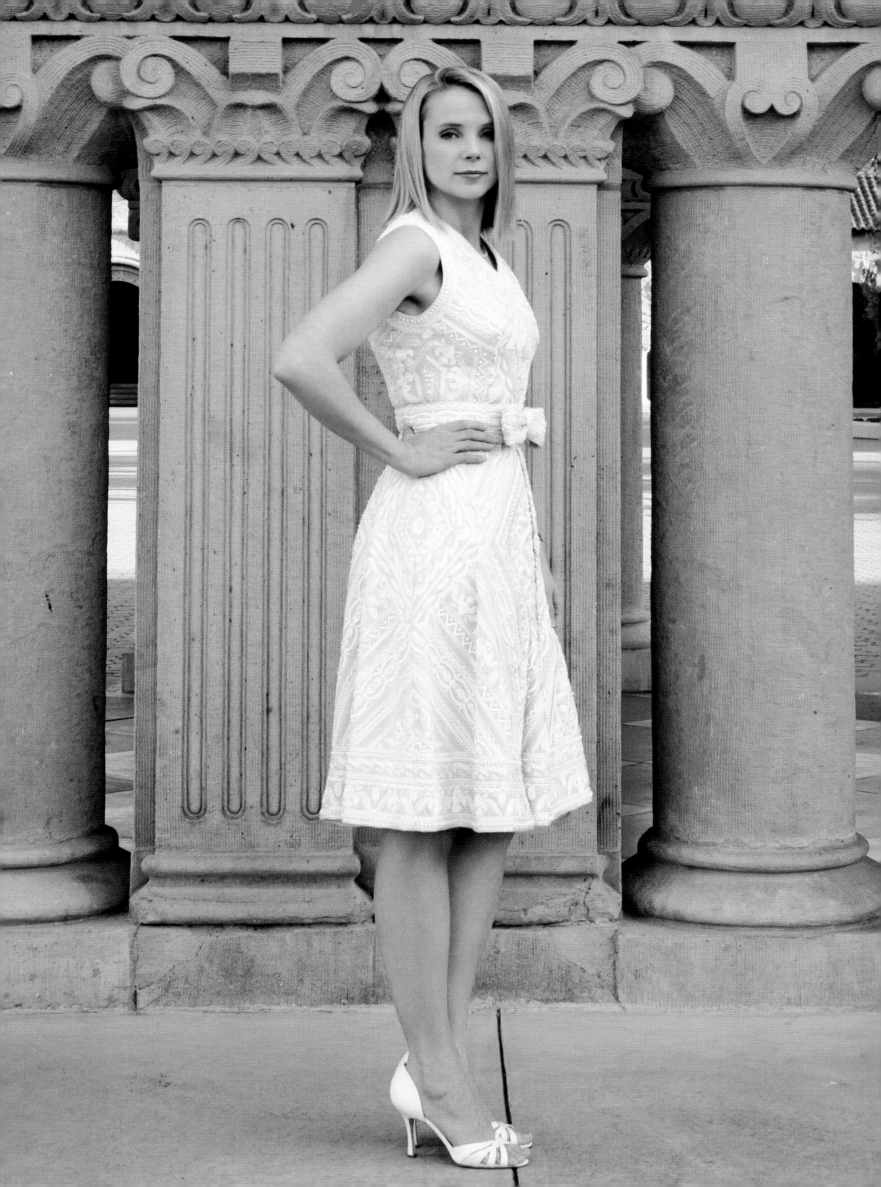

> *Out of the wonderful and difficult fight for life,*
> *the simple woman comes out victorious*
> *and the sophisticated woman defeated.*
>
> *Coco Chanel*

Kick Kennedy

b. Washington, D.C. As the grandaughter of Robert F. Kennedy, Kick is by no means the first Kennedy to choose Hollywood over Washington. Joseph P. Kennedy, her great-grandfather, was a prominent figure in 1920s Hollywood, forming "Big Five" studio RKO Pictures. A recent graduate of Stanford University, the puckish twenty-three-year-old has been studying her craft at the Lee Strasberg Theatre & Film Institute, and was just cast in Aaron Sorkin's HBO pilot, *More As This Story Develops,* a behind-the-scenes view of the world of cable news.

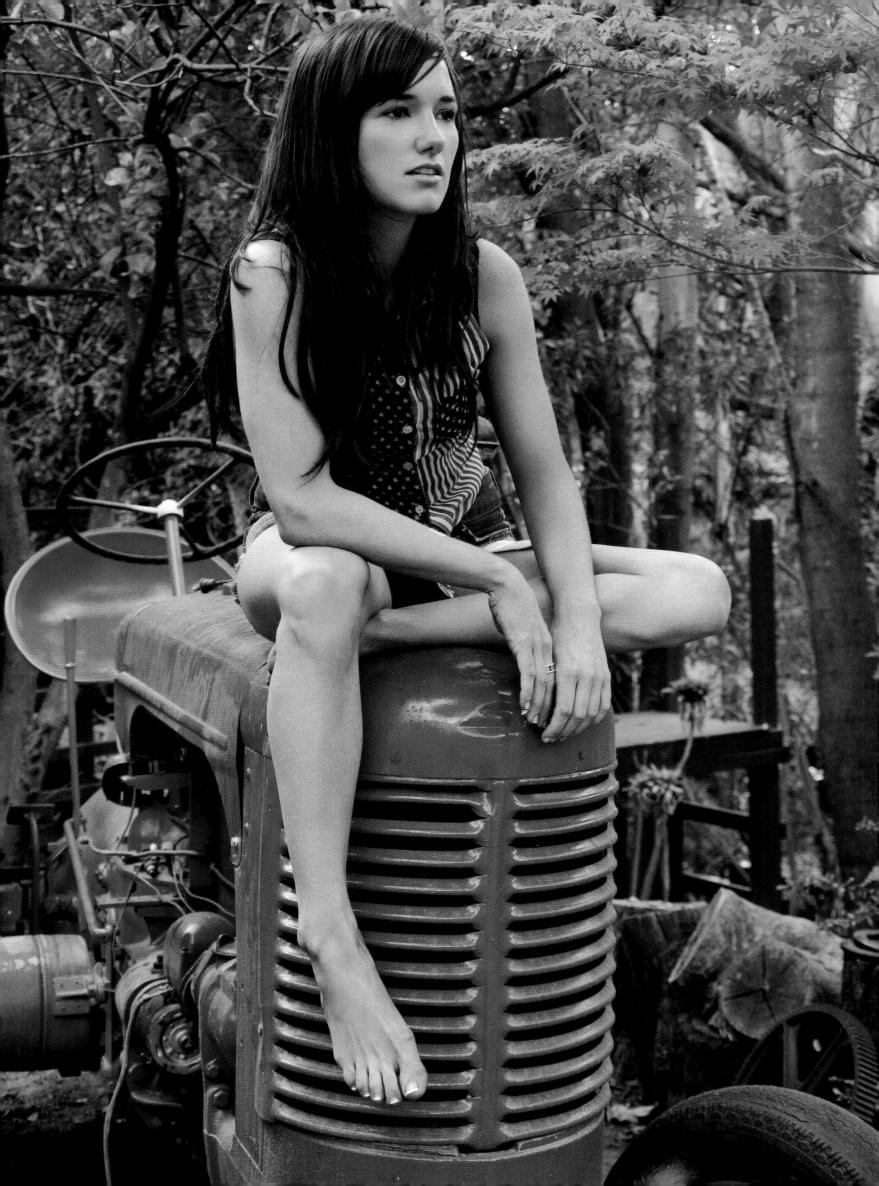

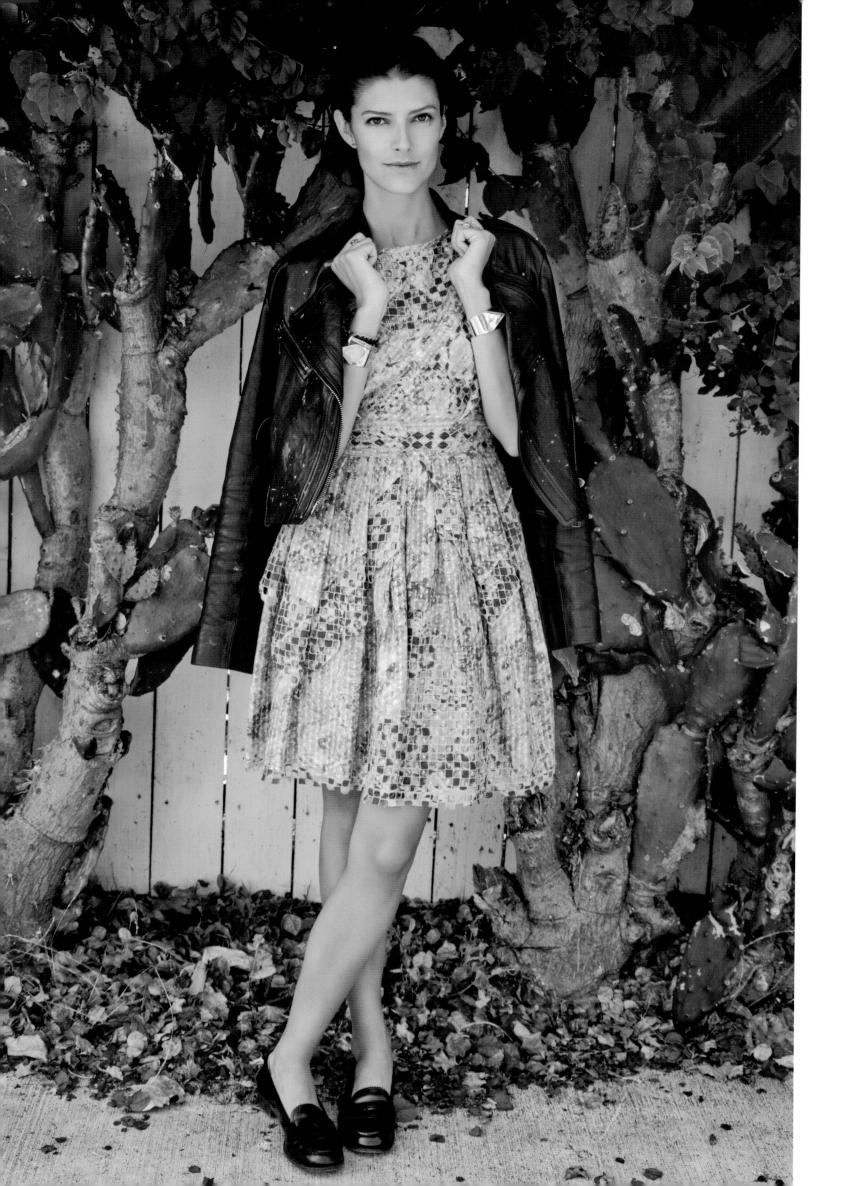

> *"The ultimate American beauty to me is Jackie Kennedy. Natural, comfortable, casual and fresh elegance."*
>
> *Pamela Hanson*

Lawren Howell

b. San Francisco, California Stylist and *Vogue* contributing editor Lawren Howell began her fashion career by assisting Anna Wintour, later moving to Los Angeles to work under senior West Coast editor Lisa Love. Photographed on a side street in Venice Beach, California, where she lives with her husband, Kris Moller, this portrait showcases the tomboy ease and cosmopolitan sophistication that have become Howell's calling cards in the fashion world.

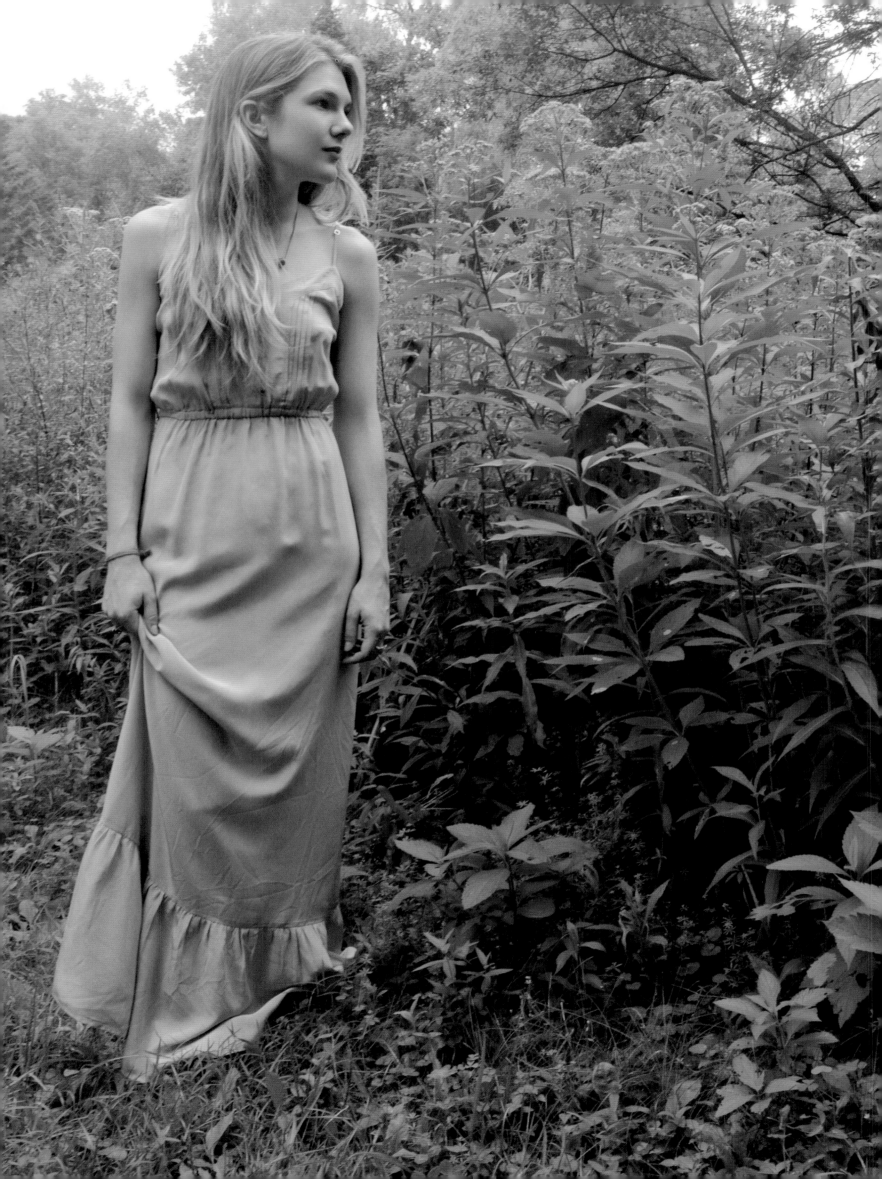

> ❝*Everything has beauty,*
> *but not everyone sees it.*❞
>
> *Confucius*

Lily Rabe

b. New York, New York Acting opposite Al Pacino for three hours (in a Broadway adaptation of *Merchant of Venice*) requires a rare kind of stamina and soul-plumbing intensity. But given Lily Rabe's theatrical genetics—she is the daughter of the late actress Jill Clayburgh and playwright David Rabe—her range is of little surprise. In addition to *Merchant of Venice,* a production that scored her a Tony nomination for Best Actress in a Play, her Broadway credits include: *The American Plan,* a revival of *Steel Magnolias, Colder Than Here,* and George Bernard Shaw's *Heartbreak House.* Rabe has appeared in the films *Never Again, Mona Lisa Smile, No Reservations, The Toe Tactic,* and *All Good Things.* She is pictured in Williamstown, Massachusetts, where she spent the summer acting in the Williamstown Theater's production of *A Doll's House,* a revival of Ibsen's 1879 classic.

> **"** *Create your own visual style…
> let it be unique for yourself and
> yet identifiable for others.* **"**
>
> *Orson Welles*

Serena
Merriman

b. New York, New York Celebrated for her sense of humor and reassuring earthiness, Serena Merriman confesses that if she weren't in public relations, she'd likely be a performer of some kind—a television personality, actress, or acrobat. For Merriman, whose formative years were spent in London, her greatest legacy would be "love, art, and kids with great hair and good manners." Here, she is captured on the windowsill of an abandoned estate in Little Compton, Rhode Island, where she spent her summers as a child.

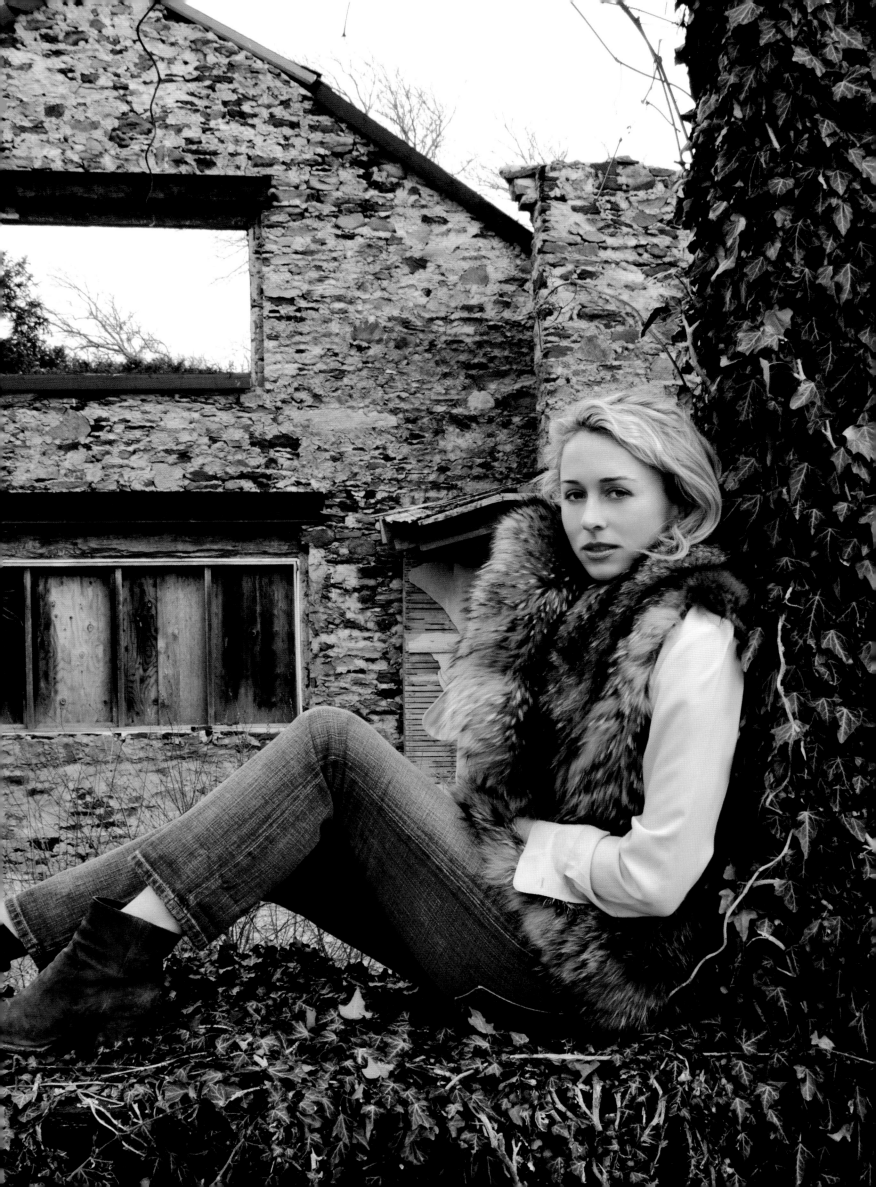

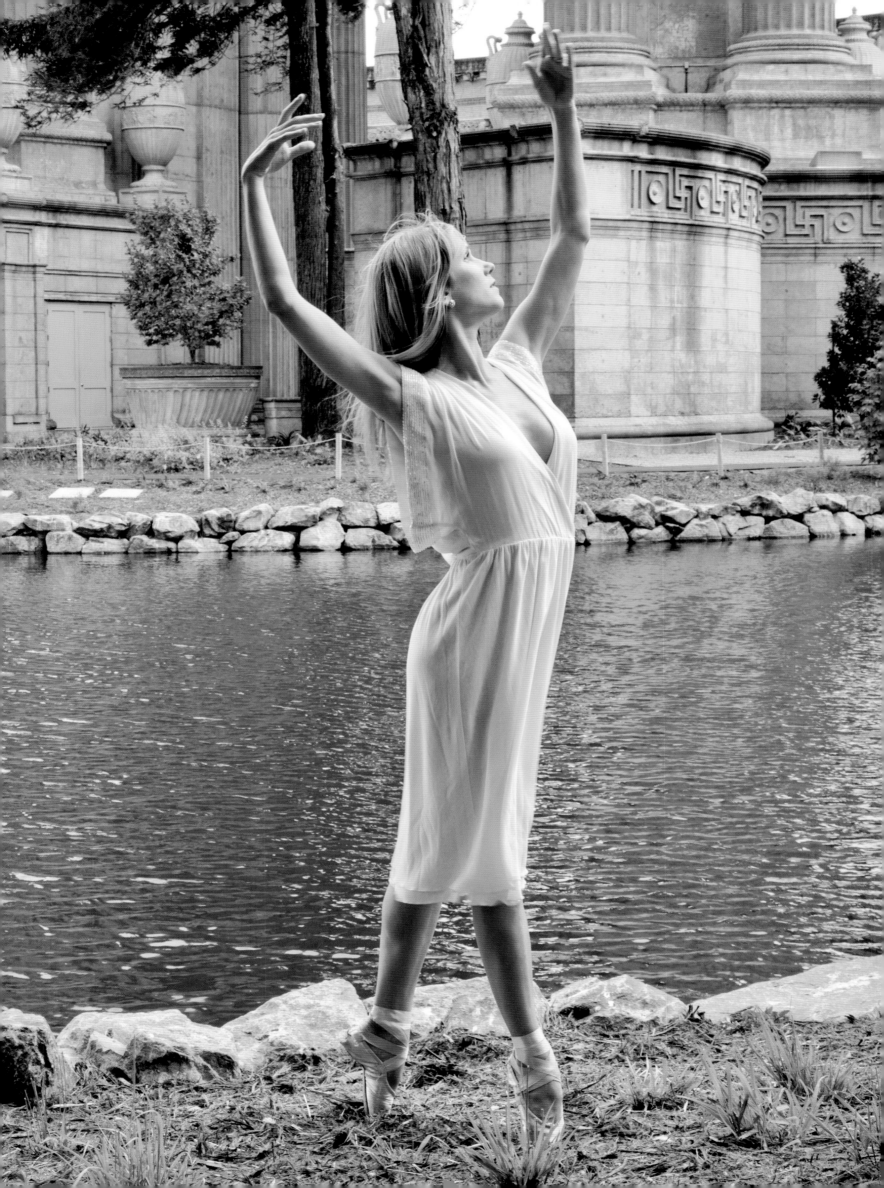

" Modern dance isn't anything except one thing in my mind: the freedom of women in America. "

Martha Graham

Indre Rockefeller

b. Washington, D.C. After years of dancing for ballet companies like the Washington Ballet, Finnish National Ballet, and the Suzanne Farrell Ballet, Indre Rockefeller possesses a timeless poise and grace that informs everything she does. "Training for a professional career in ballet throughout my childhood and young adulthood taught me the values of patience, determination, hard work, and persistence," says Rockefeller, who traces her love of dance back to when she was a five-year-old watching the Washington Ballet's performance of *The Nutcracker:* "When the Sugar Plum Fairy made her entrance in the second act, I found my calling." Photographed in her toe shoes at the Palace of Fine Arts in San Francisco, she hopes to use her Stanford MBA to act as a liaison between the creative and business worlds.

Elizabeth Woolworth

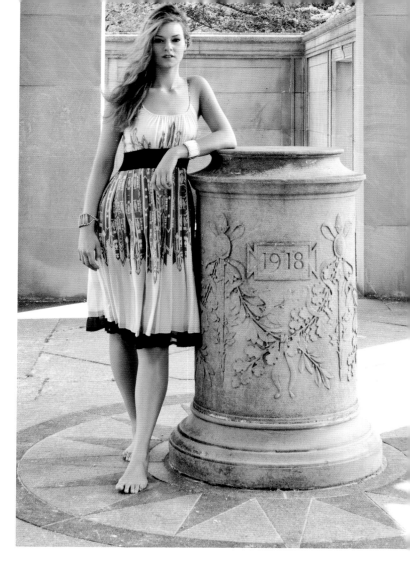

" *I believe in glamour. I am in favor of a little vanity.* "

Iman

Cena Jackson

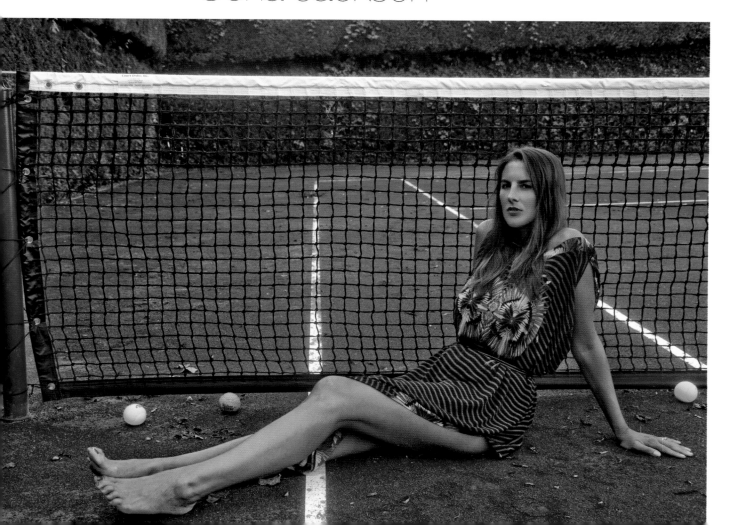

> *I dress for the image. Not for myself,*
> *not for the public, not for fashion, not for men.*
>
> Marlene Dietrich

Georgia Tapert

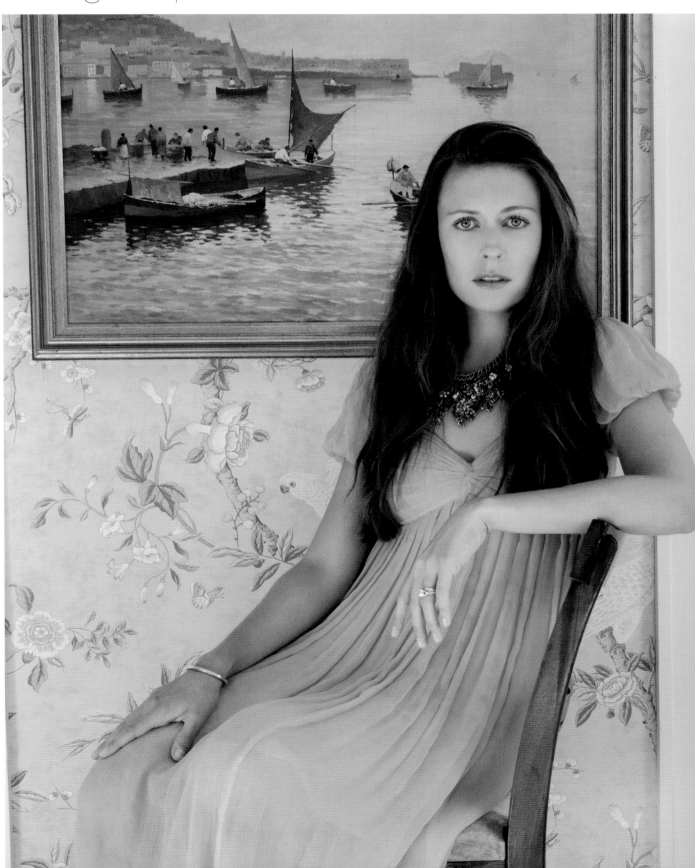

> *When she stopped conforming to the conventional picture of femininity she finally began to enjoy being a woman.*
>
> Betty Friedan

Barbara Pierce Bush

b. Dallas, Texas In a nod to her Texan heritage, Barbara Pierce Bush is photographed in an old barn, wearing a family heirloom necklace with the letter *J*—for her twin sister, Jenna. Bush is the CEO of Global Health Corps, a public health–focused nonprofit that she co-founded in 2009. It places young professionals from around the globe in yearlong fellowships with organizations that serve impoverished communities in both the U.S. and Africa. Bush knew she wanted to devote her life to improving global health when she traveled to Uganda for the launch of PEPFAR (the President's Emergency Plan for AIDS Relief). Says Bush, "My view of the world was totally changed after meeting a tiny HIV-positive girl whose mother had dressed her up in a white and lavender dress to see the American president. I didn't know the details of this child's life except that she was too weak to stand. After meeting her, I knew I wanted to spend my time and energy focusing on the problems that little girl faced."

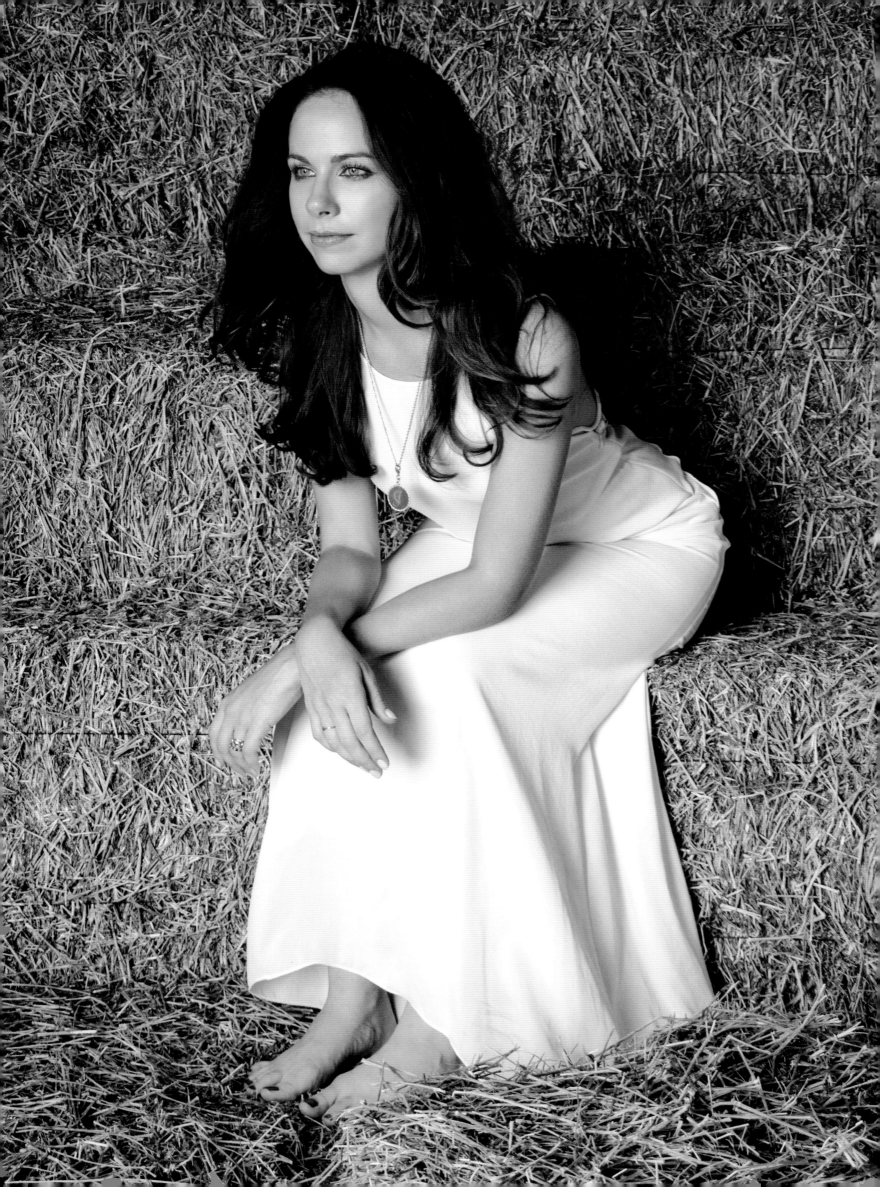

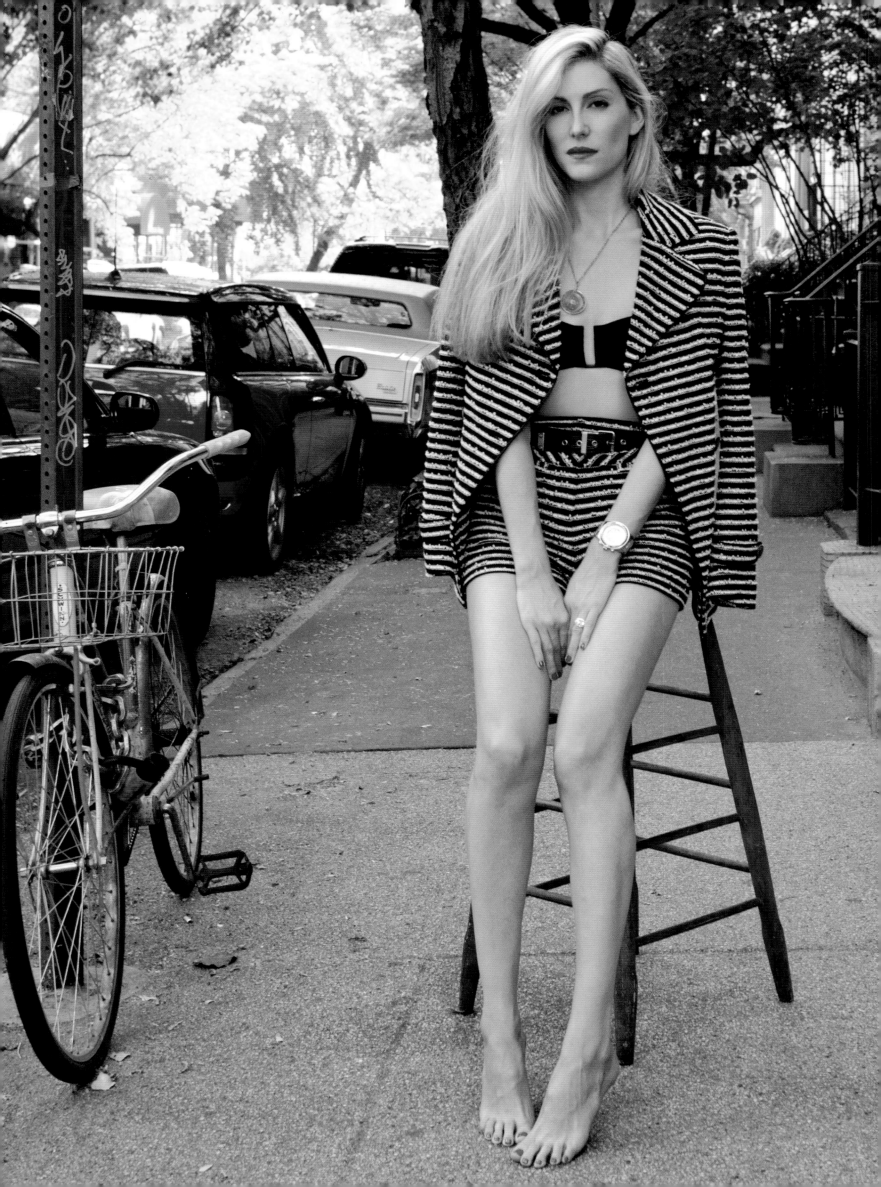

> *The most beautiful makeup of a woman is passion. But cosmetics are easier to buy.*
>
> *Yves Saint Laurent*

Joanna Hillman

b. Toronto, Canada It was a box of her mother's old modeling photographs that drove Joanna Hillman toward fashion. After begging her mother to let her model as a young girl and consequently working on set alongside photographers and stylists, she fell even more deeply in love with the glamorous world. Prior to working at *Harper's Bazaar* as senior fashion market editor, she worked at *Teen Vogue*. Hillman, photographed here on a West Village sidewalk, confesses: "I'm clearly after the American Dream, working my way up the ranks to make it in the big city."

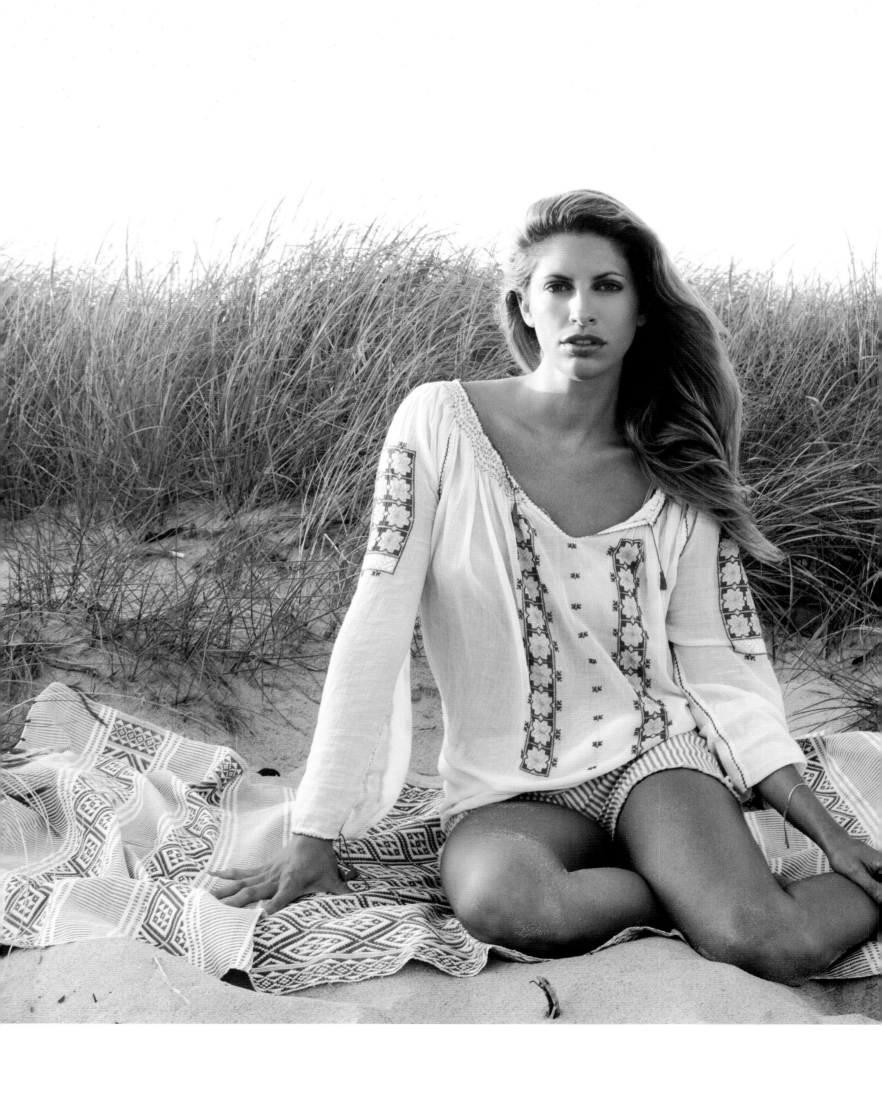

> **66** *I know very few Americans, though I like the way they think. They think big.* **99**
> *Brigitte Bardot*

Valerie Boster

b. Munich, Germany "There is something about being in the water—engulfed and submerged—that keeps me focused on the present and forces me to let everything else go," explains Boster, photographed in Montauk, New York, where she learned how to surf as a young girl. The *Vogue* bookings editor has been credited for casting many of the famous faces that have graced the magazine's pages, including Karlie Kloss, Arizona Muse, Hilary Rhoda, and Joan Smalls.

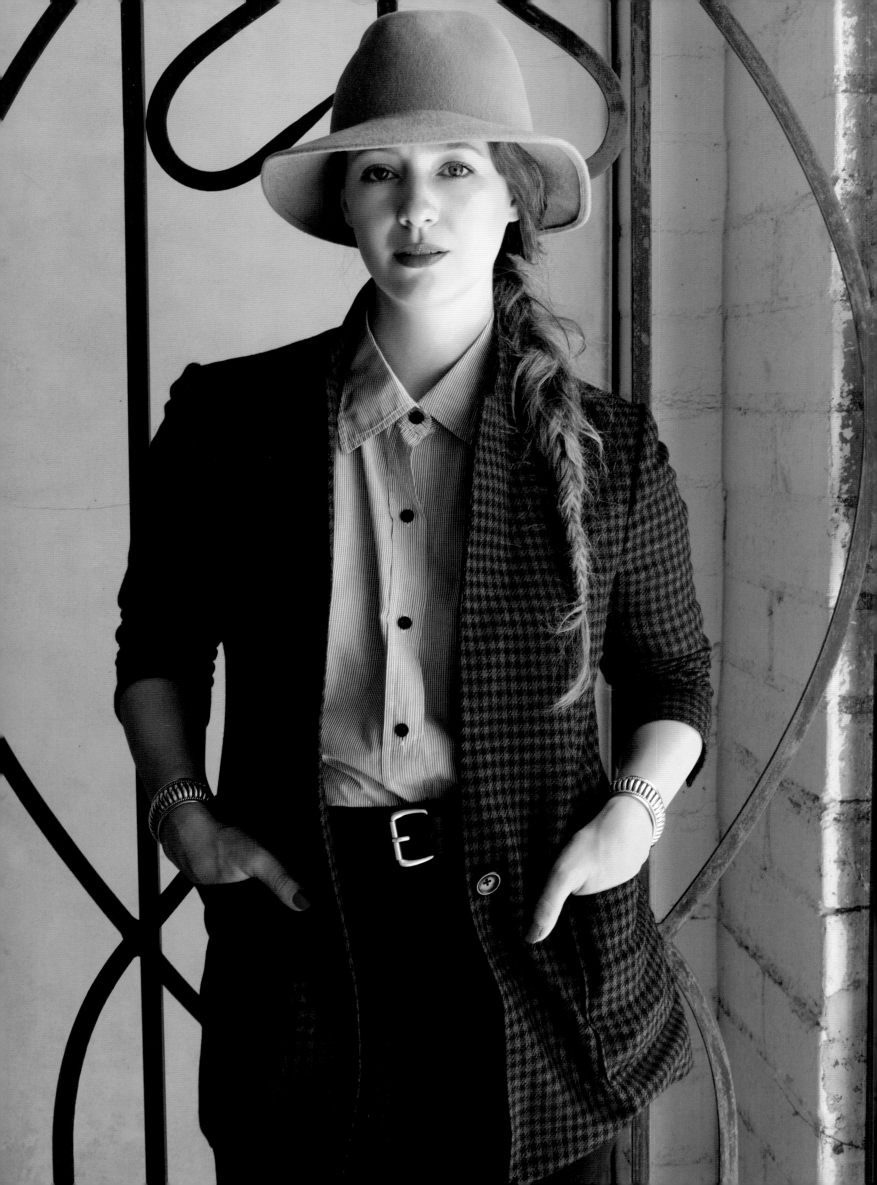

*" Beauty of style and harmony
and grace and good rhythm
depend on simplicity. "*

Plato

Jenni Kayne

b. Los Angeles, California Jenni Kayne is known in the fashion industry for her refined interpretation of classic American sportswear, which combines her California heritage with a clean, polished aesthetic. "Super-chic, easy-to-wear clothes," she says of her designs. "That's what I do. Nothing tricky, nothing precious." Photographed in front of the iron doors that she designed for her West Hollywood boutique, Kayne personifies the L.A.-meets-N.Y.C. androgyny that has garnered her the support of friends like Rachel Bilson, Demi Moore, Selma Blair, and the Olsen twins. She launched her line, Jenni Kayne, in 2003, moved her runway show from L.A. to New York in 2005, and in 2007 opened the boutique where she is photographed.

> *Smiling is definitely one of the best beauty remedies.*
> *If you have a good sense of humor and a good*
> *approach to life, that's beautiful.*
> *Rashida Jones*

Joan Smalls

b. Hatillo, Puerto Rico Joan Smalls is one of the most sought-after faces in the fashion world today. She has appeared in campaigns for Estée Lauder, Givenchy, Gucci, and David Yurman; after being selected to walk exclusively for the Givenchy spring 2010 couture show, she immediately became one the most coveted models on the catwalk. Smalls has walked for designers including Oscar de la Renta, Stella McCartney, Prada, Derek Lam, Marc Jacobs, and Hermès, as well as fellow model Naomi Campbell's charity runway, which benefits Fashion for Relief. She is also involved in Project Sunshine, a nonprofit organization that provides free educational, recreational, and social programs to children and families living with medical challenges.

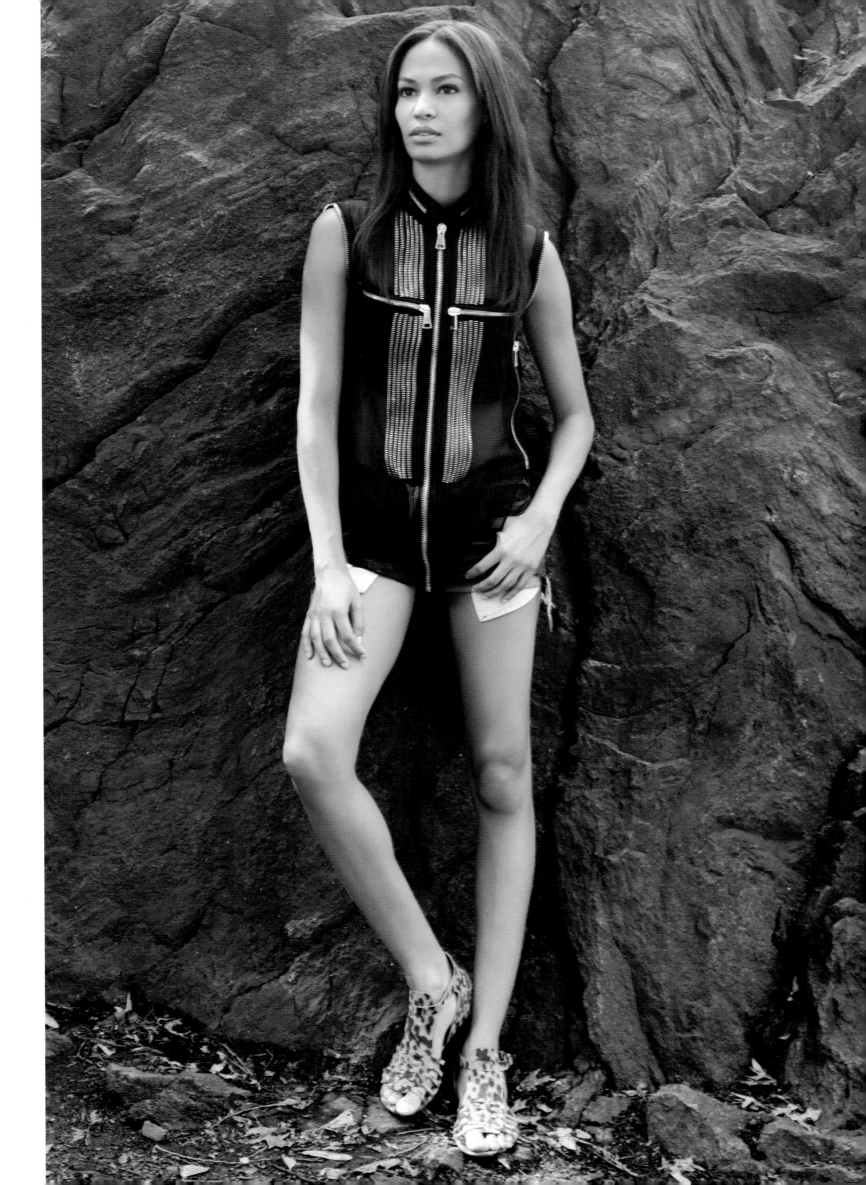

"Beauty is an attitude. There's no secret... There are no ugly women— only women who don't care or who don't believe they're attractive."
Estée Lauder

Lela Rose

b. Dallas, Texas Known for her eponymous line of intricately designed gowns, separates, and bridesmaids' dresses, Lela Rose radiates a Southern sensibility and an overriding quirkiness. Noted for designing Jenna and Barbara Bush's inaugural dresses, the charming Rose is also a celebrated hostess whose love of entertaining stems from her upbringing in a home filled with love, food, generosity, and hard work. "I have the spirit of a self-starter and a 'nothing is impossible' attitude that is a lesson I learned from my parents, and one I hope to pass on to my son, Grey, and my daughter, Rosey."

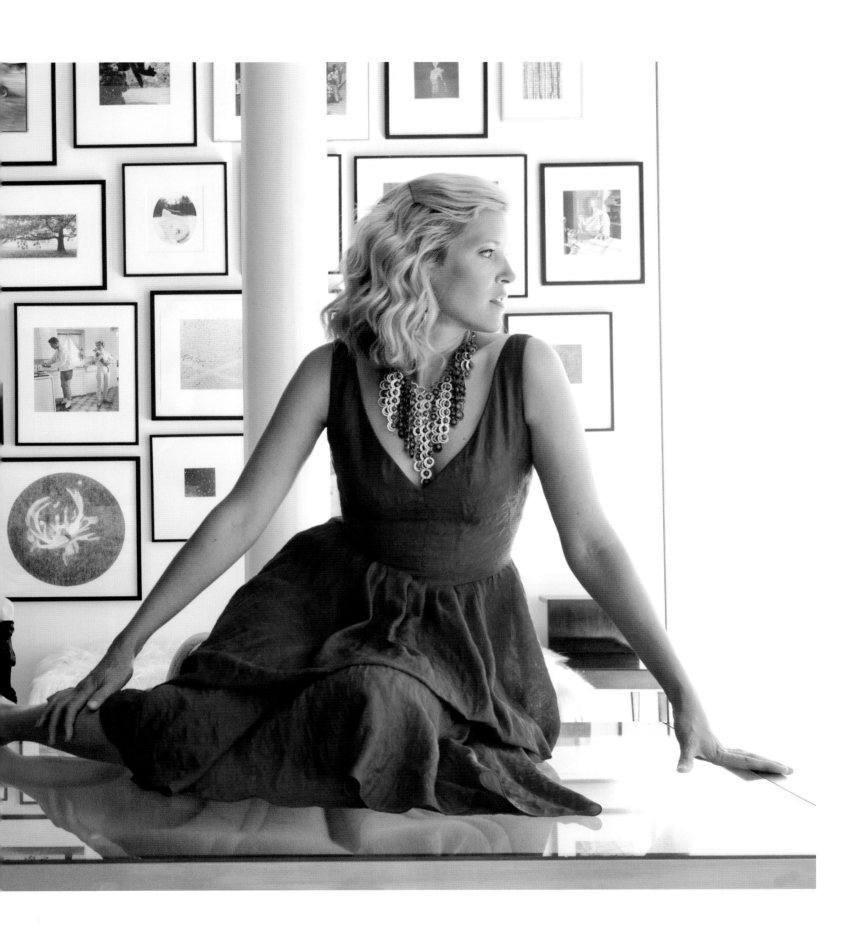

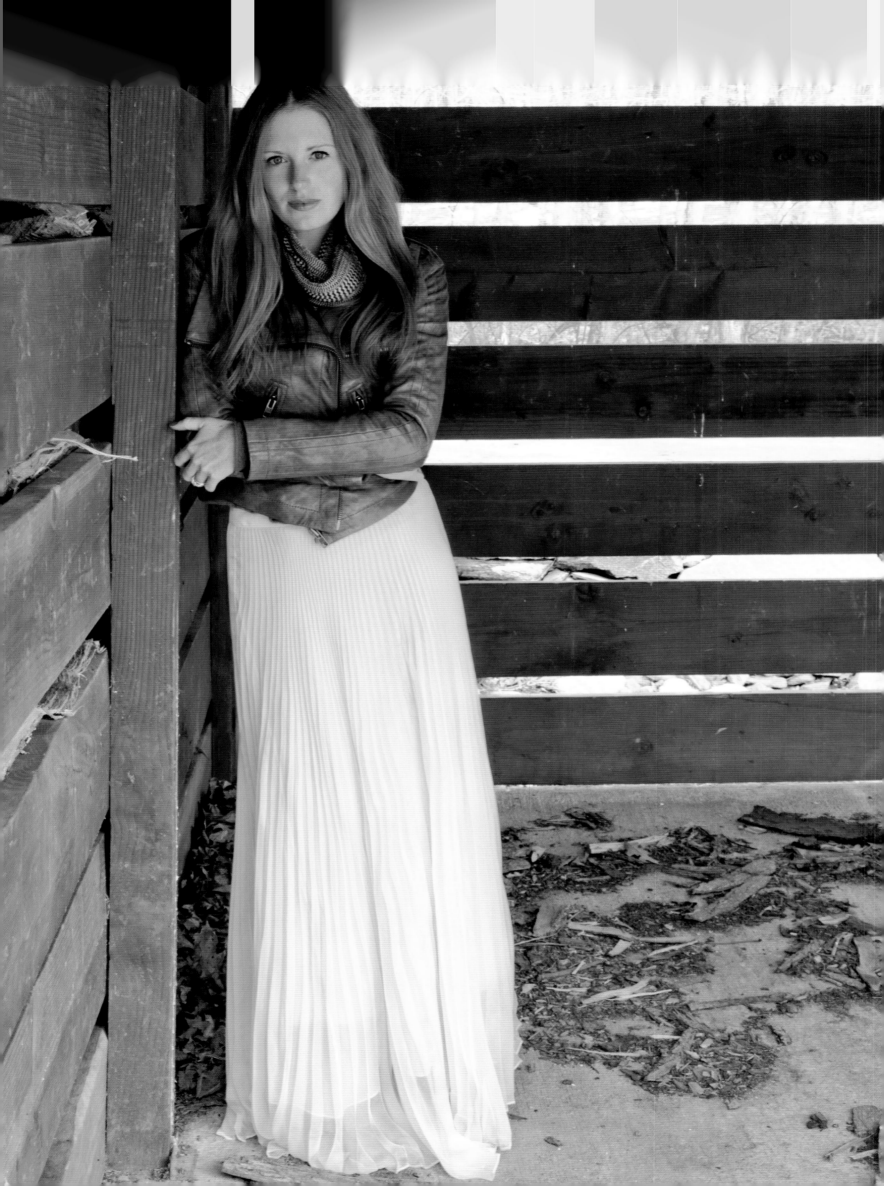

*66 People often say that 'beauty is in the eye of the beholder,'
and I say that the most liberating thing about beauty
is realizing that you are the beholder. This empowers us
to find beauty in places where others have not dared
to look, including inside ourselves. 99*

Salma Hayek

Bettina Prentice

b. New York, New York "I always knew that I wanted to work with artists; I come from a family of artists and swoon over creatives," explains the strawberry-haired, authority-shunning New York native. "I was working as the director of a gallery in Chelsea when I realized that I could channel my ability to talk about the work into something other than sales." Since then, Bettina Prentice has left her role in the press and communications department for gallerist Yvon Lambert; founded her own company, Prentice Art Communications Inc., which represents galleries like Acquavella and artists like Arthur Elgort; and become deeply involved in Coalition for the Homeless and Artwalk NY.

> *Beauty is unbearable, drives us to despair,*
> *offering us for a minute the glimpse of an eternity that*
> *we should like to stretch out over the whole of time.*
> Albert Camus

Amanda Hearst

b. New York, New York As the great-granddaughter of media titan William Randolph Hearst, Amanda Hearst, seen here at the Long Island estate her mother shares with husband Jay McInerney, mixes aristocratic class with contemporary cool and a dedication to sustainability. Causes like deforestation and climate change loom large for the part-time model and *Marie Claire* editor, who recently co-founded Friends of Finn, a charity to raise awareness about animal cruelty, with Georgina Bloomberg.

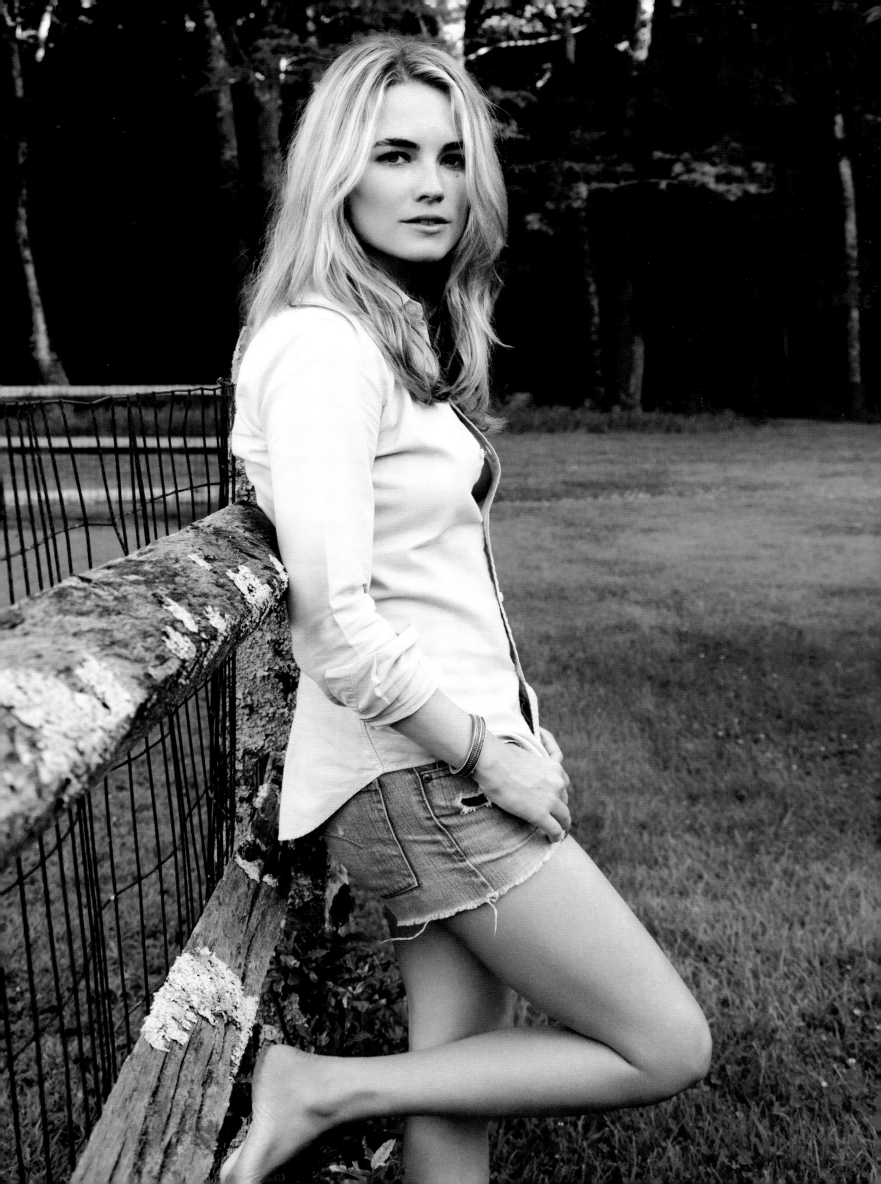

The idea that beauty is without importance is the true myth about beauty.
Nancy Etcoff

Misty Copeland

b. Kansas City, Missouri A soloist at American Ballet Theater, Misty Copeland realized that she would dedicate her life to dance the first time she went on stage. Photographed in a stone garden in Mill Neck, New York, wearing a practice tutu that was handed down to her by a former ballerina, Copeland notes: "This tutu has so much significance to me. It stands for everything that ballet is about: history, passing down the tradition, and effortless, timeless beauty."

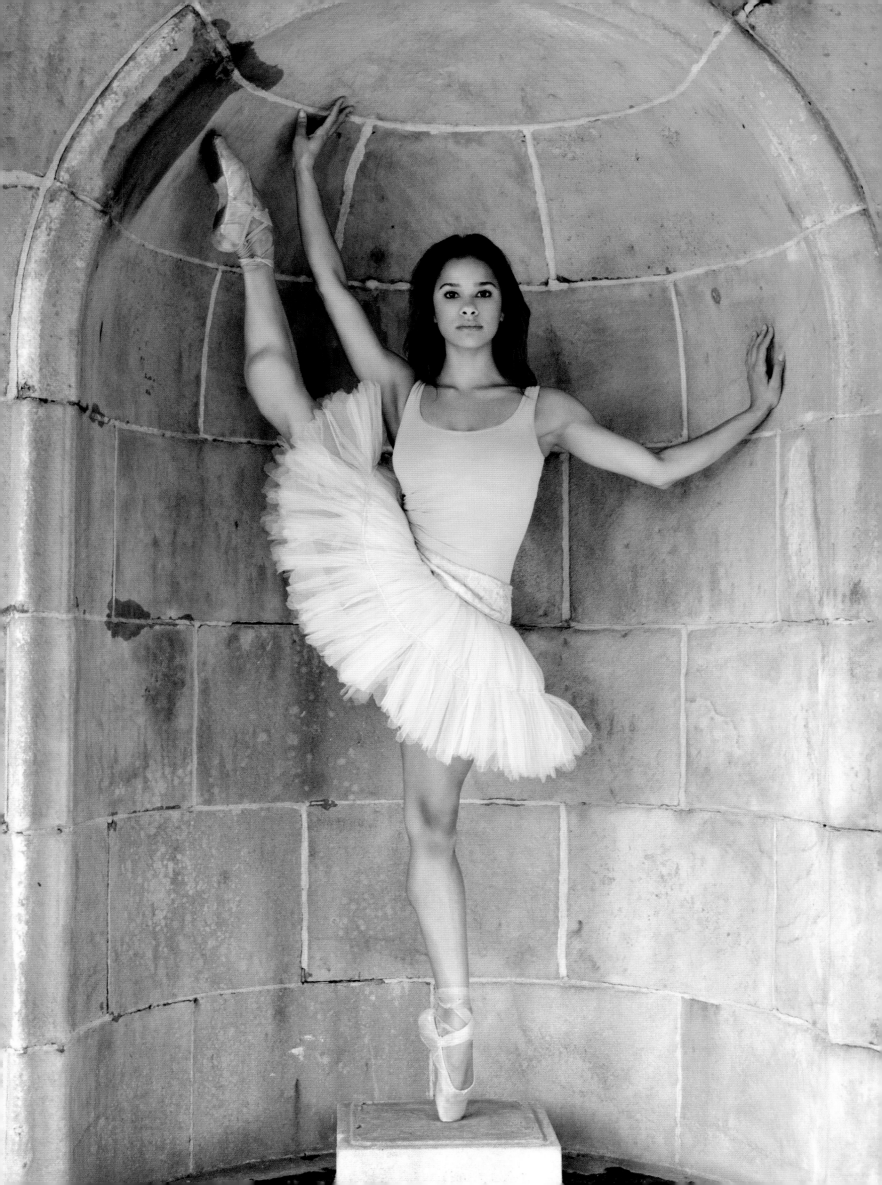

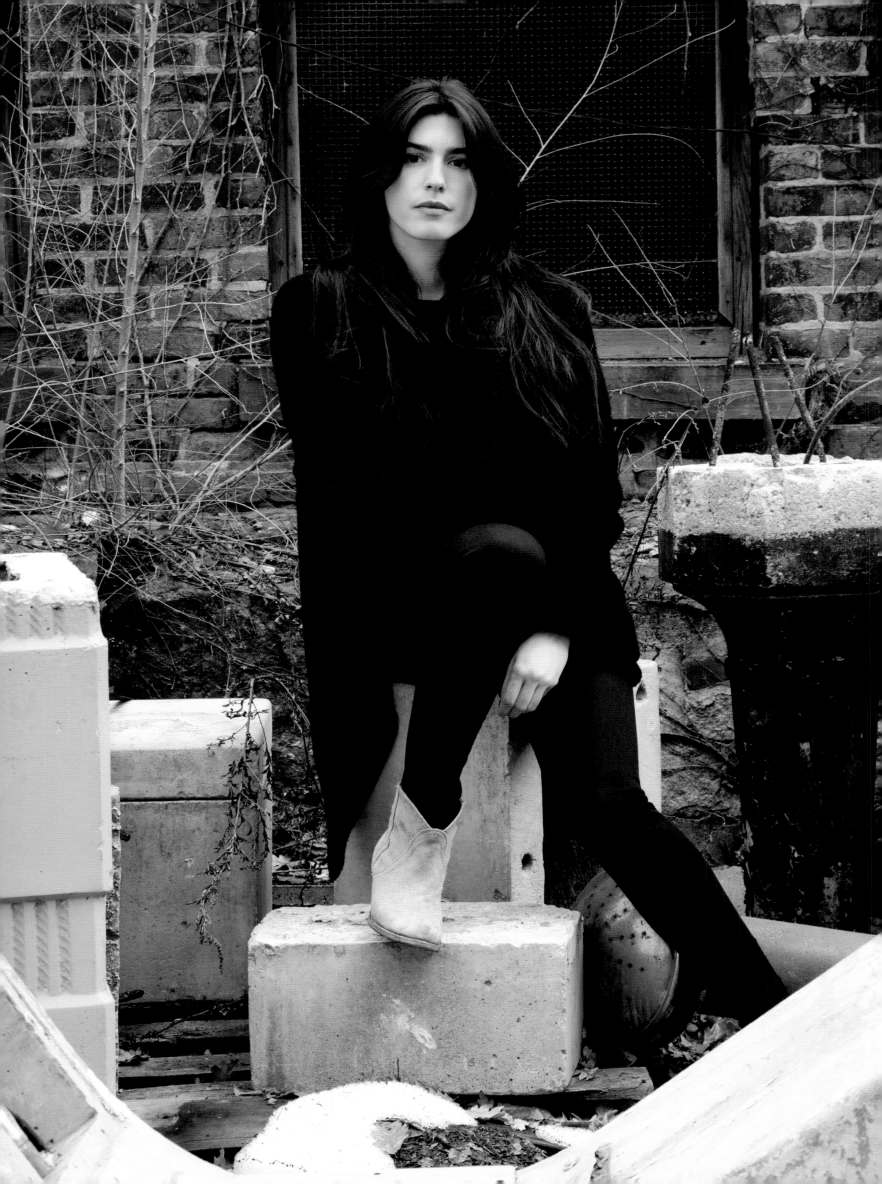

Danielle Corona

b. Miami, Florida "My father, a Cuban immigrant, was able to go from being a newspaper boy who could not speak English to a successful American businessman through the opportunities offered in this country and the values instilled in him: hard work, ambition, freedom, and independence. I like to believe I inherited these values as well," says Corona. Indeed, she has enjoyed her own American-grown ascent, working at Valentino before venturing out to create Hunting Season, a collection of deceptively simple envelope clutches, crafted from exotic skins like alligator and python, that have won her a loyal following.

Lily Chapin

b. Brooklyn, New York One half of "vintage country-folk" singing troupe the Chapin Sisters, Lily Chapin is a study in East-meets-West Americana, having transplanted her Hudson Valley roots to a life in Los Angeles, where she performs—often in the dress shown here—alongside artists like Lily Diamond, the L.A. Ladies Choir, and She & Him (actress Zooey Deschanel and M. Ward's band).

One can not be an American by going about saying that one is an American. It is necessary to feel America, like America, love America, and then work.

Georgia O'Keeffe

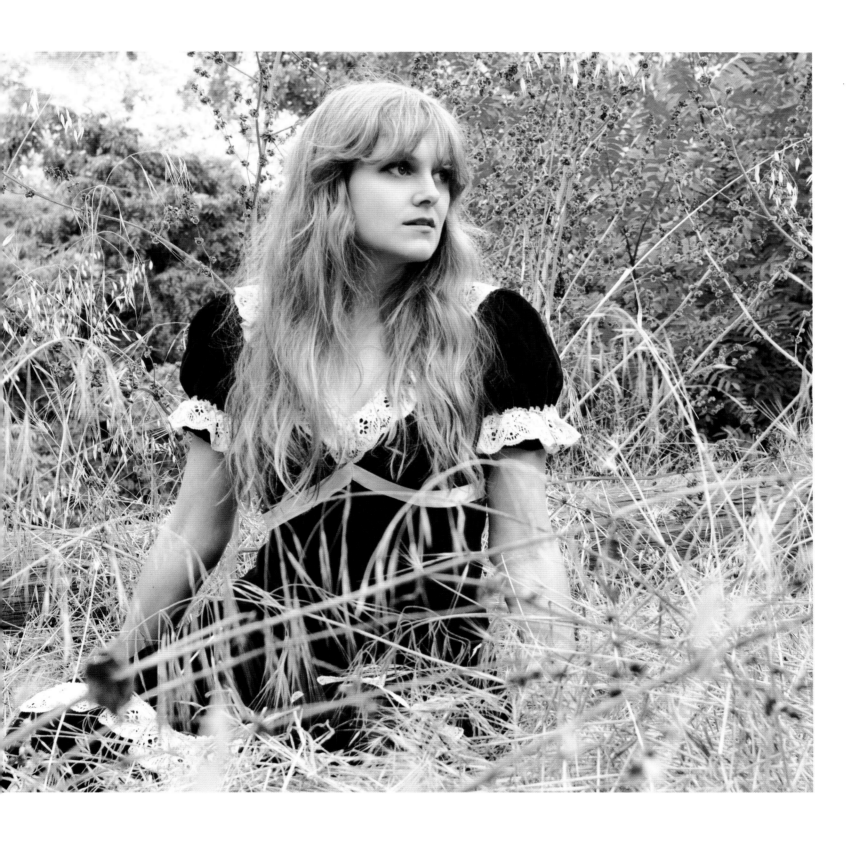

Melanie Fascitelli

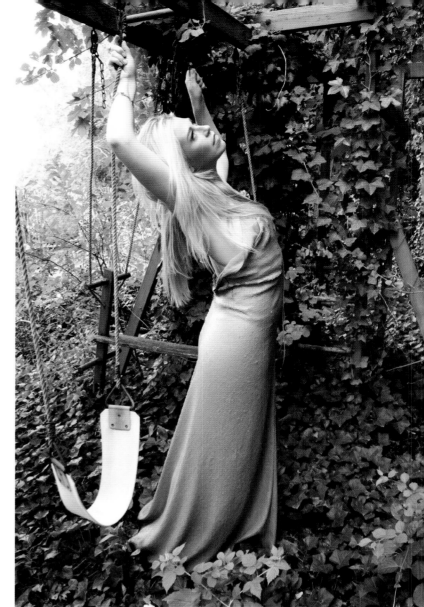

❝ *Beauty is many things to me. It's about having a strong sense of self. It's about doing things on a daily basis that make a difference. It's about always looking people in the eye. It's about seeking out joy even when faced with adversity. And of course, it's about wearing a great lipstick!* ❞

Bobbi Brown

Ashley Bernon

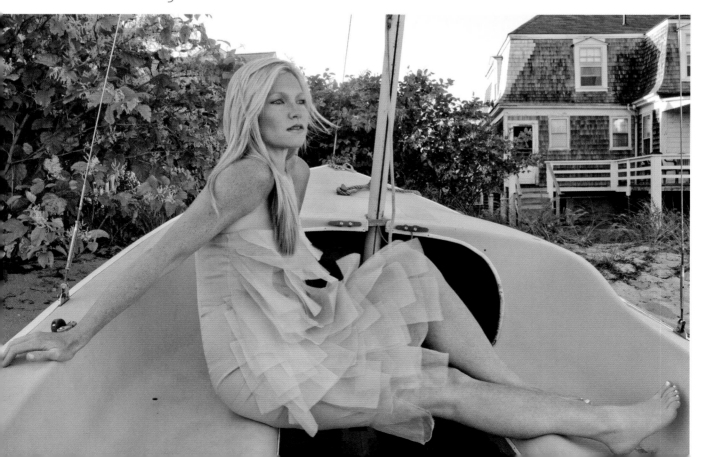

Kelsey McKinnon

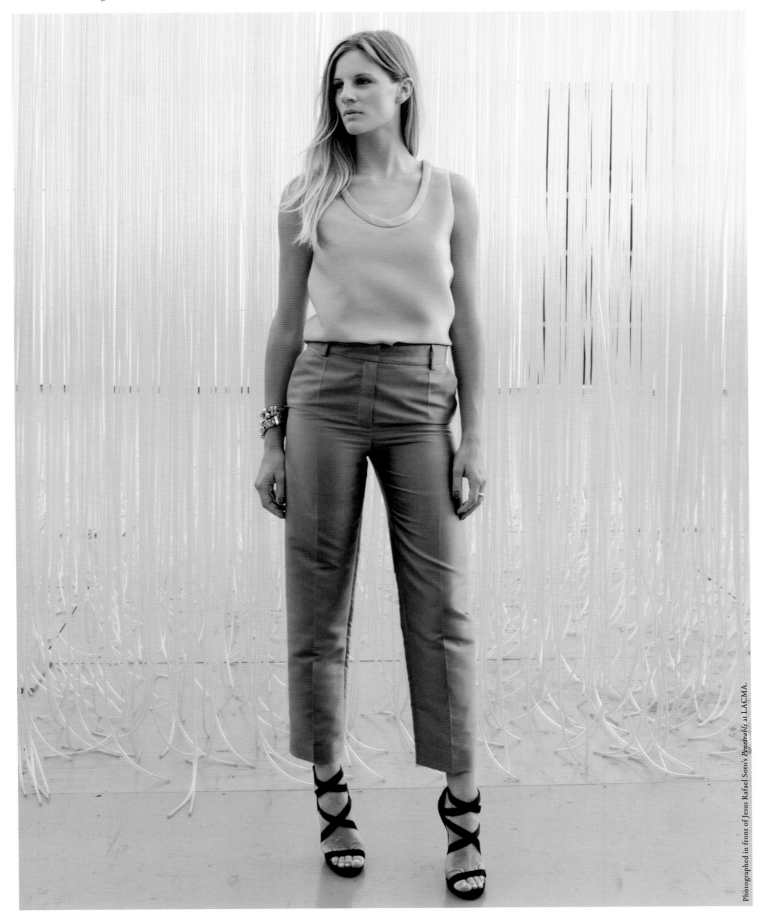

Photographed in front of Jesus Rafael Soto's *Penetrable* at LACMA.

❝ *Beauty without grace is beauty without charm.* **❞**

Ninon de Lenclos

Nena Woolworth

b. New York, New York Photographed in front of a children's dollhouse in Napa Valley, Nena Woolworth exudes a "nothing shocks me" attitude. One part WASP and one part dandy, Woolworth has found a unique balance between the frivolous, the fanciful, and the functional. An accomplished writer and the co-owner of design firm Chiqui and Nena Woolworth Design, Woolworth attributes her vivacity and wicked sense of humor to growing up in a "very large family of big personalities and eccentrics."

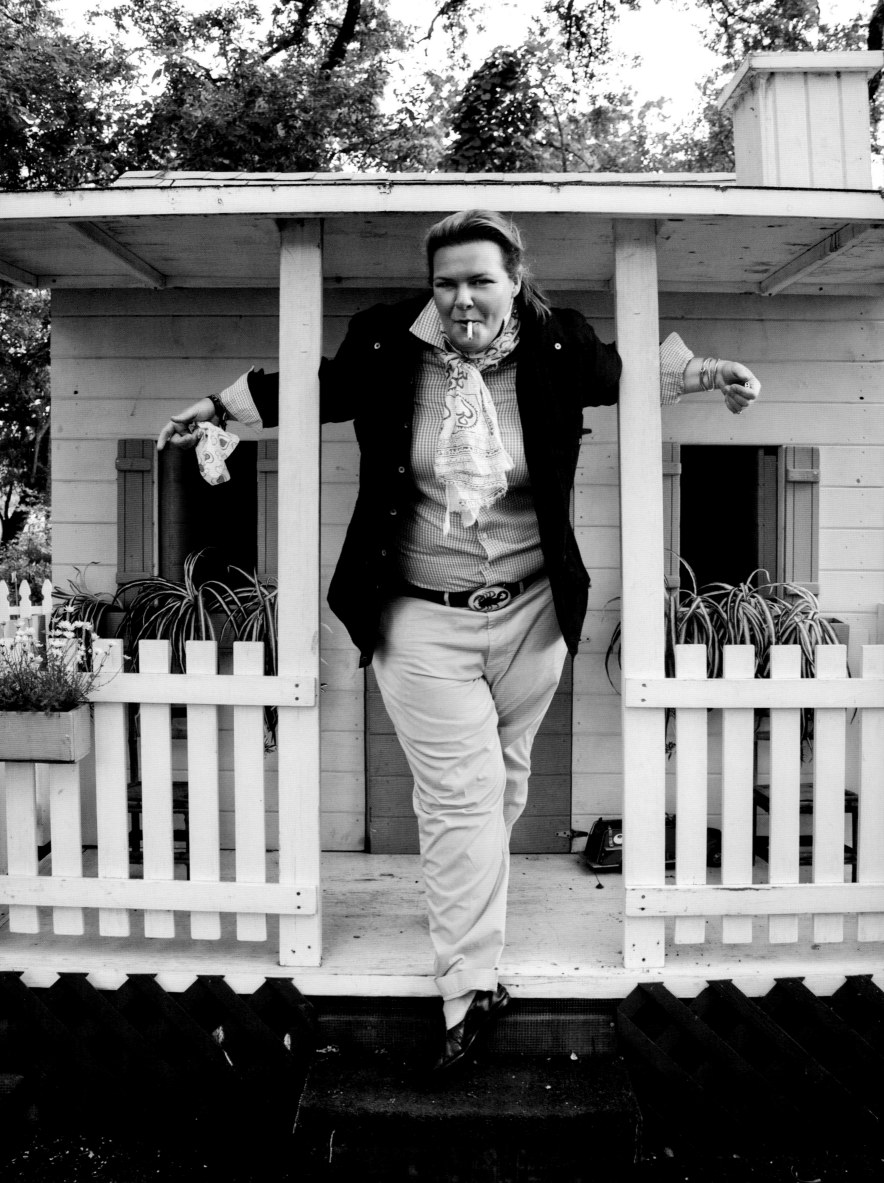

" It's a fresh outlook that makes youth so attractive anyway, that quality of 'anything's possible. '"

Estée Lauder

Connie Wang

b. Jinan, China As the global editor of Refinery29, Connie Wang is known for her quirky, eclectic personal style, dry humor, and increasingly popular blogs. Mixing menswear with more feminine pieces to create a sophisticated, downtown look—a patchwork inspired by living in Nebraska, Alabama, Minnesota, California, and now New York City—Wang has won a loyal following among style watchers and readers alike. Notes Wang: "American beauty is about creating the fullest, must exuberant version of yourself. I love how experimental American women are with their looks."

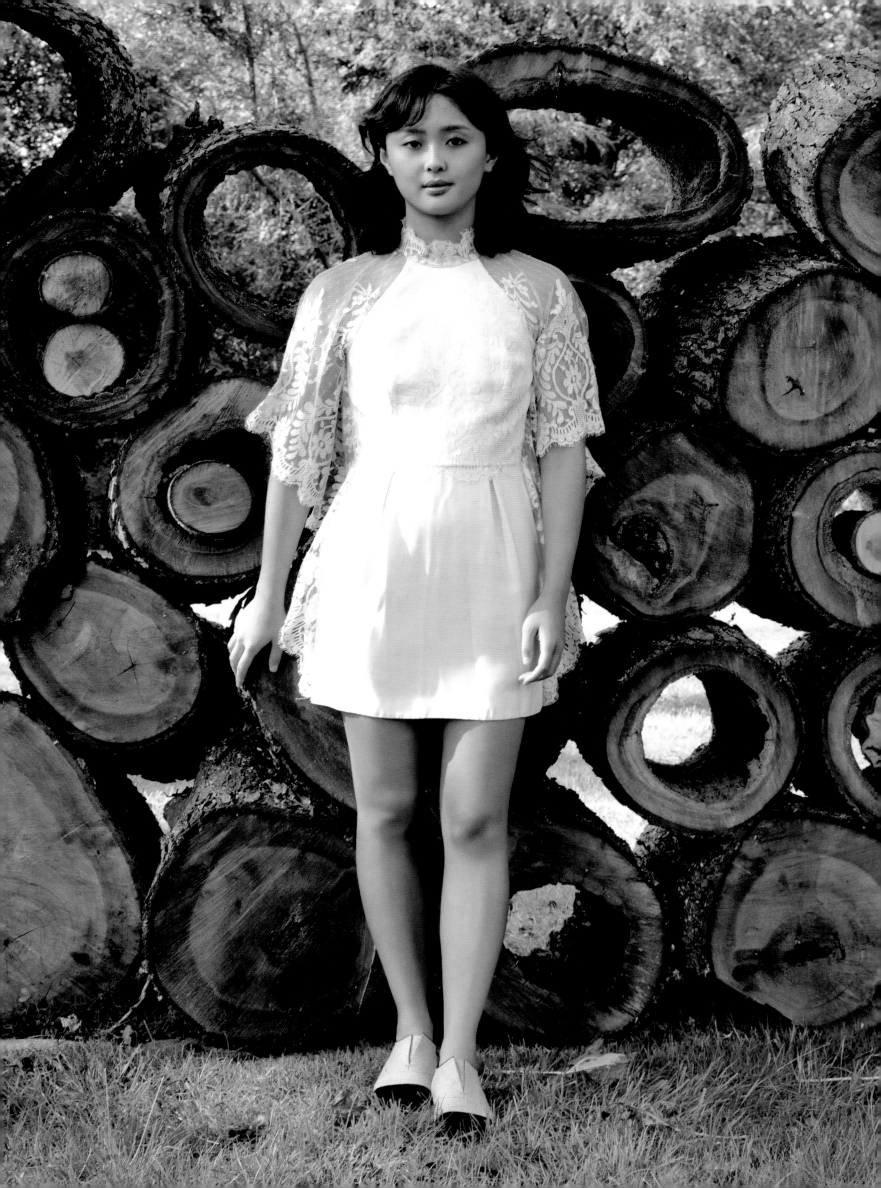

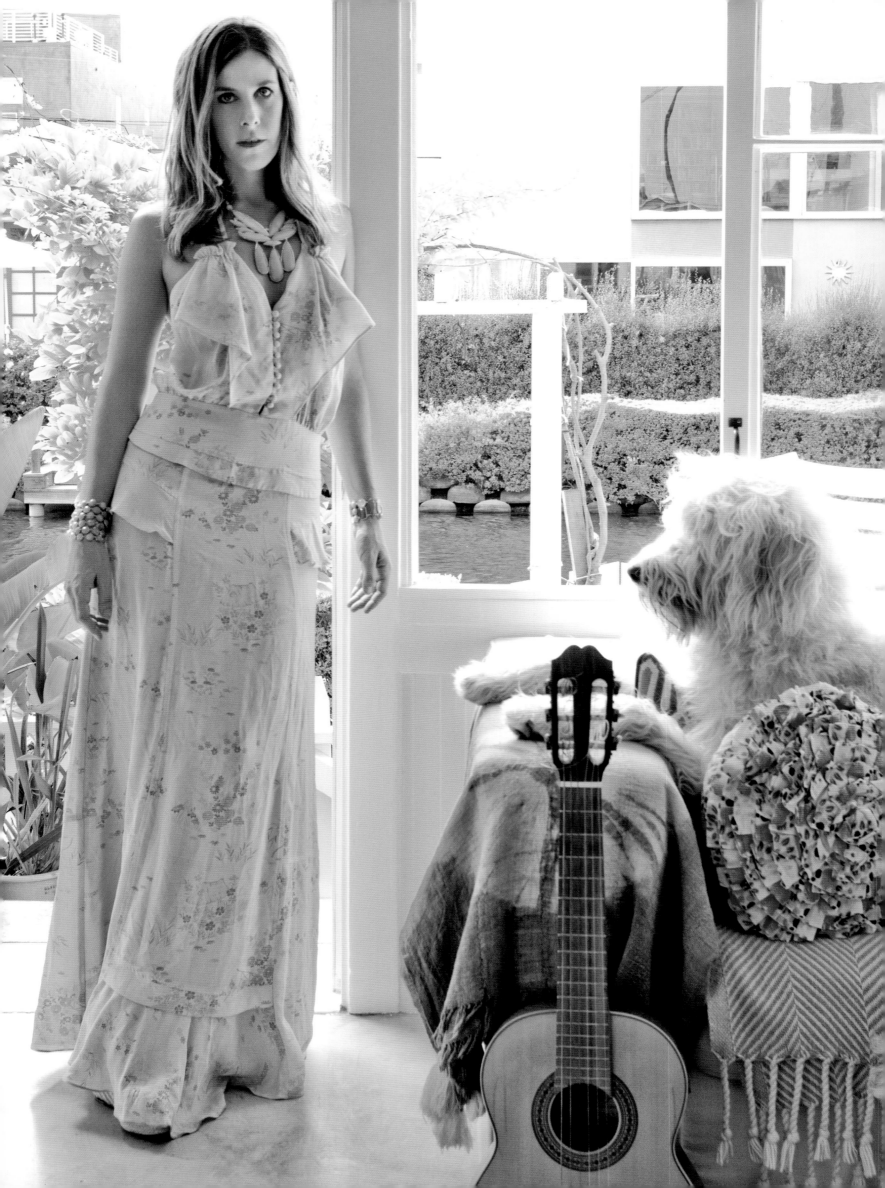

> 66 *Chasing beauty is a synonym for desperation.*
> *I always loved the process of transformation.* 99
>
> *Linda Wells*

Irene Neuwirth

b. Los Angeles, California From the time she started designing jewelry in her early twenties, Irene Neuwirth was flooded with requests from friends, family, and clients to create her own line. In 2000, she brought a small collection to Barneys New York, where the buyer placed a significant order. Neuwirth founded her eponymous company in 2003, and it has since become known for its modern, raw gem cuts and intense color combinations, using stones like chrysoprase, Rose de France, Peruvian opal, and carnelian. Her principal inspiration is the ocean: Its purity and pigments are integral elements in her work.

> *In ancient Greece, beauty was a gift from the gods. One knew that you had to admire it for its ephemeral qualities.* 99
> Carolina Herrera

Abigail Chapin

b. Brooklyn, New York With a sound inspired by Bob Marley and Bob Dylan, and an aesthetic equal parts Georgia O'Keeffe and Frida Kahlo, Abigail joins sister Lily in crafting haunting harmonies that combine elements of pop, blues, country, and psychedelic rock. In 2008, Abigail and Lily launched their debut album, *Lake Bottom LP,* to critical acclaim—and no wonder, given a musical lineage that includes Grammy Award–winning father Tom Chapin, and uncles Steve Chapin and late singer-songwriter Harry Chapin.

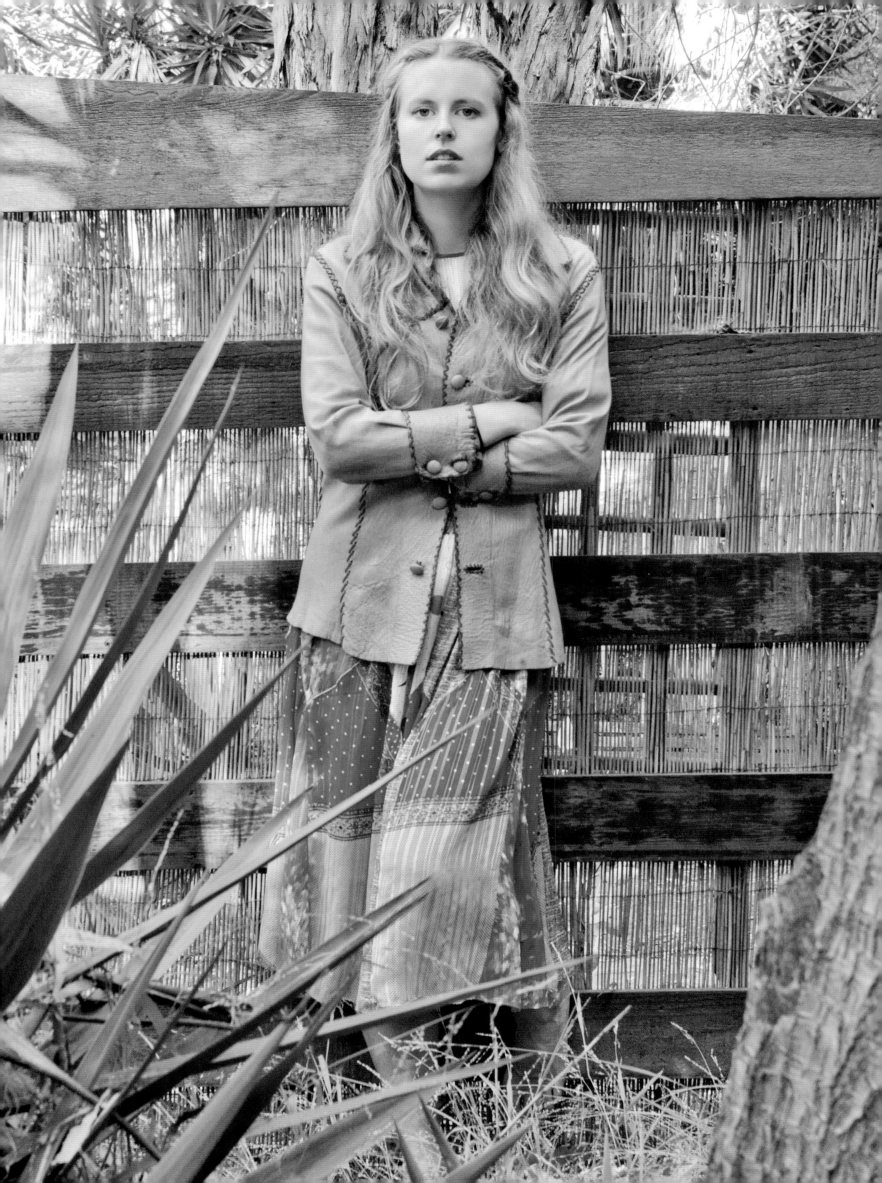

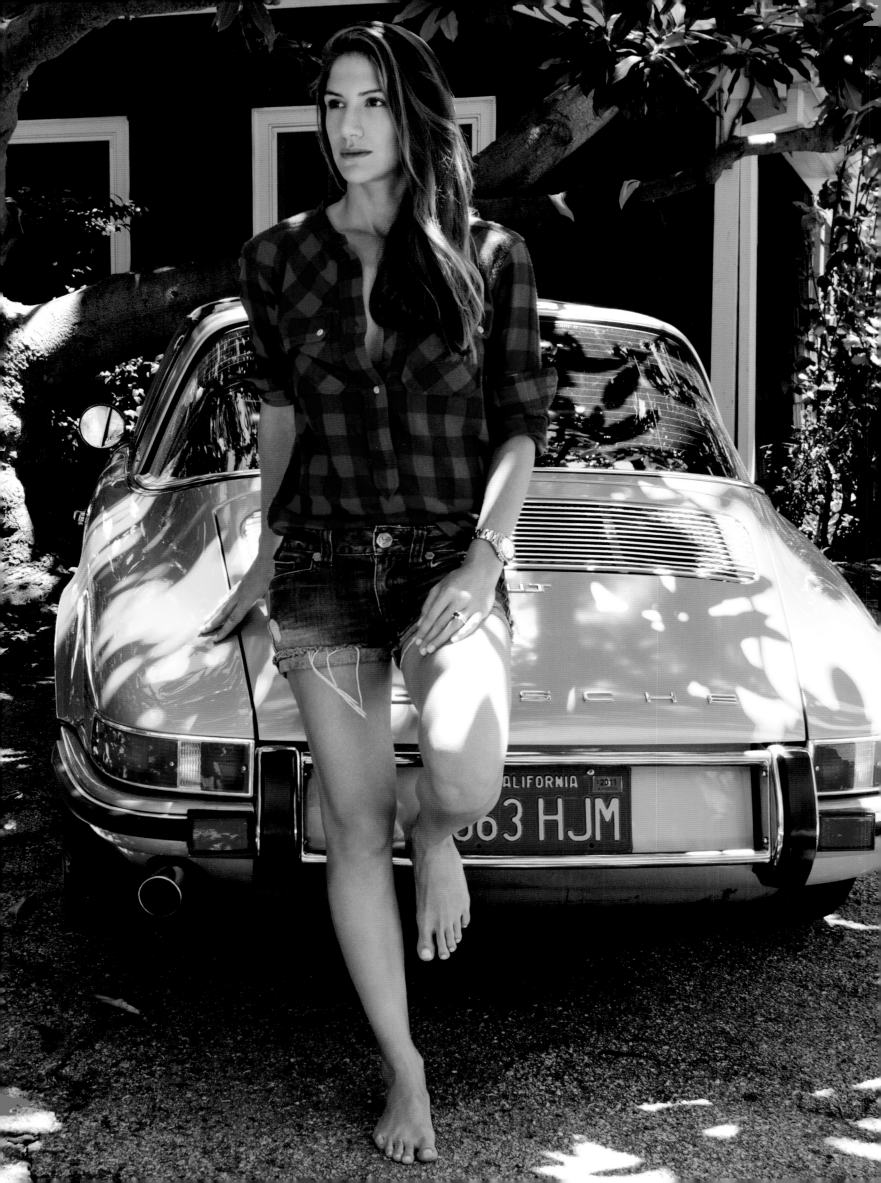

"I been all around this great big world
And I seen all kinds of girls
Yeah, but I couldn't wait to get back in the states
Back to the cutest girls in the world."
The Beach Boys

Minnie Mortimer

b. New York, New York Great-great-great-great-granddaughter of John Jay, the first Chief Justice of the United States, and granddaughter of Stanley Mortimer, founder of Standard Oil, Marian Fountain "Minnie" Mortimer is a designer known for her signature blend of Americana. Fusing East Coast prep with laid-back L.A. surf style, her self-titled line features versatile, wearable American staples like striped T-shirts and day dresses. She is seen here in front of her Malibu home, where she lives (and surfs) with her husband, Oscar-winning filmmaker Stephen Gaghan.

> **_"A girl should be two things: classy and fabulous."_**
>
> *Coco Chanel*

Marissa Webb

b. Seoul, Korea Frequently borrowing separates like white shirts and ties from her husband's wardrobe, Marissa Webb has a distinct personal style based around experimentation with proportion, contrast, and texture. Photographed on her fire escape, the former J.Crew head designer has loved fashion since early childhood, when she would sketch and paint designs to show her mother "for approval."

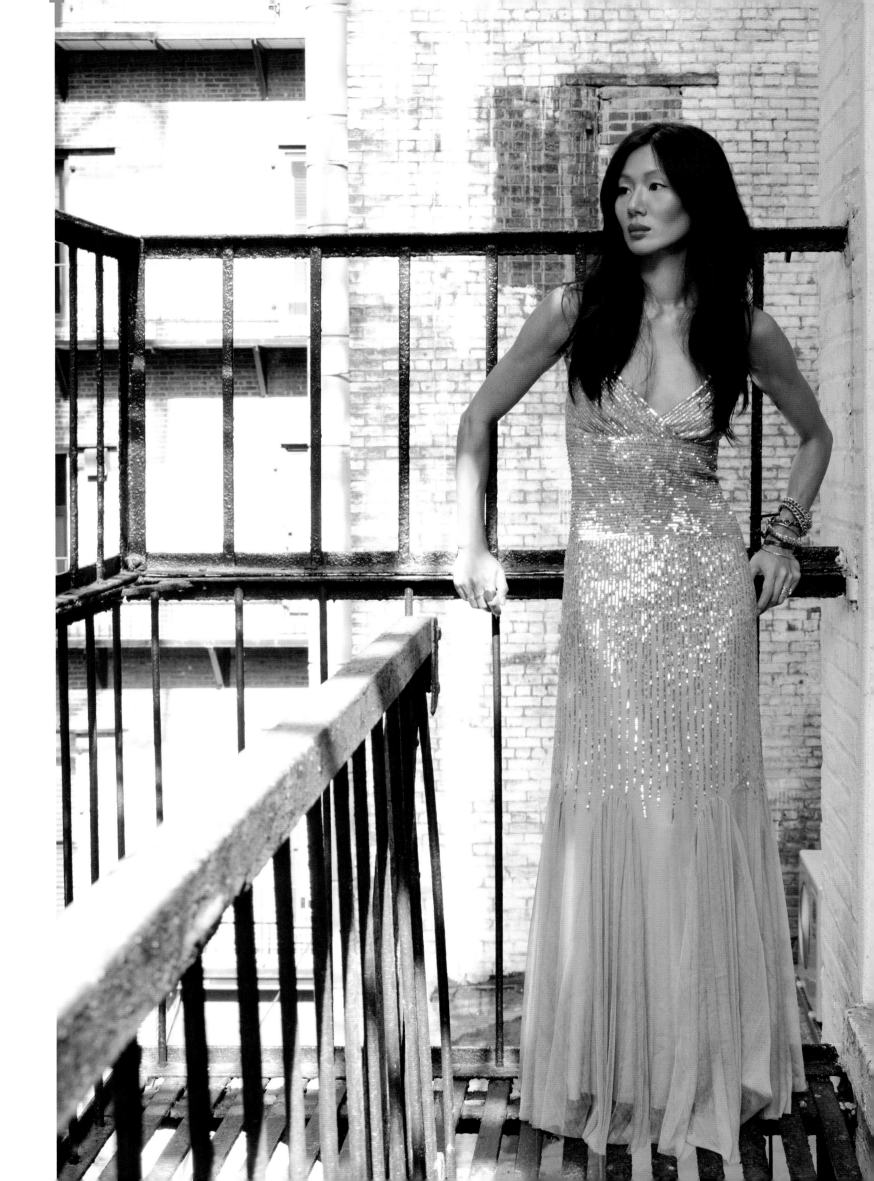

Beauty is eternity gazing at itself in a mirror. But you are eternity and you are the mirror.

Kahlil Gibran

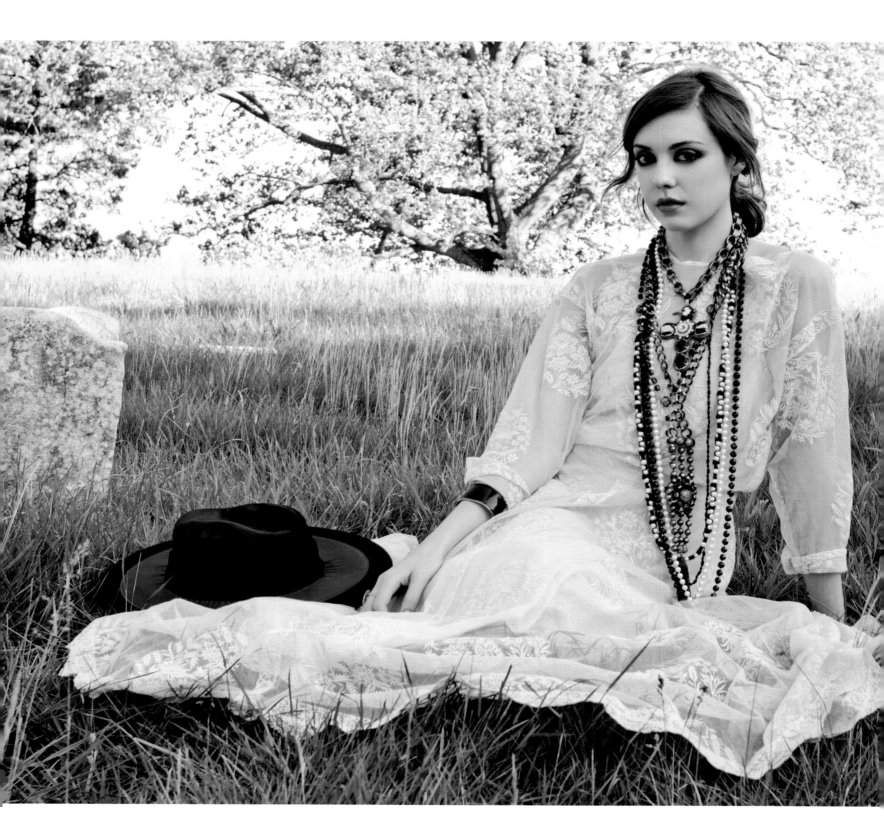

Diane Birch

b. Berrien Springs, Michigan Singer-songwriter Diane Birch is "a tapestry of vastly varied influences and experiences—a baroque soul with a punk heart, and a die-hard dreamer with a relentless spirit." She always knew that she was destined for big things, but it look her a long time to realize her specific path. "I remember once watching a Nina Simone performance and thinking, "That's it... that's who I want to be," says Birch, who would have been a perfumer had she not pursued a career as a musician. She was raised between Oregon, South Africa, and Australia, which helped form her appreciation of America. With the hope of becoming a film composer, Birch left home at age eighteen for L.A., playing the piano in bars before landing a record deal—the result of a talent scout listening to one of the tracks on her MySpace page. Photographed in a cemetery in Brooklyn with her trademark hat on the ground next to her, Birch emanates gothic beauty and a style that she describes as "Coco Chanel and Patti Smith having a threesome with a Parisian gypsy."

> *"The American woman of my generation who had the foresight to take care of herself is in an enviable position."*
>
> *Lauren Hutton*

Vanessa Getty

b. San Francisco, California As the founder of the San Francisco Bay Humane Friends animal shelter, Vanessa Getty has always felt it was her calling to care for those who don't have a voice. "Whether it is by helping animals through my charity or guiding my own children, it is important to me that every living, breathing thing has an equal opportunity in life." For Getty, when it comes to style, that voice is something that comes naturally. "Once you accept who you are, it opens up the world enormously for you."

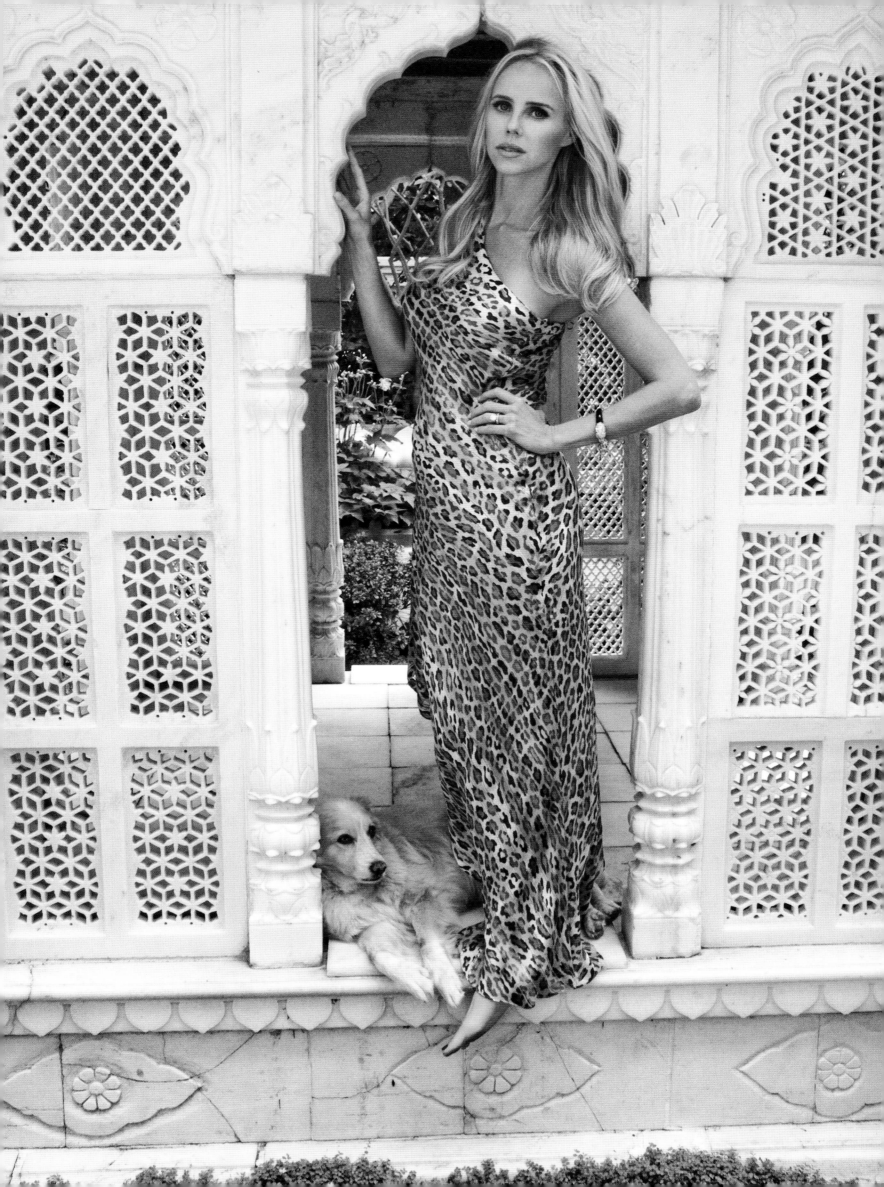

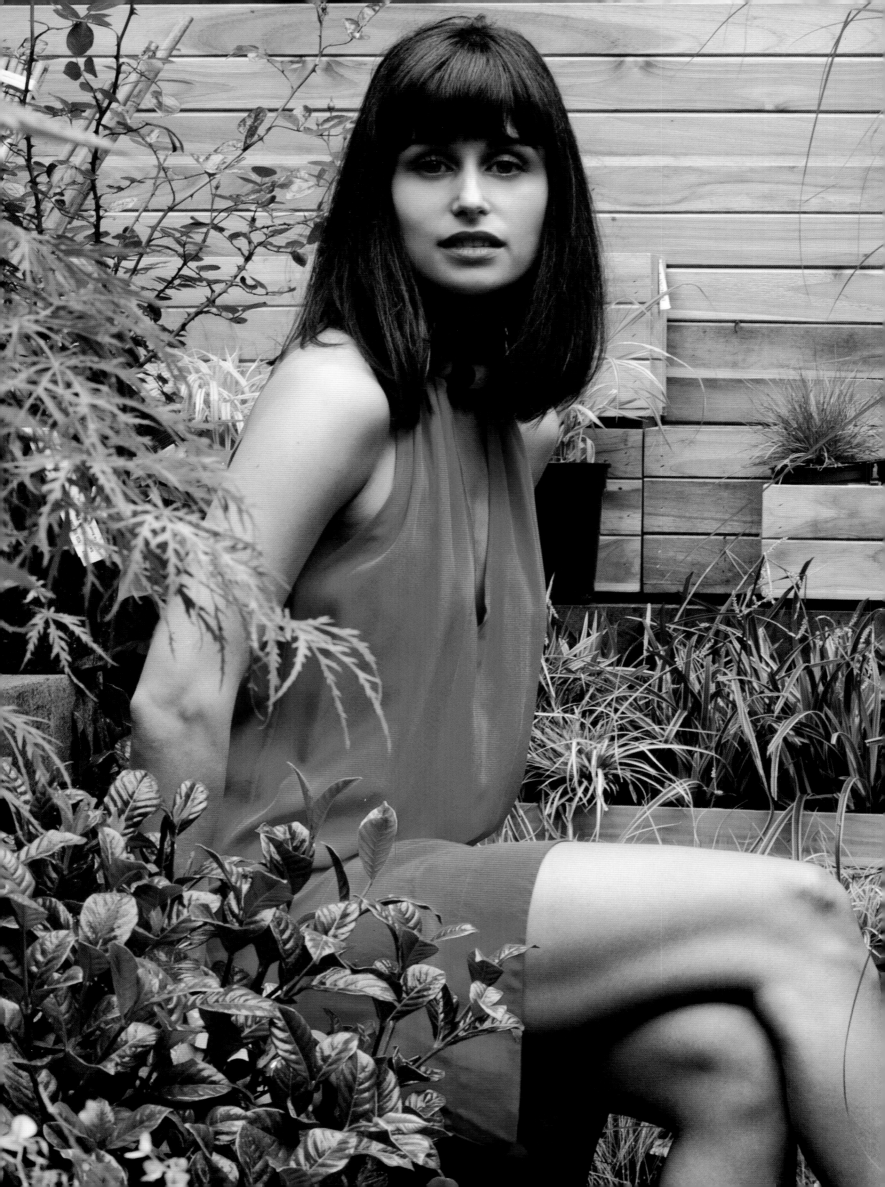

" Beautiful young people are accidents of nature, but beautiful old people are works of art. "

Eleanor Roosevelt

Lisa Mayock

b. Pasadena, California It was watching her best friend's mother come home from work—wearing a perfect black bob with bangs, matching silk suits, and big stones that could pass for beyond-beautiful eye candy—that Lisa Mayock, at age five, knew she wanted to design. Three weeks after graduating from Parsons in 2003, Mayock and her partner, Sophie Buhai, decided to launch Vena Cava—a now phenomenally successful women's clothing line—and set about designing their first collection of twelve hand-sewn looks on their living room floor. With a personal aesthetic of "more is more," she explains, "[Some] aspects of my childhood were really free-form, and other aspects very meticulous and detail-oriented. I learned that a hard-work ethic is equally as important as having a good time."

153

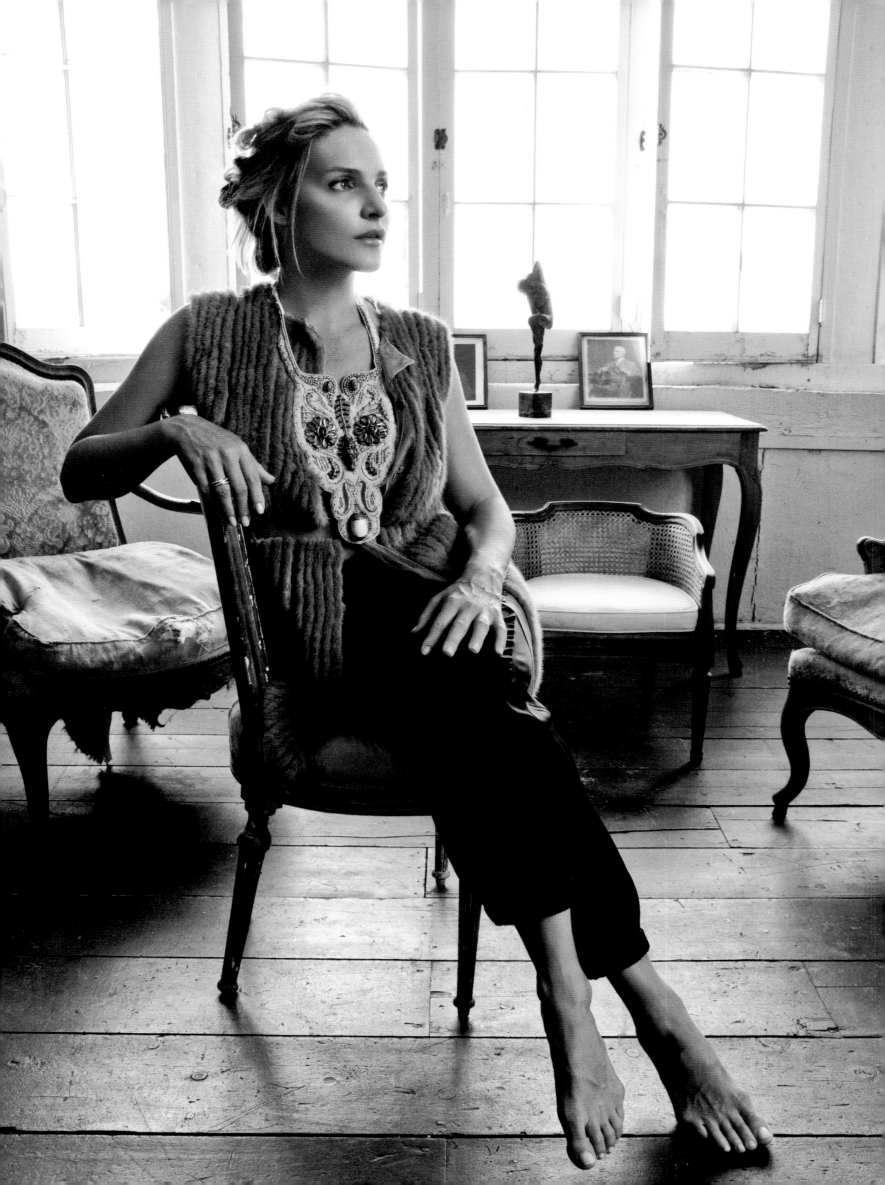

> *At some point in life the world's beauty becomes enough. You don't need to photograph, paint, or even remember it. It is enough.*
>
> Toni Morrison

Emma J. P. Goergen

b. Melbourne, Australia Interior designer Emma Jane Pilkington Goergen is celebrated for her sophisticated, original aesthetic, which fuses the workmanship of old-world traditionalism with the restraint of modern design. "As a girl who spent her early childhood in Australia, I brought the English discipline and manners, and the Australian love of the outdoors, cold food, and wanderlust with me to America," she explains. "I added the open-minded and questioning spirit of my American schooling, and became the woman that I am today." Goergen's preternaturally discerning design sense started at a young age, when she chose hand-blocked floral wallpaper, an antique pale pink silk spread, and a mahogany cheval mirror to decorate her room. Pilkington's approach has, of course, matured significantly—and she has brought her elevated polish to the homes of clients like Ivanka Trump, Sasha Lazard, and Cristina Cuomo.

Cristina Cuomo

b. New York, New York Cristina Greeven Cuomo traces the beginnings of her media career to falling in love at age sixteen with Edith Wharton's *Summer.* "I thought if I could read for a living, well, then that wouldn't feel like work at all. When I got to eleventh grade, I read Tennessee Williams's play *Summer and Smoke.* In that moment, I knew I wanted to be a writer too." Currently the content chief and a host for Plum Networks, she counts Emily Dickinson, Sacajawea, Susan B. Anthony, and Dante's Beatrice as sources of inspiration, and notes that "poetry, a communion with nature, and my imagination are what define my happiness, and hence, my womanhood." Married to ABC's Chris Cuomo, she is half of one of New York's most visible media couples.

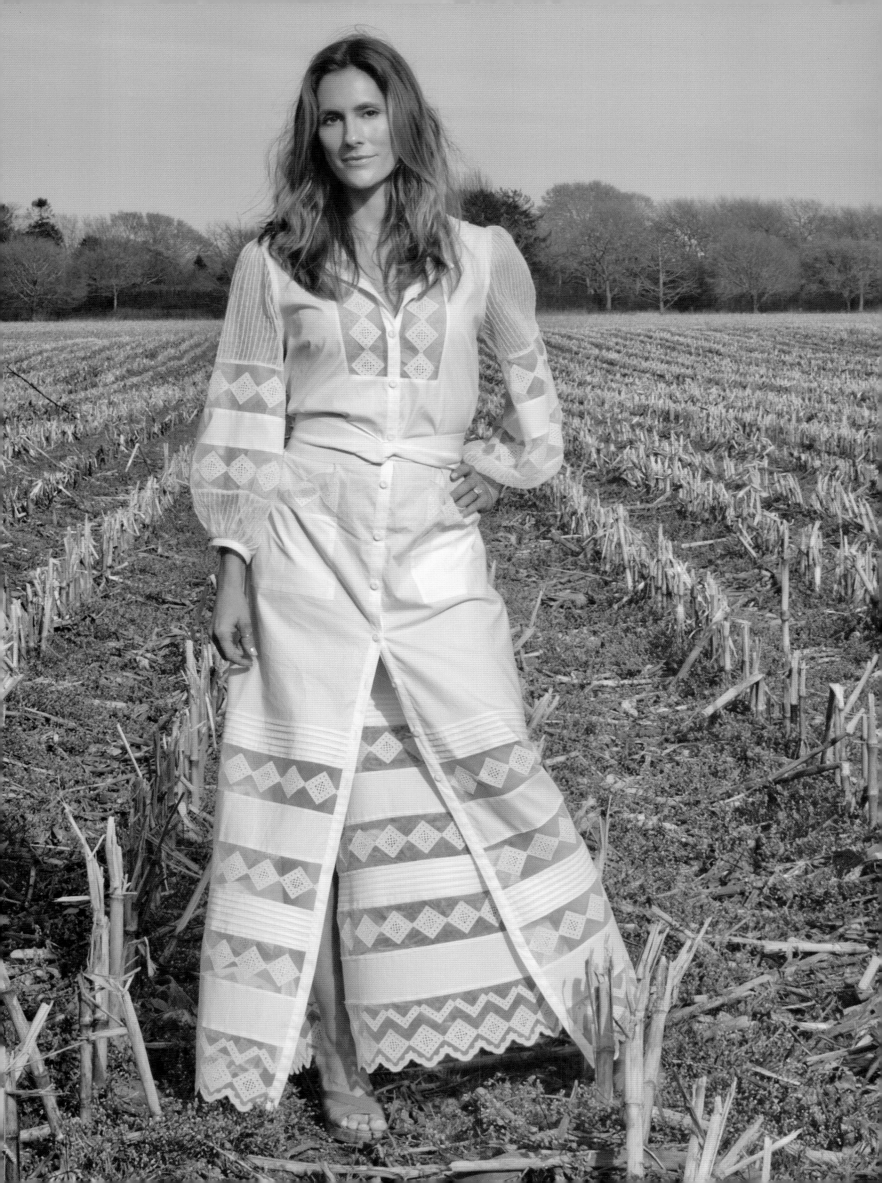

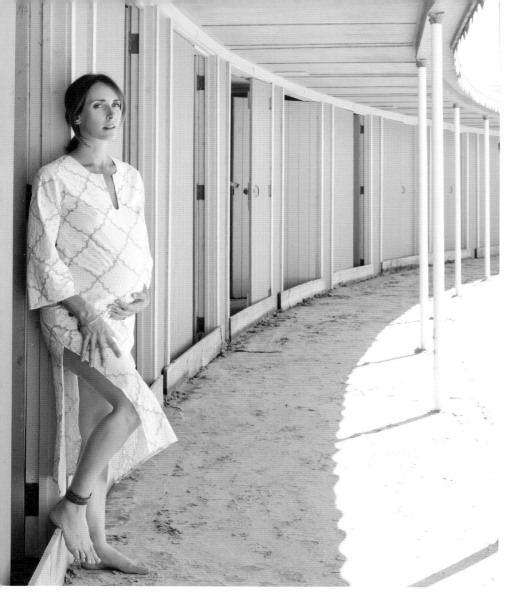

66 *Beauty is a form of Genius—
is higher, indeed, than Genius,
as it needs no explanation.* 99
Oscar Wilde

Ruthie Sommers

66 *When someone
expresses an emotion,
I'm immediately aware
of their beauty.* 99
Isabella Rossellini

Gillian Schwartz

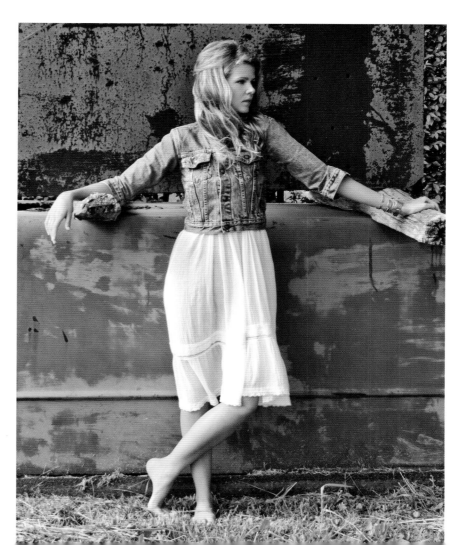

Carolyn Burgess

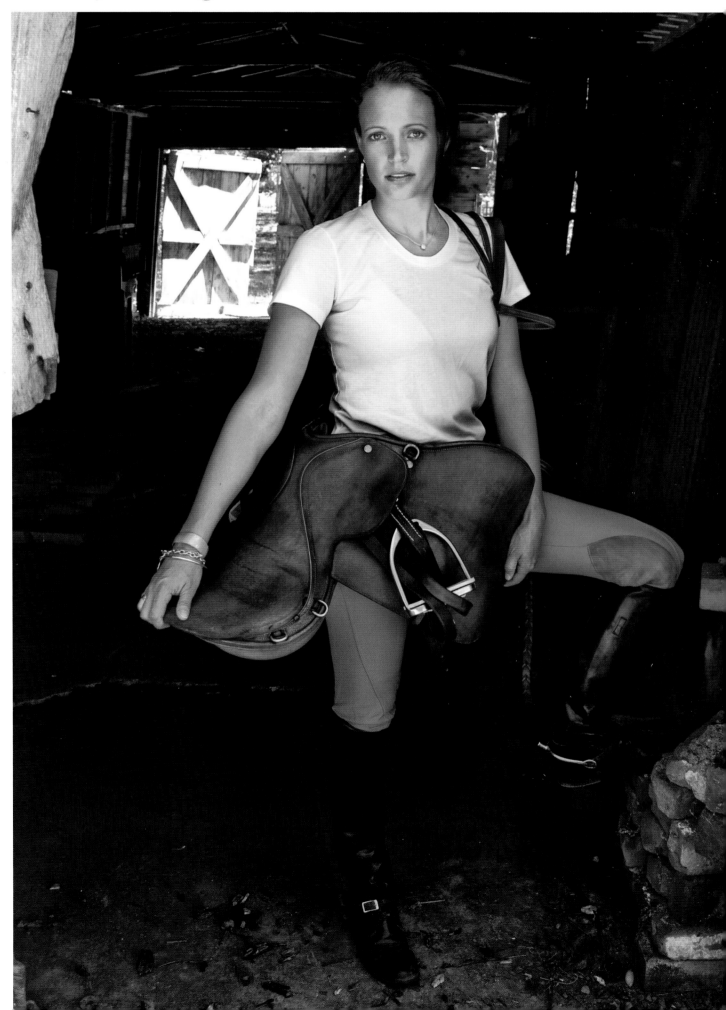

> *Every culture has their own nuances in their criteria for defining the notion of beauty, but a beautiful face is always beautiful throughout the world. The human spirit has a natural penchant for symmetry, proportion, equilibrium, tone, shadow, and form.*
>
> Helen Fisher

Monique Péan

b. Livingston, New Jersey Since she started creating jewelry as a young girl, Monique Péan has emerged as a widely acclaimed figure in the industry. An environmentally conscious designer and CFDA/*Vogue* Fashion Fund winner, Péan, who designs under her own name, promotes awareness of indigenous art and culture with her exquisite pieces. In addition to her creative outlets, she also runs the Vanessa Péan Foundation—in honor of her deceased sister—that aids disadvantaged communities in Haiti.

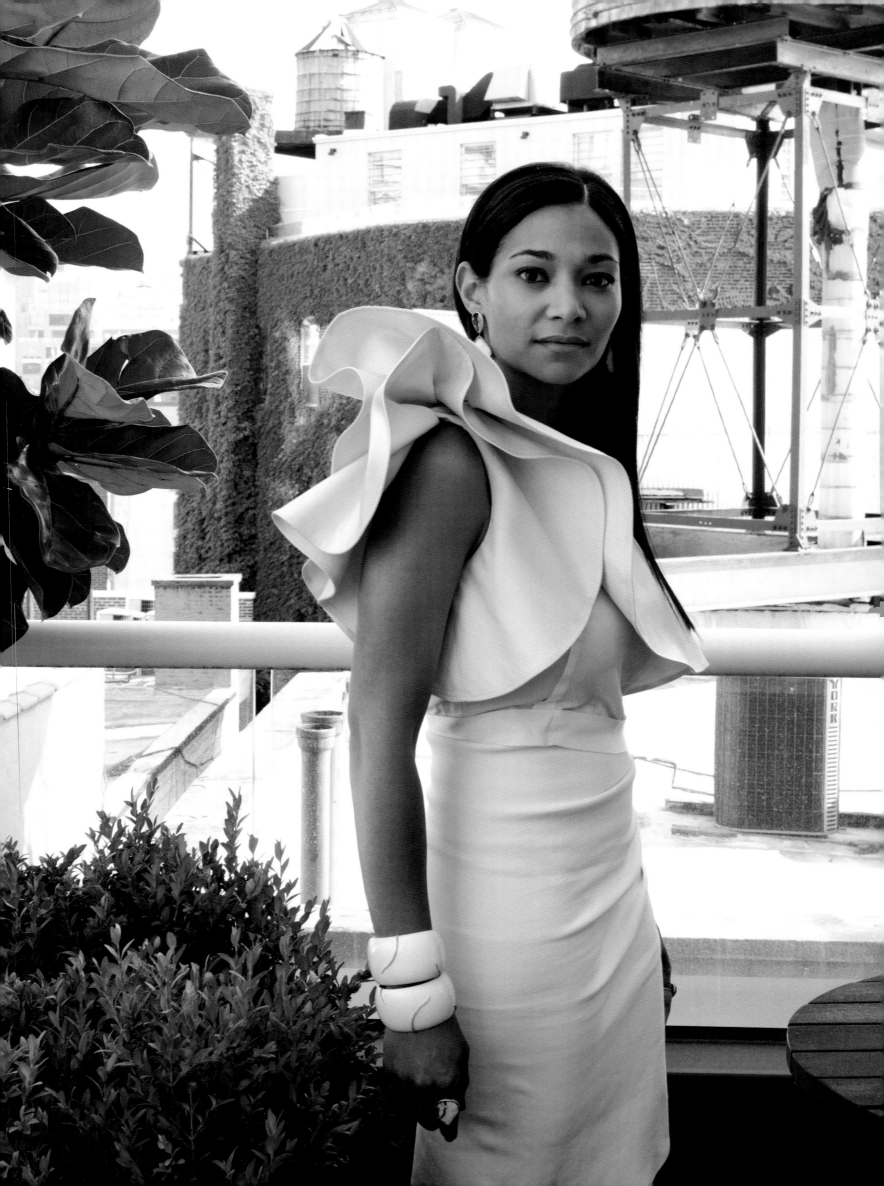

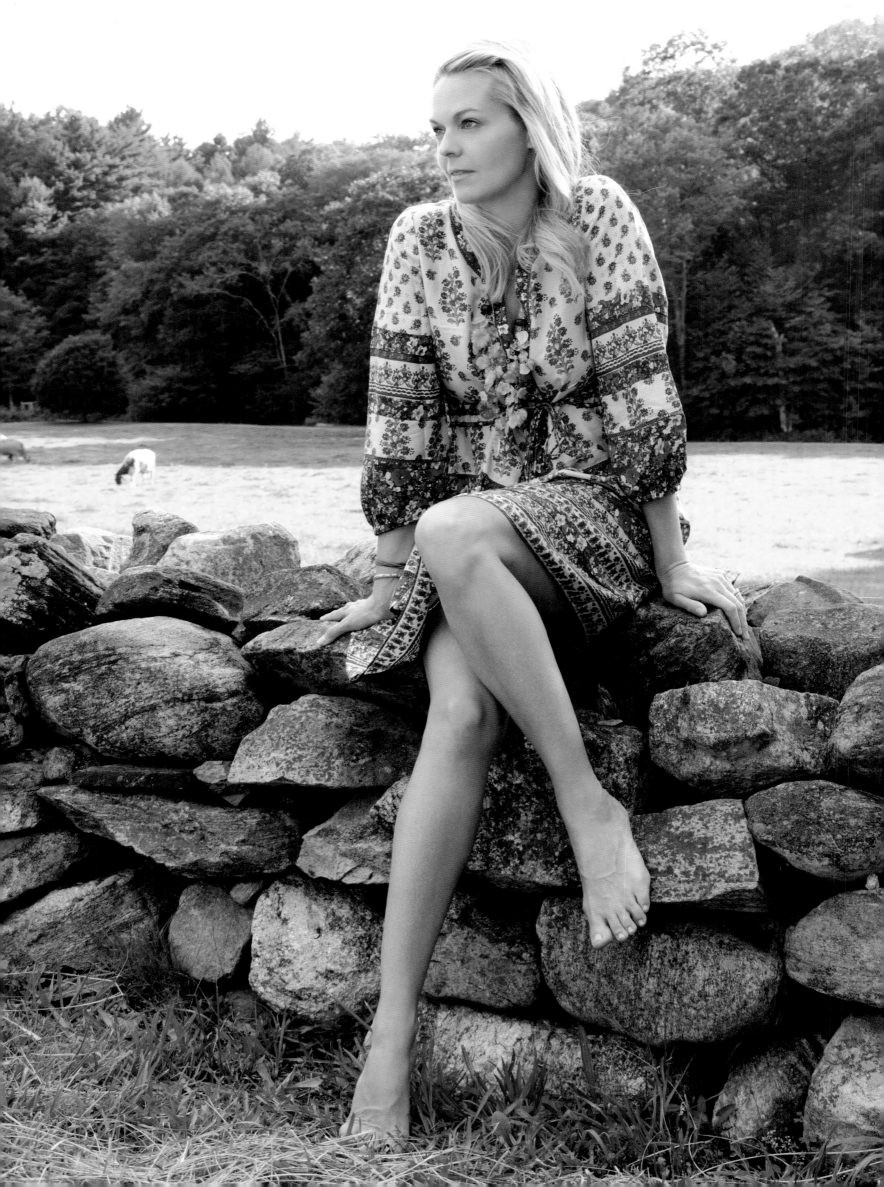

> 66 *Beauty is a kind of radiance. People who possess a true inner beauty, their eyes are a little brighter, their skin a little more dewy. They vibrate at a different frequency.* 99
> *Cameron Diaz*

Lauren duPont

b. New York, New York "Spending time in Louisville really grounded me. The land and the light were incredibly beautiful," says Lauren duPont, seen here on a farm, a location that nods to her love of bucolic settings. Currently a creative director at Jack Rogers, she has worked at *Vogue,* Style.com, and Polo Ralph Lauren, and recently completed a children's book about a designing elephant. She lives in New York City with her husband, artist Richard duPont, and their three children.

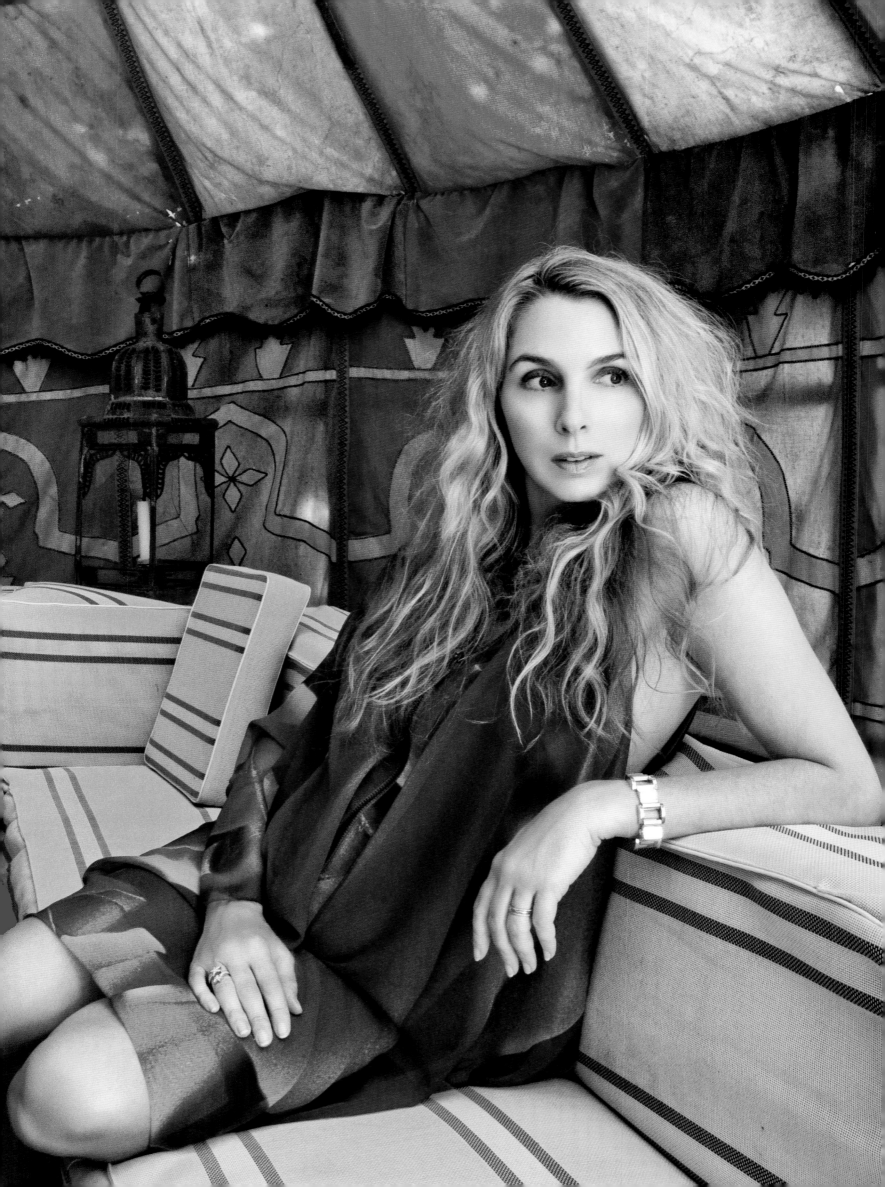

> *"Beauty pleases the eyes and gentleness charms the soul."*
>
> *Voltaire*

Beth Blake

b. Grosse Pointe Farms, Michigan After discovering that she had nothing to wear to her sister's wedding—and searching in vain for stylish bridesmaid dresses—designer Beth Blake decided to take matters into her own hands and design the dress herself. Following the enthusiastic encouragement of her friends, Blake, co-owner of Thread Social, launched Thread Bridesmaid in 1999. Prior to that, she worked for American *Vogue* and Chanel. She currently lives in Tribeca with husband Corbin, son George, and baby girl Blake.

> **And there is a beautiful thing which is wonderful, to look like a woman, not a green bean.**
> *Laetitia Casta*

Nicole Simone

b. Los Angeles, California With her sultry voice and bluesy melodies—and the support of big-name bands like Arcade Fire and Beirut—Nicole Simone is a rapidly rising talent in the indie music world. Inspired by an old family home in the desert, the singer, whose next album is due in 2012, was photographed in a cactus garden in her native Los Angeles. "I grew to love the dusty roads, cactus, abandoned motels, and dry heat. The desert is so lulling and mysterious, and I wanted to evoke that romance."

166

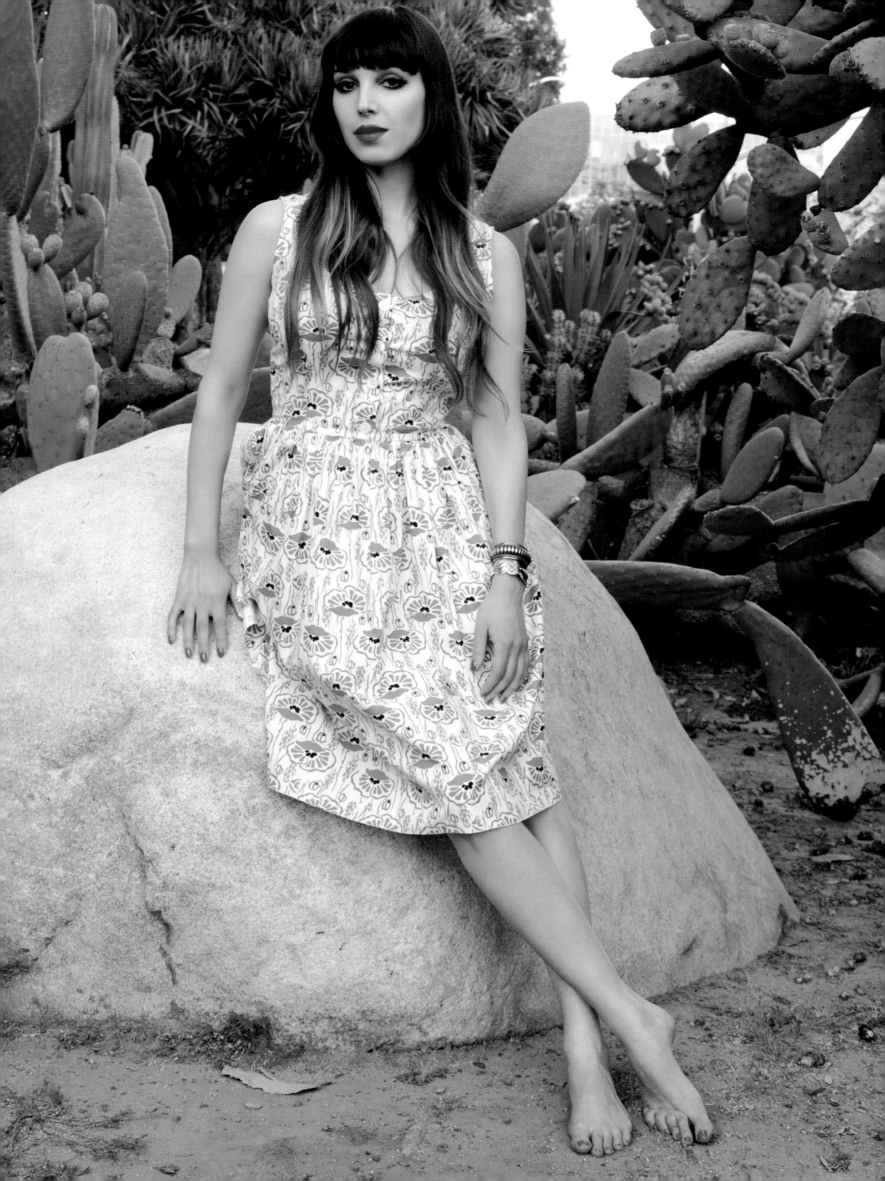

> *American women possess a natural, effortless beauty, which makes them both feminine and powerful—modern yet timeless.*
>
> Francisco Costa

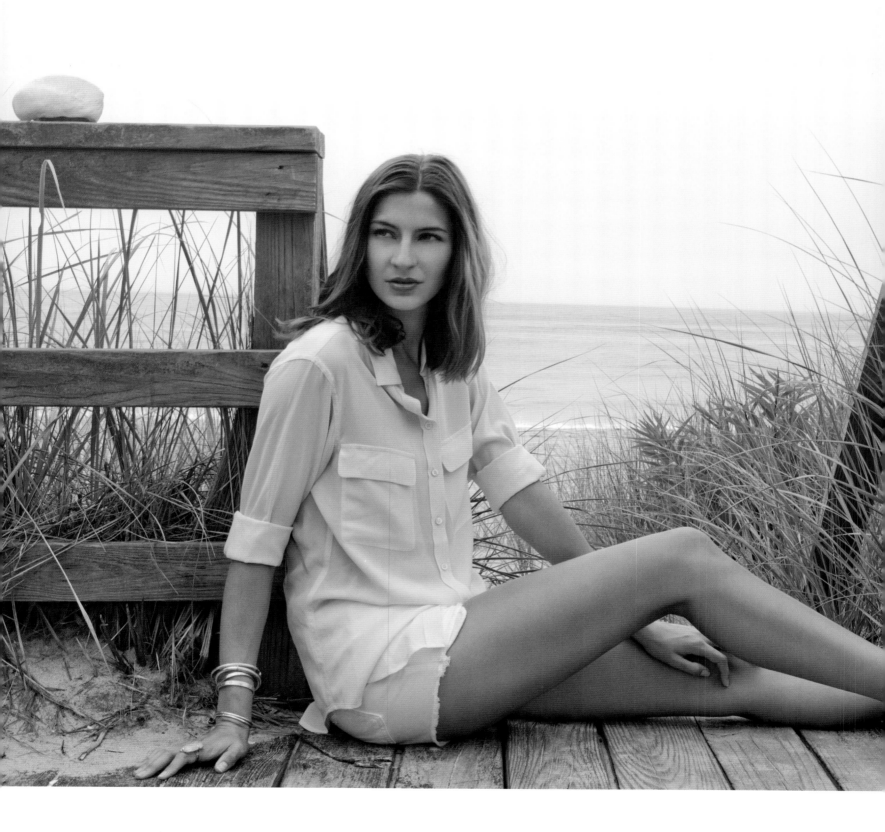

Sylvana Soto Ward Durrett

b. Los Angeles, California Sylvana Soto Ward Durrett is the director of special events at *Vogue,* responsible for organizing all of the magazine's events, from the CFDA/*Vogue* Fashion Fund awards to the annual Costume Institute Benefit at the Metropolitan Museum of Art. Raised in California, Durrett radiates her vision of American beauty, which is "simple, clean lines, and more than the clothes, the confidence in the person wearing them."

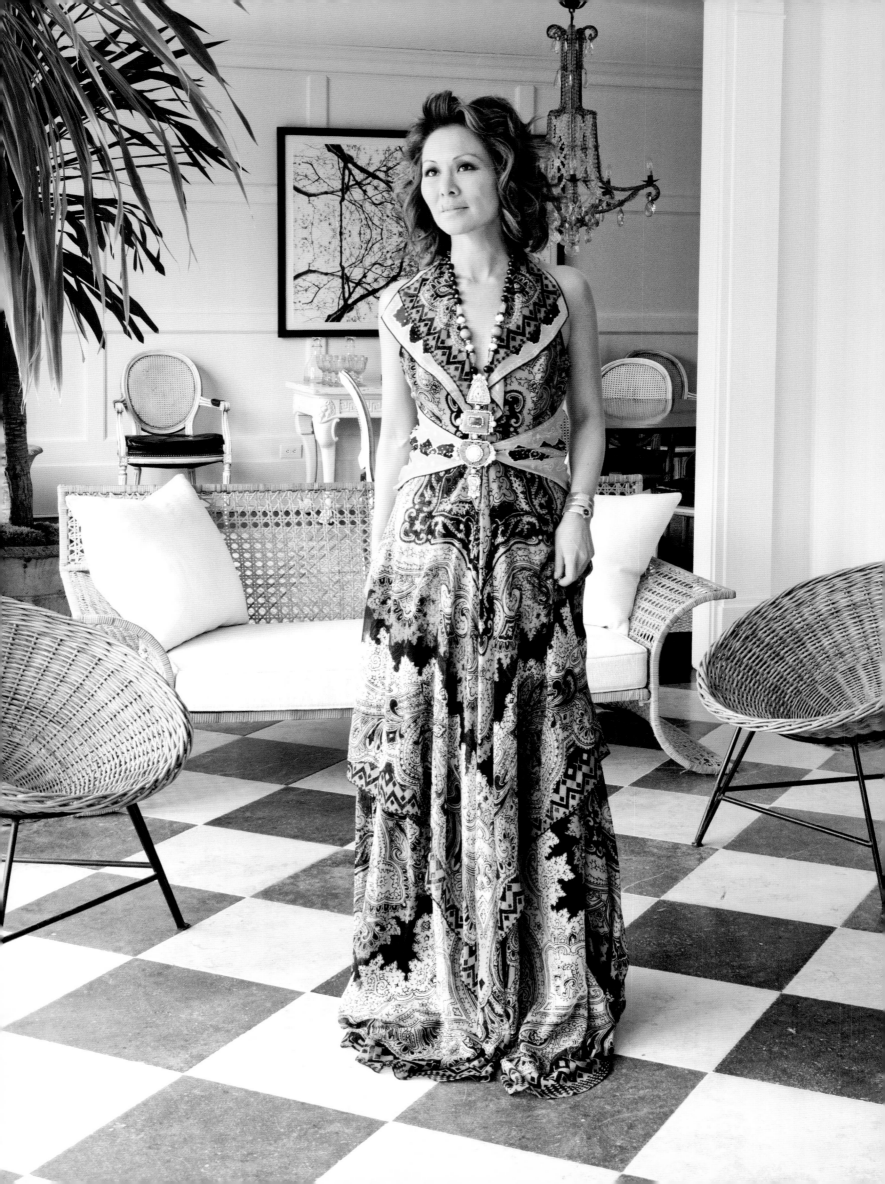

*The only real elegance is in the mind;
if you've got that, the rest really comes from it.*

Diana Vreeland

Alina Cho

b. Vancouver, Washington "As an Asian-American woman, my notion of American beauty has evolved," notes Alina Cho. "As a child, I longed to be blond with blue eyes. Today, I feel American beauty defies definition. America is truly a melting pot, and the beautiful faces you see reflect that." One of television's most widely watched news anchors, the CNN star made her mark as a correspondent in the segments *Fashion: Backstage Pass* and *Big Stars, Big Giving,* and by providing insight into the divide between North and South Korea through the eyes of her parents, Korean War survivors. Cho has also covered President Obama's historic inauguration speech and was part of the Emmy and Peabody award–winning team that covered the aftermath of Hurricane Katrina in New Orleans.

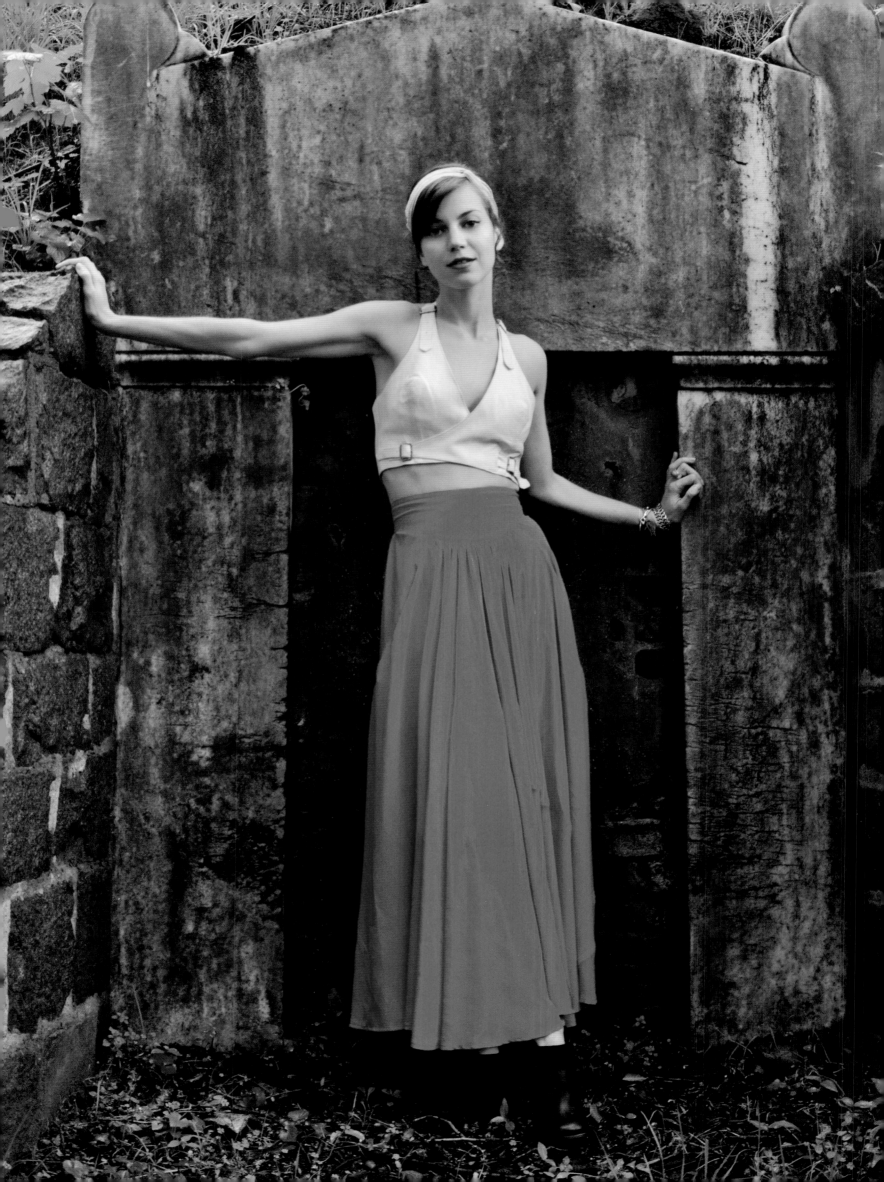

66 It's not vanity to feel you have a right to be beautiful. 99

Elle Macpherson

Sophie Buhai

b. Los Angeles, California Sophie Buhai is one half of the dynamic duo that is clothing label Vena Cava, a brand instantly recognizable for its fresh spin on vintage peppered with hand-drawn prints. She met her design partner, Lisa Mayock, when they were both seventeen and heading off to Parsons. Photographed in a graveyard in Brooklyn, Buhai admits to constantly feeling both eighty-four and fourteen years old, her style a mix of minimalism, French Gothic, and old Hollywood influences. "I've dressed the same way for ten years. I like simple, classic pieces that are elegant and usually come in dark colors, things that can be worn time after time. I love modern jewelry and subtle details, and I wear a lot of hand-me-downs from my mother and my grandmother." Buhai credits her understanding of American fashion design to studying the works of Claire McCardell and Liz Claiborne, who she believes paved the way for women in America.

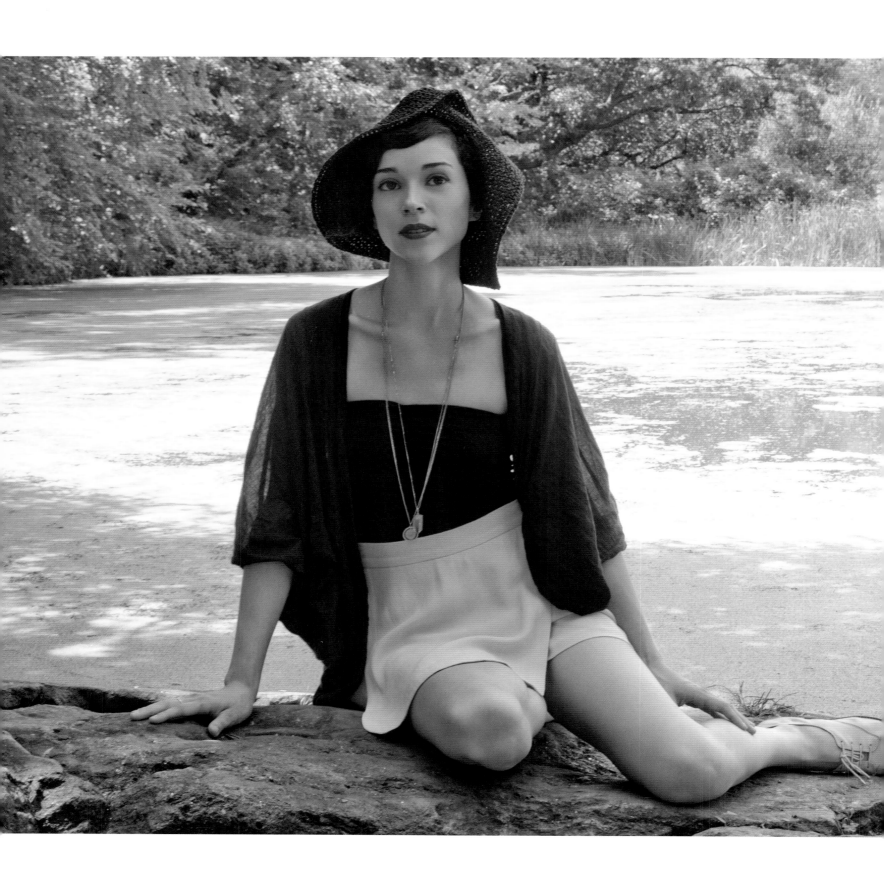

> *The beauty of a woman is not in a facial mode, but the true beauty in a woman is reflected in her soul. It is the caring that she lovingly gives, the passion that she shows. The beauty of a woman grows with the passing years.*
>
> Audrey Hepburn

Annie Clark

b. Tulsa, Oklahoma Singer Annie Clark began playing the guitar at the age of twelve, and, as a teenager, worked as the tour manager for her uncle's band, Tuck & Patti. In 2007, Clark made her recorded debut as St. Vincent with *Marry Me,* giving immediate notice that a fresh new talent had emerged from the flatlands of Texas. Following her 2009 effort *Actor,* Clark's latest album, *Strange Mercy,* examines the complexities of personal catharsis with her signature mix of chamber rock, pop, indie rock, cabaret jazz, and show tunes.

> " Youth never moves me. I seldom see anything very beautiful in a young face. I do, though—in the downward curve of Maugham's lips, in Isak Dinesen's hands. So much has been written there, there is so much to be read, if one could only read. "
>
> *Richard Avedon*

Casey Fremont Crowe

b. New York, New York "I grew up surrounded by artists, looking at art, and often understanding myself and situations that I was confronted with through art," states Crowe, here photographed in New York's Washington Mews, a site where she spent many an adolescent evening. Now herself a formidable force in the art world, as the director of New York's Art Production Fund, Crowe experienced an early inclination toward the arts from parents Shelly and Vincent Fremont, who ran Andy Warhol's foundation and co-produced and directed *Pie in the Sky: The Brigid Berlin Story,* a documentary about the late Warhol superstar.

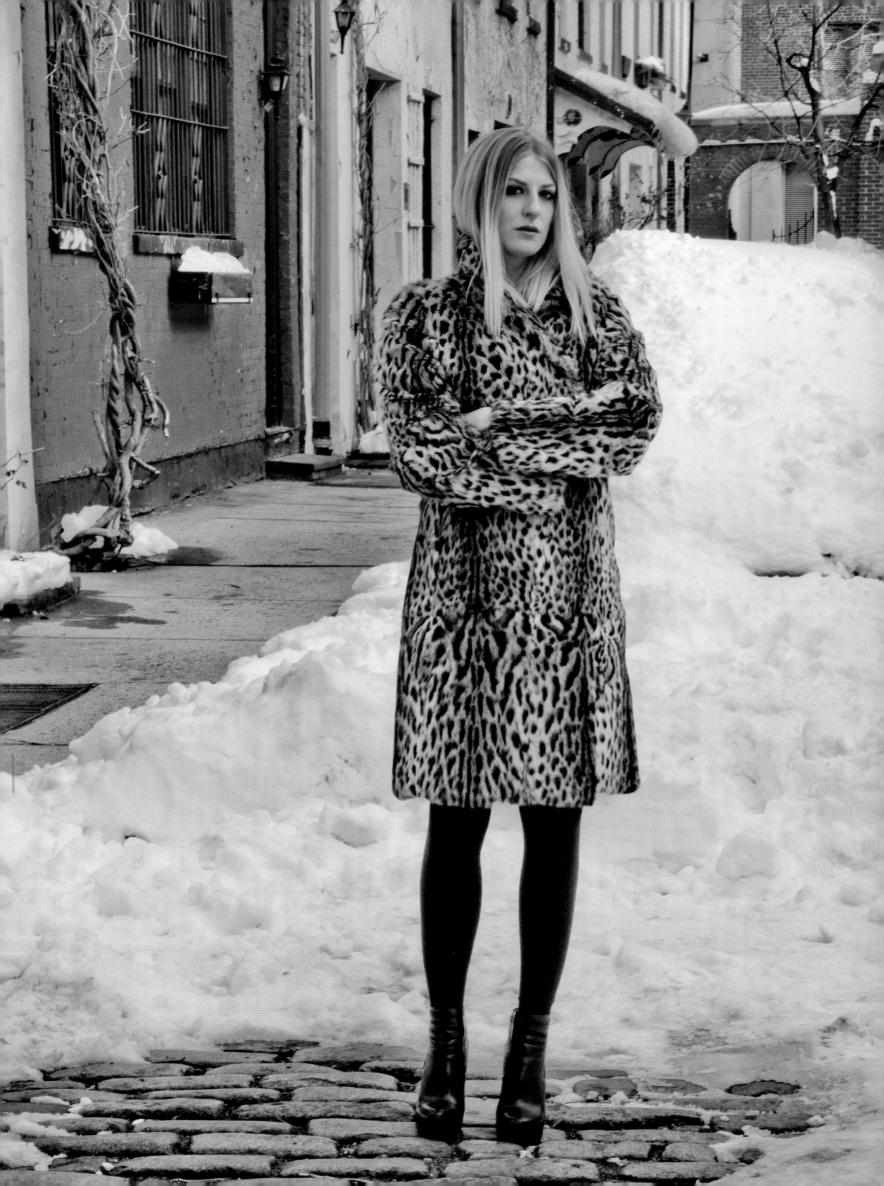

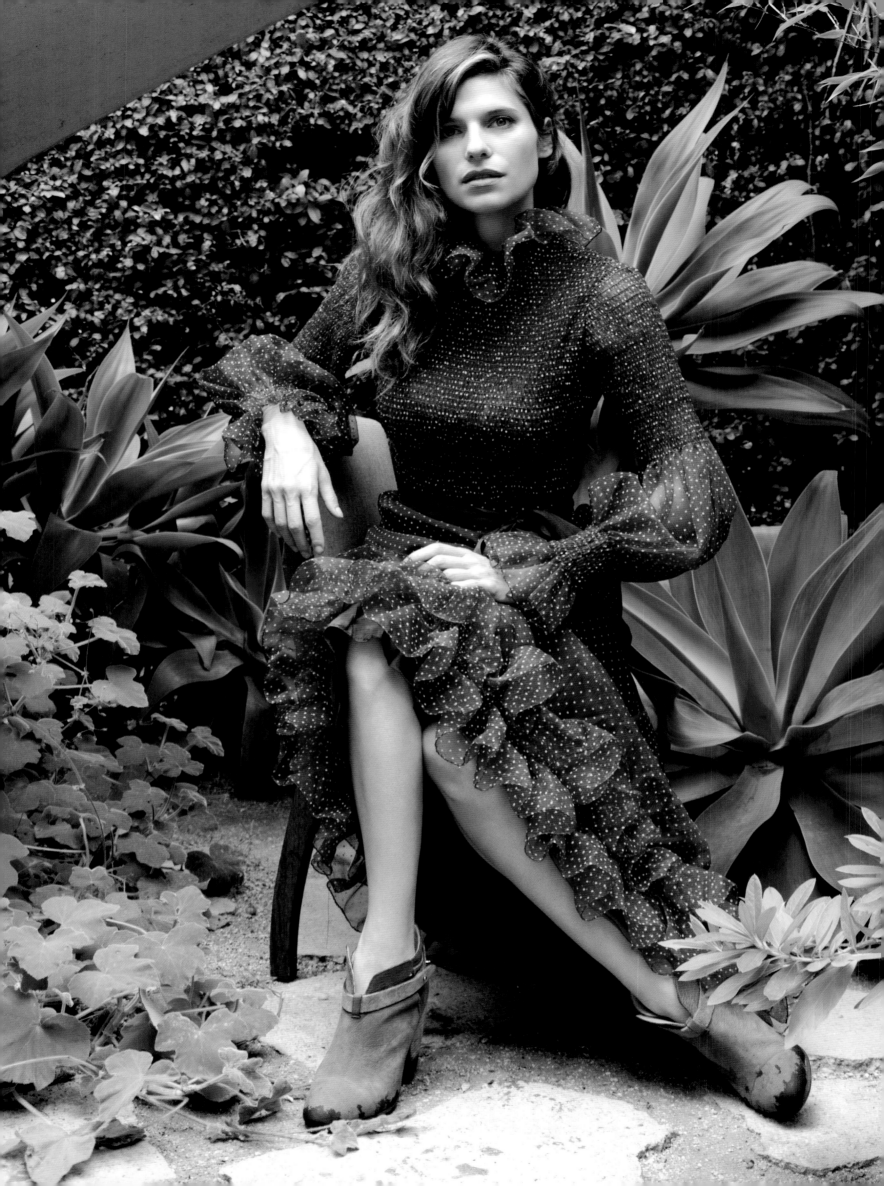

> **66** *Beauty without grace is the hook without the bait.* **99**
>
> Ralph Waldo Emerson

Lake Bell

b. New York, New York Actress Lake Bell, photographed here in her mother's vintage Adolfo dress, is best known for her roles in films *What Happens in Vegas, Shrek Forever After, It's Complicated, Little Murder,* and *No Strings Attached.* Before breaking onto the silver screen, Bell attended Rose Bruford College of Speech and Drama in London, where she acted in theatrical productions like *The Seagull* and *Pentecost.* Currently Bell is starring in the HBO series *How to Make It in America.*

> *First, the sweetheart of the nation, then her aunt, woman governs America because America is a land of boys who refuse to grow up.*
> *Salvador de Madariaga*

Field Kallop

b. New York, New York "My goal is to examine, harness, and display the effects of gravity," says artist Field Kallop. After spending a year in Lima working at the Museo de la Nación and curating an exhibition of modern Peruvian paintings, Kallop returned to New York to assist artist Chuck Close. Field recently earned her MFA in Painting from the Rhode Island School of Design, where her studio featured a self-built pendulum suspended from the ceiling to inform her spatially focused paintings.

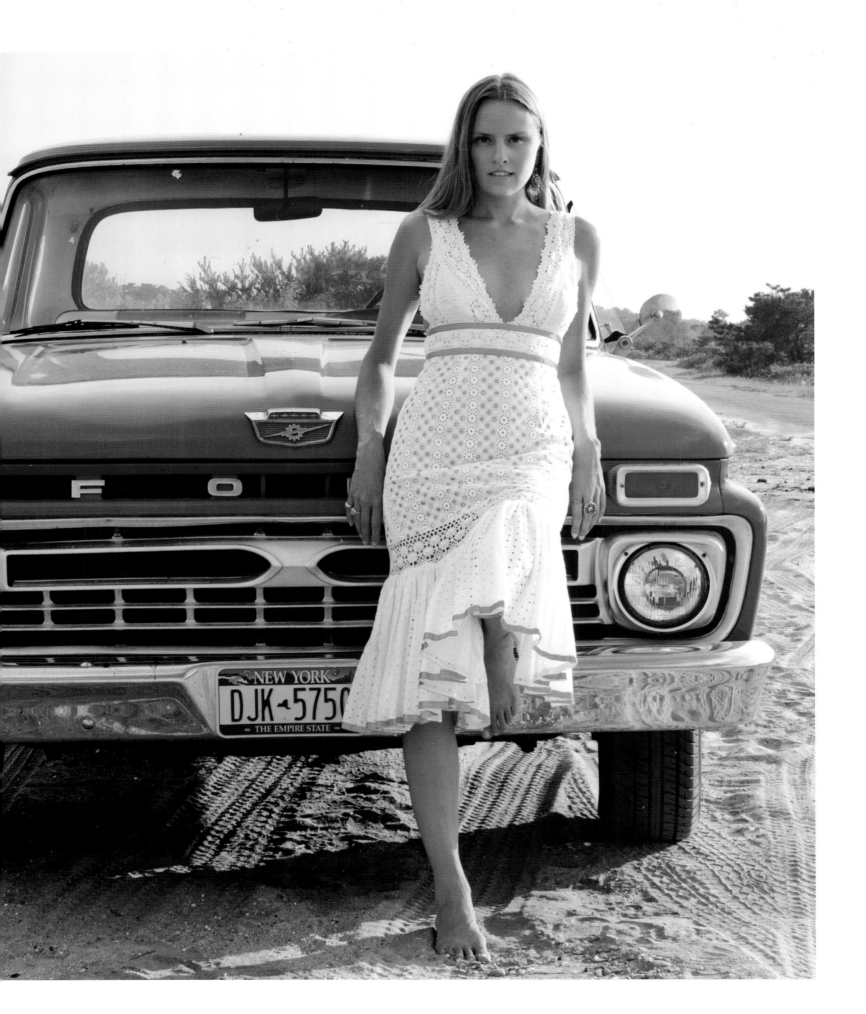

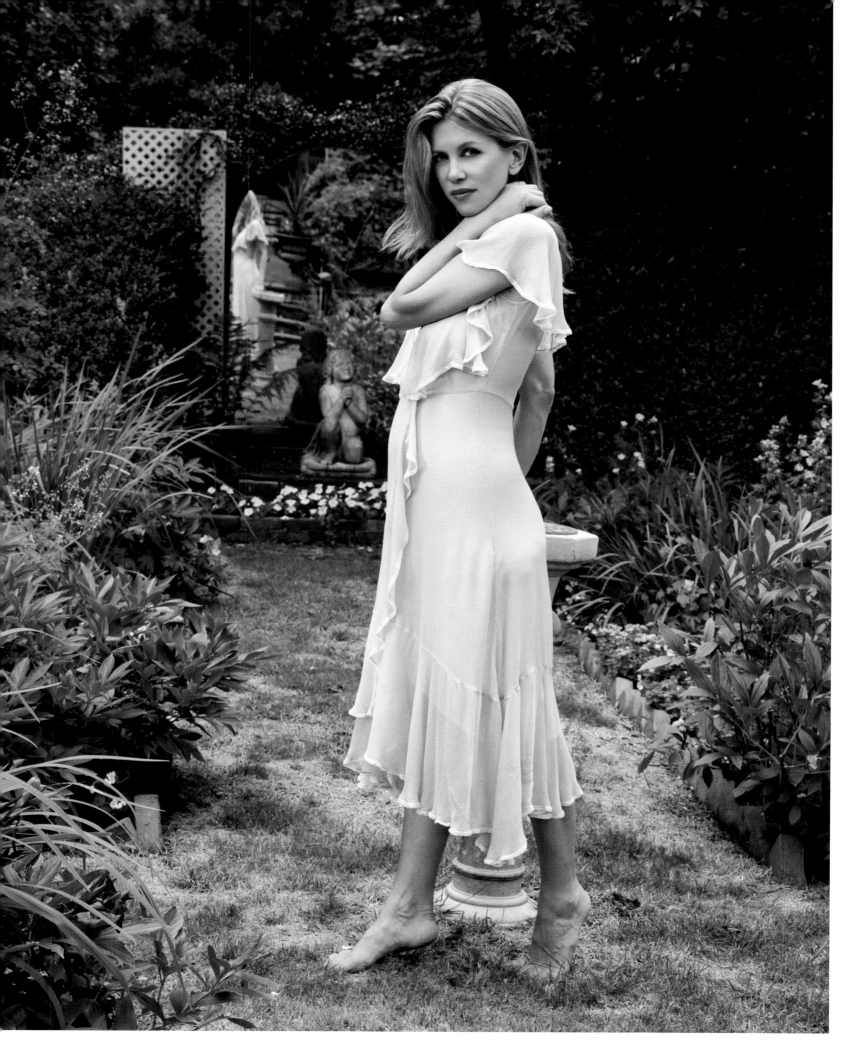

Sasha Lazard

*Beauty seduces
flesh to be granted
the permission to
overtake the soul.*

Simone Weil

Mary Alice Haney

*Do I love you because
you're beautiful,
Or are you beautiful
because I love you?*

Rodgers and Hammerstein's Cinderella

Sarah Hoover

> *Some people are physically beautiful but they're completely uninteresting, and thus they're not beautiful.*
> Tom Ford

Georgina Bloomberg

b. New York, New York "For me, it's about the competition. I love horses, but if I couldn't show, I wouldn't ride," says world-class equestrian grand prix jumper Georgina Bloomberg, who has been captivated by all things equine since girlhood. The younger daughter of Mayor Michael Bloomberg is photographed here on her mother's property in North Salem, New York. After attending New York University's Gallatin School, where she took classes in sports management and studio art, she co-authored a young-adult novel called *The A Circuit* (2011), based on true stories from the competitive show-jumping world. She is highly committed to her work with several organizations, including the Equestrian Aid Foundation, the ASPCA, and the Humane Society. In 2006, Bloomberg started The Rider's Closet, which collects and redistributes riding clothes and equipment to intercollegiate riding teams and those who cannot afford the clothes they need to show. Says Bloomberg: "I think the beauty of being American is that it is growing away from the ideal that is the blond, blue-eyed look. Being American now is growing toward everyone being different and unique."

"*There is no exquisite beauty...*
without some strangeness in the proportion."

Edgar Allan Poe

Erin Martin

b. Seattle, Washington Before launching her raw-yet-refined interior design company, Erin Martin was a mural artist. She relies on the bones and energy of each place—and unexpected materials like found objects, recycled wood, sandblasted steel, leather, and linen—to create her ruggedly authentic interiors, which run the gamut from contemporary green farmhouses to French country kitchens. As the daughter of an architect and an interior designer, Martin grew up surrounded by design, and spent four years early in her career working in orphanages in Morocco, Romania, Israel, and Hungary; she has since incorporated the aesthetics of those places into her design lexicon. Martin is photographed in one of the barns she conceived in Napa Valley.

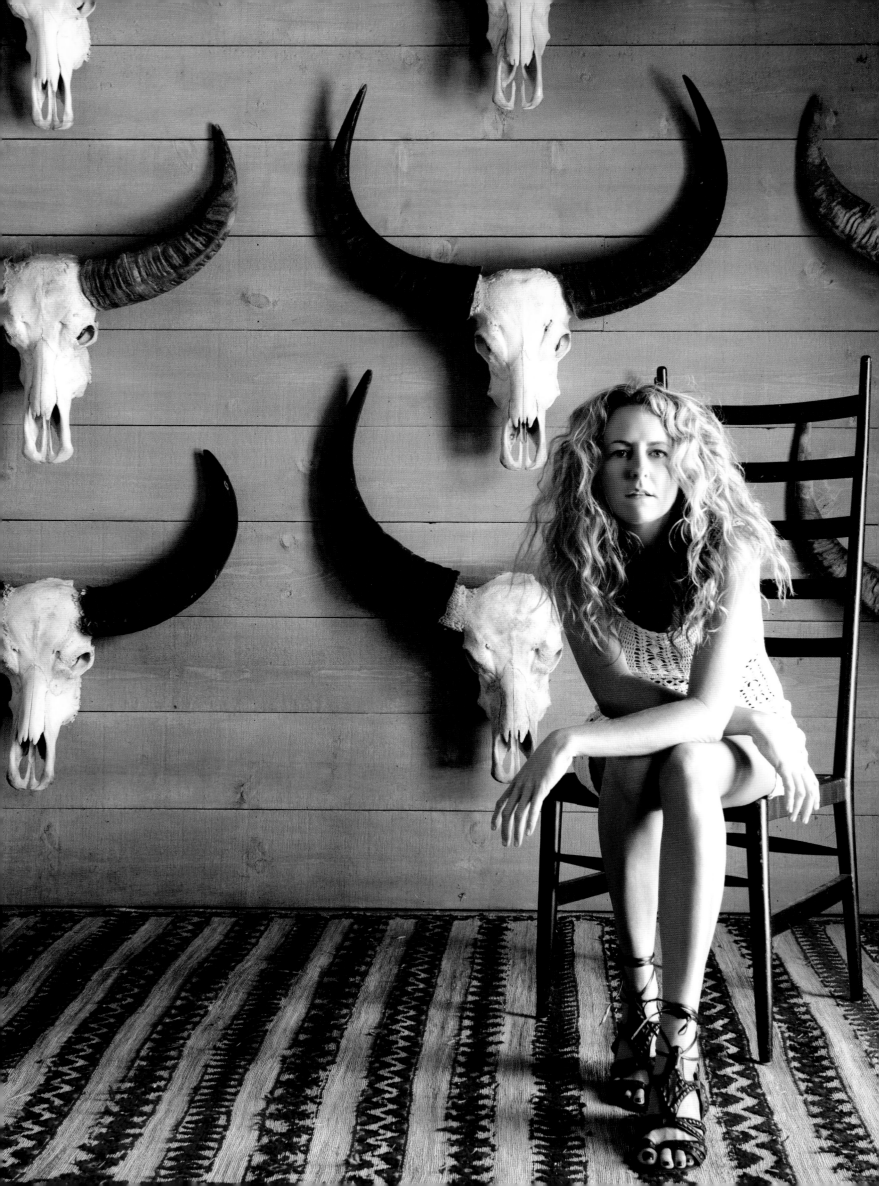

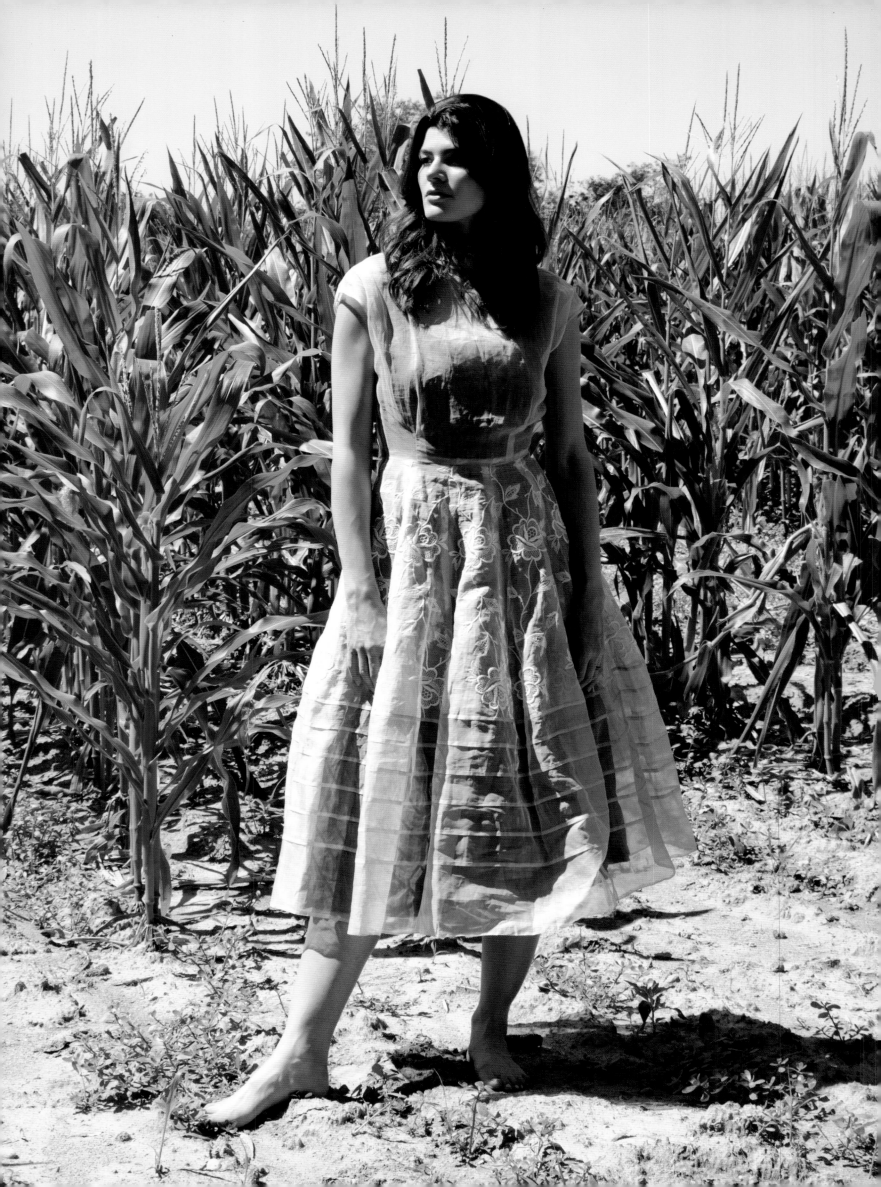

"I don't think beauty is just youth."

Linda Evangelista

Summer Rayne Oakes

b. Scranton, Pennsylvania "I am one of the lucky ones: I've always had a passion," says Summer Rayne Oakes, whose love of the environment began at an early age. She now travels the globe to raise awareness of environmental issues such as deforestation and climate change, serves as editor at large at Above LIVE, and is a regular contributor to and co-founder of the Web site Source4Style, which aids in sourcing sustainable materials for fashion design.

" I love beautiful women. I love to show their personality,
their sexuality. There's a fashion side to my erotic pictures:
I love beautiful shoes and jewellery. "

Ellen von Unwerth

Alexandra Fritz

b. San Francisco, California After honing her aesthetic at the most disciplined of houses—Francisco Costa's Calvin Klein—Alexandra Fritz moved on to consulting for Danielle Corona's Hunting Season, a line of exotic-skin bags inspired by English manors and fox hunting. Known for her polished, minimalist style, which includes a wardrobe full of Isabel Marant and Maison Martin Margiela, Fritz is seen here in her New York apartment, surrounded by the contemporary art pieces she collects, such as the Jean-Michel Basquiat hanging above her dining room table.

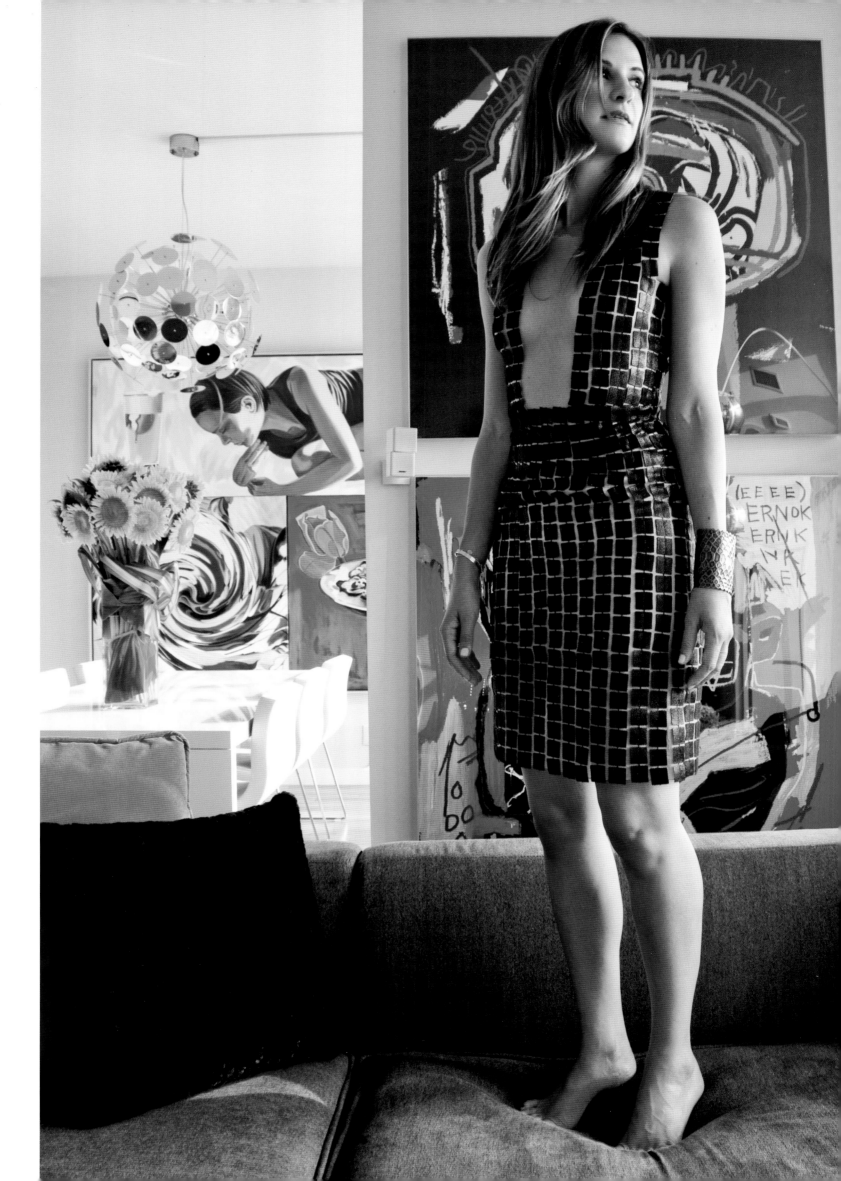

> *All women want to be desired, but when someone is beautiful, people look for a default... If you're beautiful, everyone expects for there to be something else that isn't right.*
> Raquel Welch

Stephanie Winston Wolkoff

b. New York, New York Stephanie Winston Wolkoff is the style industry's backstage icon. Serving as the inaugural fashion director of Lincoln Center, the mother of three orchestrates an ambitious year-round calendar of fashion events for the world's premier home for the performing arts, including the biannual Mercedes-Benz Fashion Week. She assumed her current position after eleven years as the director of special events at *Vogue;* in addition to her responsibilities at Lincoln Center, she acts as a consultant to IMG Fashion. She holds a black belt in karate and is a former Division I basketball player.

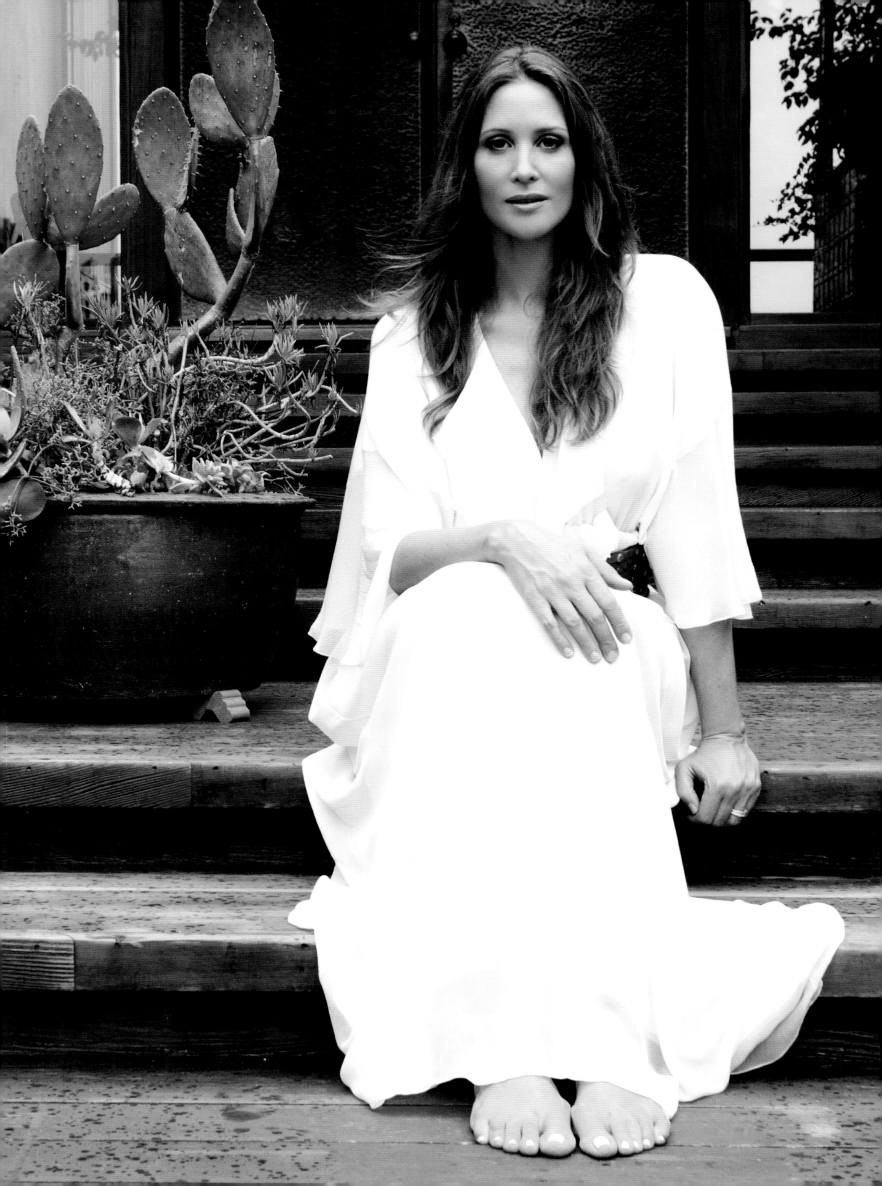

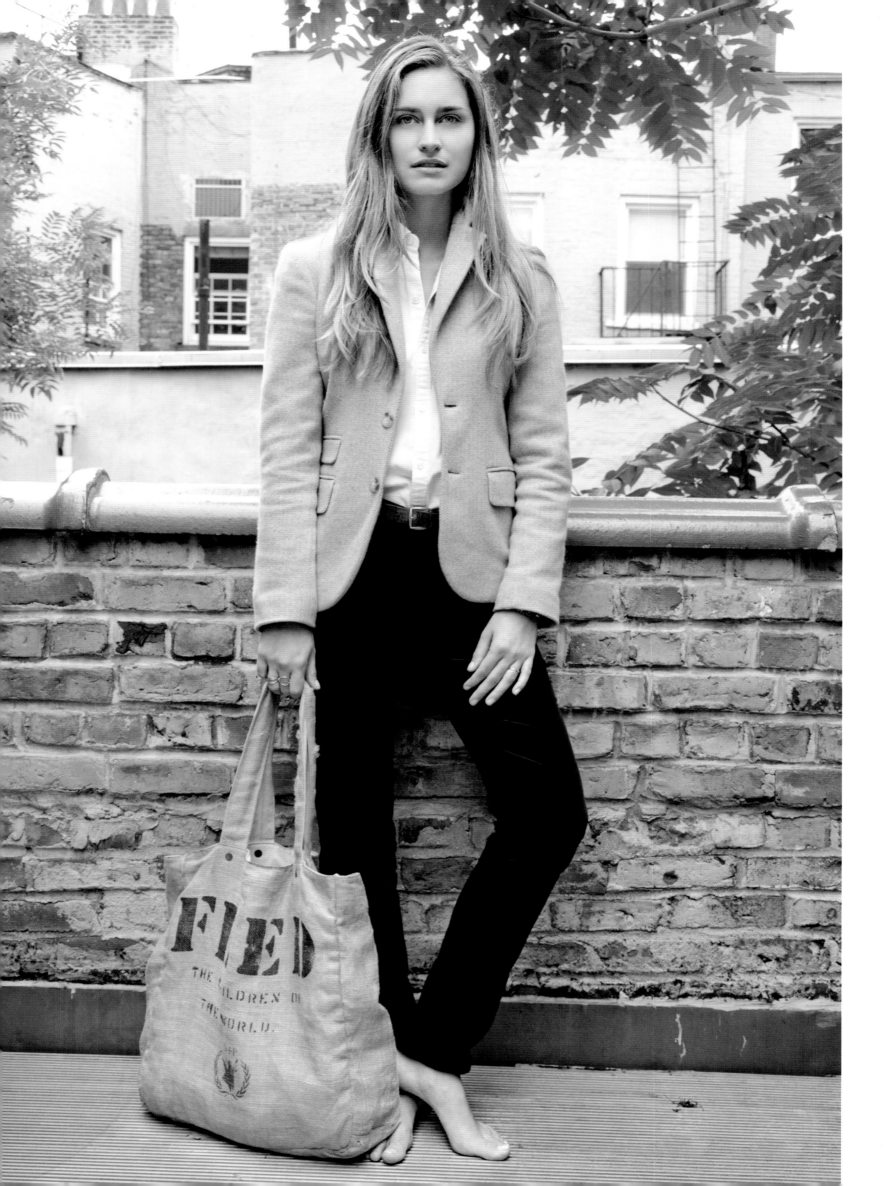

> *Their point of resemblance to each other and their*
> *difference from so many American women, lay in the fact that they*
> *were all happy to exist in a man's world—they*
> *preserved their individuality through men and*
> *not by opposition to them.*
>
> F. Scott Fitzgerald

Lauren Bush Lauren

b. Denver, Colorado Lauren Bush Lauren, the creative director and co-founder of FEED Projects, was brought up with the notion that it is imperative to give back to your community. As a young child, her mother encouraged her to volunteer and serve food at soup kitchens, but the "Aha!" moment came when she was able to travel the world as a student with the UN World Food Program and learn about the issues of hunger and poverty firsthand. "Once you see others suffering because of lack of food, it's something you have to respond to and make part of your life. And I feel blessed that I was able to combine it with something I also love, which is design and running a business," she says. As a student, she traveled to several countries as the World Food Program's student spokesperson. On one trip in 2005 to Chad, Lauren, granddaughter of George H. W. Bush and niece of George W. Bush, spoke to Sudanese refugees about their experiences fleeing Sudan and living in refugee camps in Chad. FEED Projects was started in 2006, when she designed a bag to benefit the World Food Program's school feeding operations. FEED Projects' mission is to provide meals all over the world—through the sale of environmentally friendly bags, teddy bears, T-shirts, and other accessories—by building a set donation into the cost of each product. Through FEED, Lauren has provided over 60 million meals worldwide. Her portrait was taken on the roof of the West Village, New York, apartment that she shares with her husband, David Lauren.

> *Whenever I become absorbed in the beauty of a face, in the excellence of a single feature, I feel I've lost what's really there… been seduced by someone else's standard of beauty or by the sitter's own idea of the best in him [or her].*
>
> Richard Avedon

Jessica de Ruiter

b. Toronto, Canada A celebrated stylist in Los Angeles—seen here in Silver Lake, California, in the pickup truck of her husband, artist Jed Lind—Jessica de Ruiter regularly works with *Harper's Bazaar, Elle, Teen Vogue,* and *V,* where she demonstrates her unique ability to cobble together a polished, effortlessly cool look. Raised by a single mother who "worked very hard to create a wonderful life for me out of sheer determination and drive," de Ruiter credits her upbringing with instilling in her the confidence that a woman can achieve anything she wants.

196

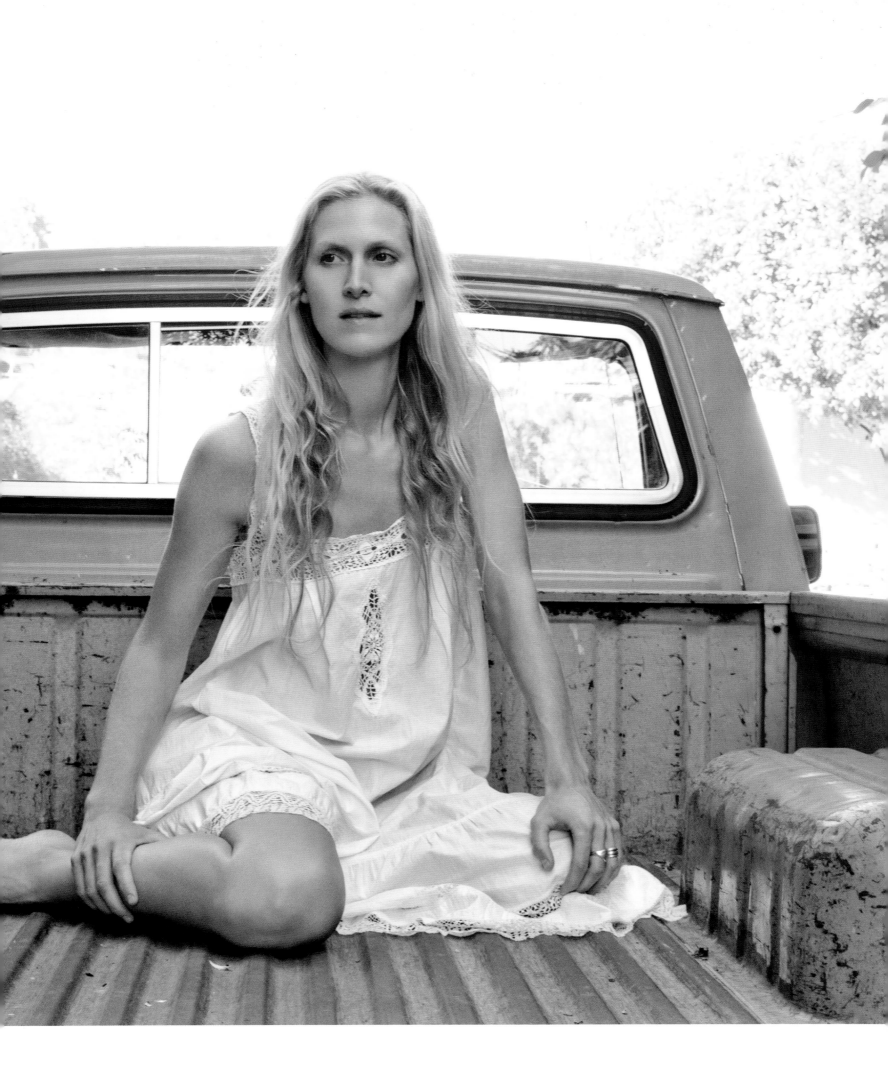

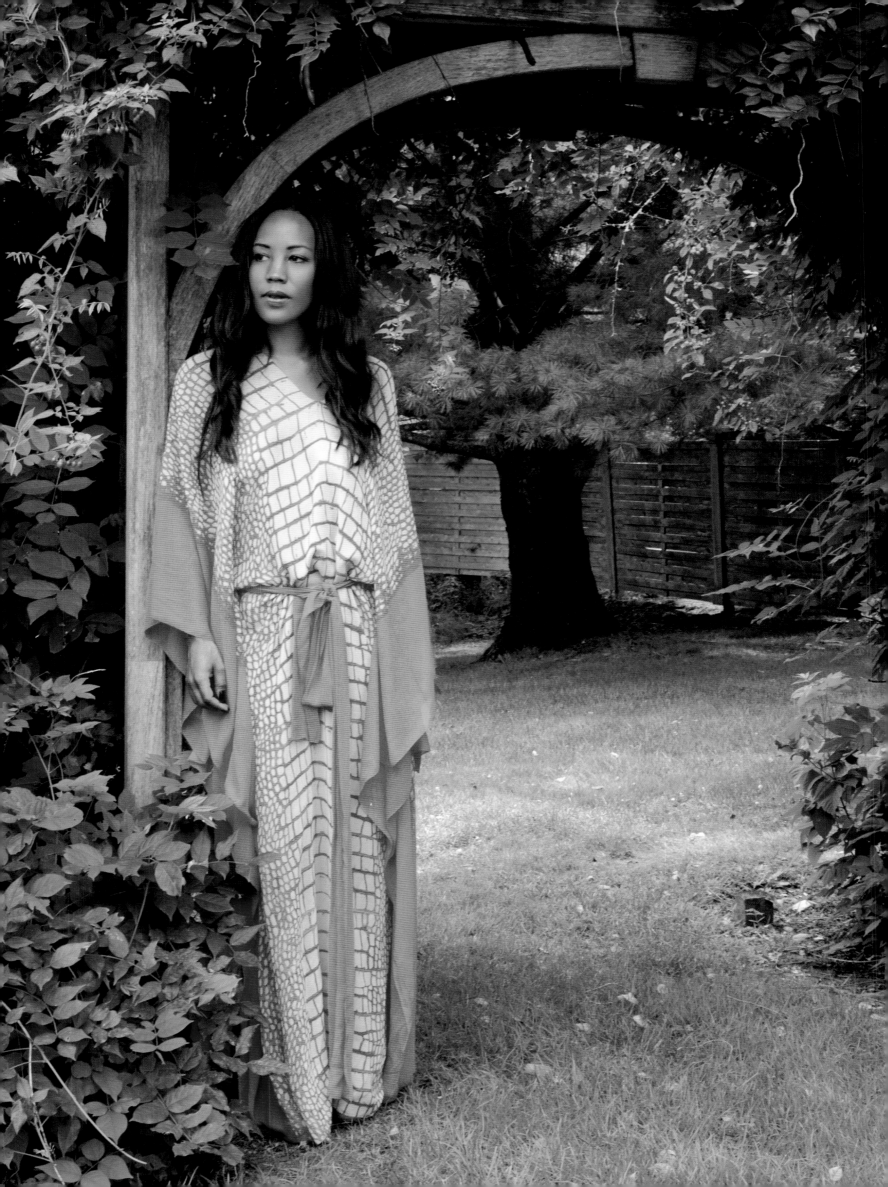

Maggie Betts

b. New York, New York "When I was young, I used to entertain all these fantasies of glorious and exotic professions I'd like to have as an adult: a pearl diver, or a lepidopterist, or some kind of world-traveling adventurer, like Indiana Jones," says documentary filmmaker Maggie Betts, photographed at her home in the Berkshires. Yet despite the departure from her early dreams, the decision to become a filmmaker was a natural one: "The strange alchemy of creating things suddenly became completely addictive for me." This year she directed her debut documentary film, *The Carrier,* which follows a pregnant, HIV-positive Zambian woman in a polygamous marriage.

"Beauty is not caused. It is."

Emily Dickinson

Taylor Tomasi Hill

b. Dallas, Texas Mixing daring prints and unexpected chromatic combinations, Taylor Tomasi Hill's audacious personal twist on fashion has earned her style-icon status. The *Marie Claire* style and accessories director, also a freelance stylist and consultant, likes to have her "hand in lots of different pots," and hopes to one day create a small fine-jewelry ring collection. Photographed in her Chelsea apartment wearing a linen Jil Sander blazer and neon green Chanel belt, Hill believes that "American style is the freedom and confidence to express yourself through your wardrobe, being able to express your mood and inspirations on your exterior."

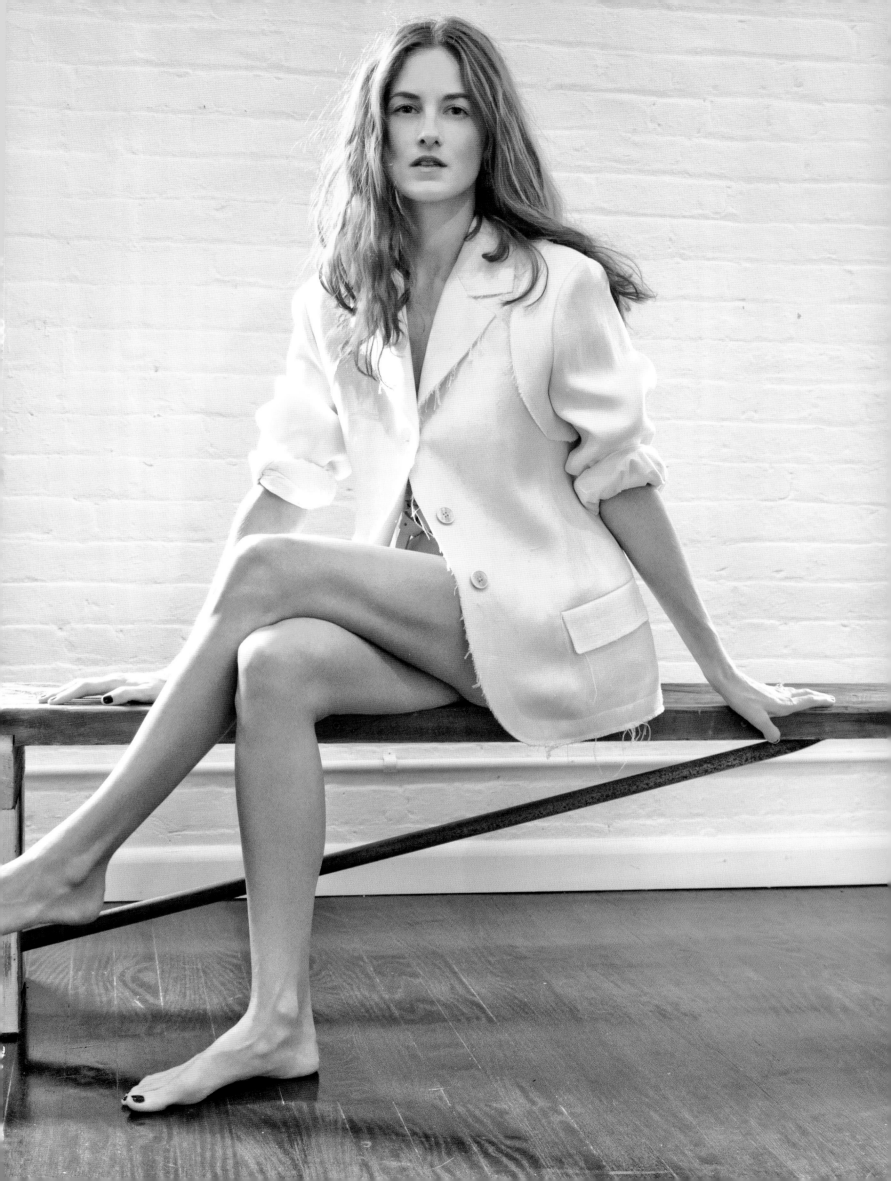

> 66 *Over the years I have learned that what is important in a dress is the woman who is wearing it.* 99
>
> *Yves Saint Laurent*

Jenna Lyons

b. Boston, Massachusetts From the moment she created a skirt for herself out of yellow watermelon-print rayon, Jenna Lyons, J.Crew's president and executive creative director, realized that she wanted a career in fashion. Photographed in her Park Slope, Brooklyn, brownstone, her style is, in her own words, "a touch tomboy mixed with grandma—something tailored, always paired with something sparkly." For Lyons, one of this country's foremost tastemakers, American style is defined by anything "timeless, individual, and relaxed." Raised in Palos Verdes, California, she began her career at J.Crew as a men's knitwear designer—a job she landed thanks to J.Crew co-founder Emily Woods reviewing a series of her sketches. Lyons's goal for the future is simple: She hopes to create "something beautiful, something smart, something lasting, and something funny."

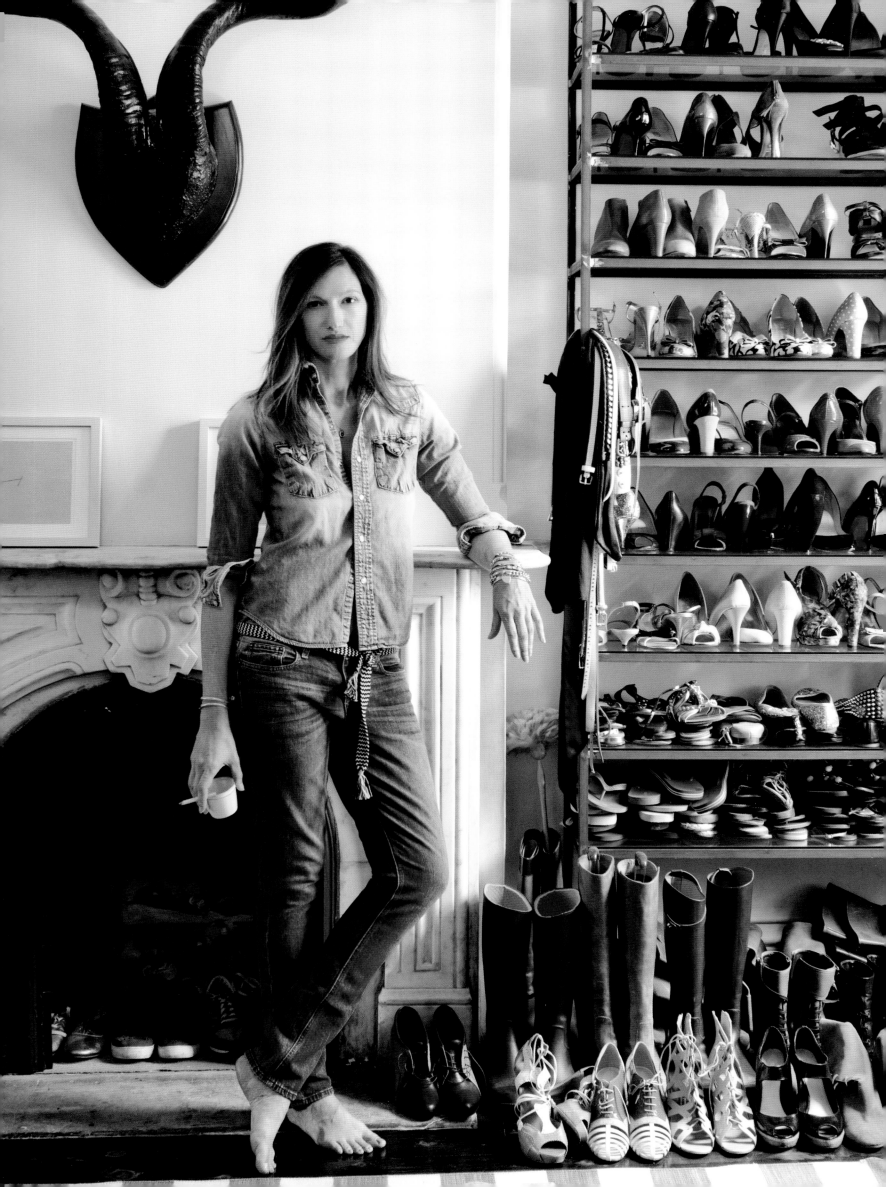

> **" *I am basically a feminist. I think that women can do anything they decide to do.* "**
>
> *Grace Kelly*

Genevieve Bahrenburg

b. New York, New York With a predisposition toward media—instilled by her father, former president of Hearst Magazines—Genevieve Bahrenburg spent four years in the features department of *Vogue* before becoming features editor at Elle.com. Currently the executive editor of *Above* magazine and Above LIVE, a sustainability minded online media platform, she is seen here beside a prop plane on Tuckernuck Island, just off Nantucket, on July 4, 2010—the weekend *American Beauty* was conceived. Bahrenburg comes from a long line of impassioned first-born women, who taught her to follow her aspirations wherever they led—be it an English classroom in a Buddhist monastery in rural Thailand, a grief counseling session with one of 9/11's many widows, or a UN summit on social innovation.

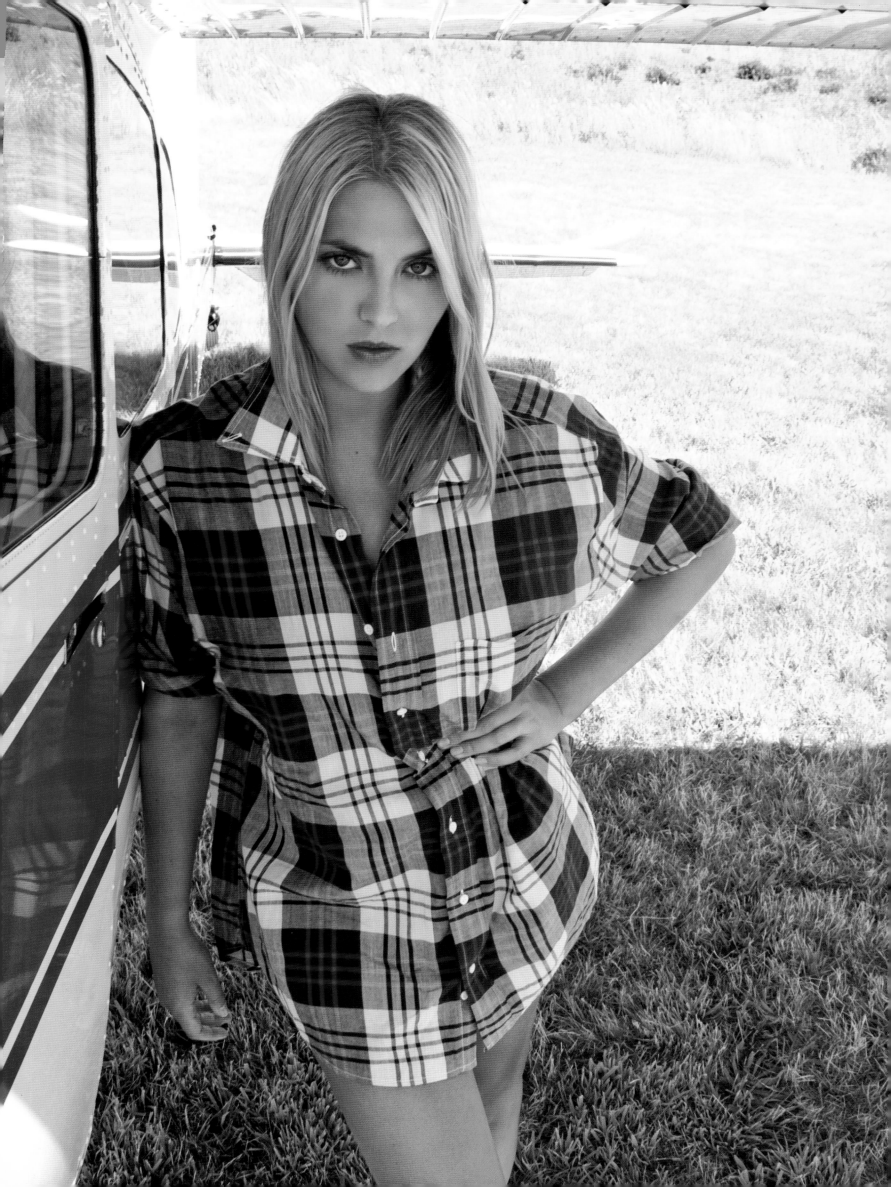

With deepest gratitude and thanks to:

The publishers Prosper and Martine Assouline, for believing in my vision of *American Beauty* and making my dream a reality. My amazing family and husband for their deep belief in me—and enduring the past two years of this ride. My mother-in-law, Cynthia Frank, for her daily support, amazing eye, and ever-present enthusiasm through this project. Genevieve Bahrenburg, for her tremendous friendship and her beautiful words—for writing my story, the story of all these amazing women, and producing this book with me. Ivan Shaw, for taking a chance on me, and pushing me to explore my world through portraiture. This book wouldn't exist without you. Lesley M. M. Blume for her passion and love of American women and the art of the portrait. Emma Greenberg for assisting in the birth of this book—from producing shoots to editing text to holding my tripod. I will be forever grateful. John Argote for his ability to take each portrait higher. Anna Wintour for opening a door, and giving me the courage to see that all things are possible. To Lily Aldridge for giving me the great honor of posing for the cover and allowing me to borrow her great beauty and grace for the afternoon. With greatest love and thanks to: all of the amazing women in this book—for your patience, your passion, and your beauty. For reminding us again and again of the power and grace of American women today. Lastly I would like to thank the editor, Ariella Gogol, for bringing it all together, and Camille Dubois, for her brilliant art direction and design.

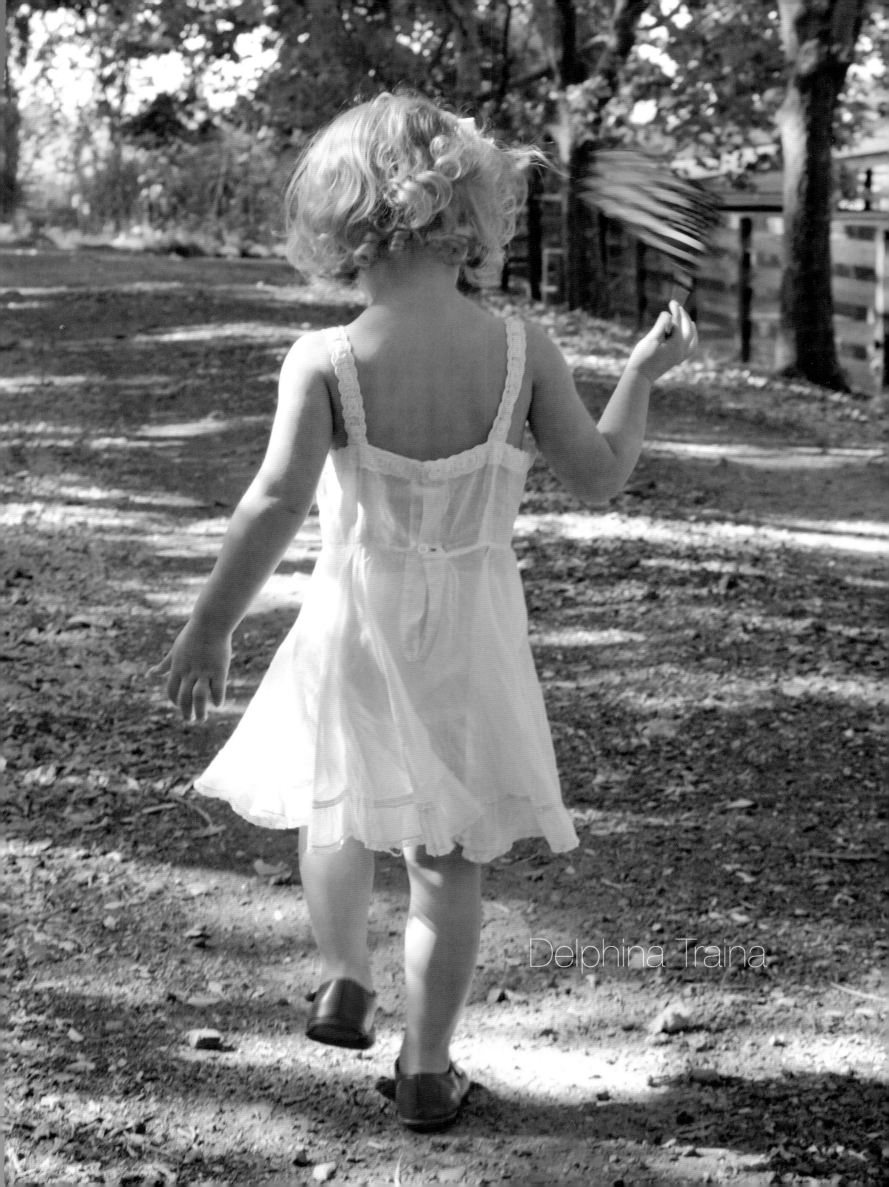